PHOTOGRAPHIC COMPOSITION

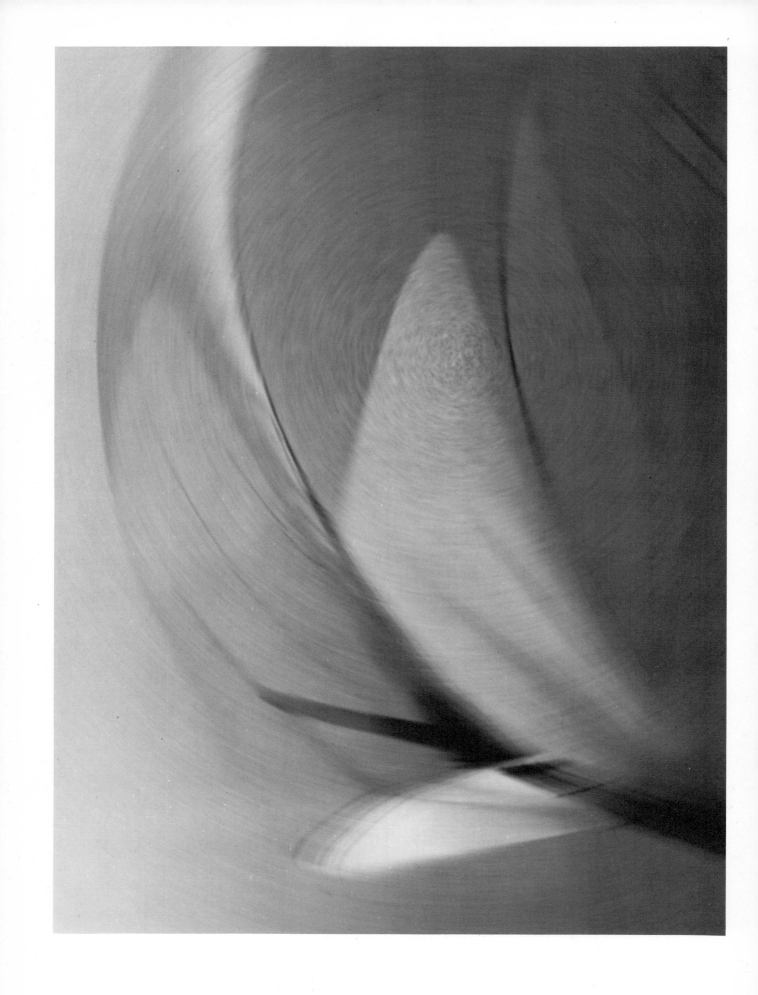

PHOTOGRAPHIC COMPOSITION

BEN CLEMENTS and DAVID ROSENFELD

 VAN NOSTRAND REINHOLD COMPANY
NEW YORK CINCINNATI TORONTO LONDON MELBOURNE

To MINNA And ADELAIDE

First published in paperback in 1979
Copyright © 1974 by Ben Clements and David Rosenfeld
Library of Congress Catalog Card Number 79-11937
ISBN 0-442-23212-8

Printed in the United States of America

Van Nostrand Reinhold Company
A Division of Litton Educational Publishing, Inc.
135 West 50th Street, New York, NY 10020, U.S.A.

Van Nostrand Reinhold Ltd.
1410 Birchmount Road, Scarborough, Ontario M1P 2E7, Canada

Van Nostrand Reinhold Australia Pty. Ltd.
17 Queen Street, Mitcham, Victoria 3132, Australia

Van Nostrand Reinhold Company Ltd.
Molly Millars Lane, Wokingham, Berkshire, RG11 2PY, England

Cloth edition published 1974 by Prentice-Hall, Inc.

16 15 14 13 12 11 10 9 8 7 6 5 4 3

Library of Congress Cataloging in Publication Data

Clements, Ben, 1910-
 Photographic composition.

 Includes index.
 1. Composition (Photography) I. Rosenfeld,
David, 1907- joint author. II. Title.
TR179.C55 1979 770'.11 79-11937
ISBN 0-442-23212-8

CONTENTS

RHYTHM
pattern and pace **187**

DEBUNKING BALANCE **218**

UNITY
the singleness of intention **230**

CONCLUSION **255**

PREFACE

Few words in the vocabulary of the visual arts are as intimidating to photographers as *composition*. Unlike students of painting, who study composition simultaneously with drawing, painting, and design, photographers concentrate their early attentions on mastery of the camera, lighting, and processing. Only after they have achieved reasonable advancement in the techniques and skills connected with sharp focus, correct exposure, film and paper characteristics, and processing controls do they permit themselves the time to consider composition. All through the period of postponement, however, they have been hearing the term from more experienced photographers and reading it in the publications.

Thus, when photographers turn to the literature on composition for serious study, they are full of apprehension about their own inadequacy. Most articles and books on composition, however, add frustration to the existing apprehension because they treat the subject in one of several ways:

1. From an analysis of paintings by old masters, the authors evolve a series of oversimplified schematic patterns based on the pyramid, S curve, diagonal, L shape, etc. These have little relevance with either the appearance of modern photographs or the world we see about us. The guidance is academic. It is useless when the photographer is confronted by the disconcerting welter of detail from which he must select a subject. The schemes are much too limiting, being more applicable to painting of the Renaissance and Baroque periods than they are to either photography or painting today.

2. Photographs of interesting, well-composed subjects are published, accompanied by a complete description of the photographer's procedure. Readers are practically urged to go to the same spot or a similar one to repeat the conditions of the photograph and to obtain the same result as the original. Such slavish imitation is demoralizing.

3. The author analyzes the composition of fine photographs with diagrams of lines, planes, and points of tension that frequently bear little relationship to the photographs themselves. These have meaning only to the person doing the analysis. Unfortunately, the most tangible effect on the reader is extraordinary respect for and envy of the analyst. Novices regard these incomprehensibe diagrams as a sequence of magic rites, performed by the special few who have the privilege of some prodigious secret knowledge. None of this knowledge is communicated to the reader.

4. Visual organizations of graphic images are presented and analyzed by psychology-oriented artists and then applied to problems of forms and space. These are remarkably good, but they are intended for the most advanced artists who are familiar with the language of Gestalt Psychology and who have already absorbed the essentials of design through long study and practice.

The poor seeker of understanding of photographic composition is further disheartened by listening to glib speakers who are more knowledgeable about the language of composition than they are about its practice or content.

All of this is most unfortunate because the theory and practice of composition can be learned by almost anyone who is willing to devote some time to it. Most of the knowledge proceeds from rational, easy-to-understand principles that have usually been sensed intuitively. In the process of learning, one cannot help feeling that formalized study merely gives expression to understandings that have been perceived, subconsciously, all along. Given the confidence to proceed, objectives to attain, and criteria for evaluation, people who relate to pictures and have experienced them over a moderate period of time can solve the problems through normal reasoning.

It is our intention, in this book, to examine the qualities and forces that function together to produce art in photography. In order to accomplish this, we have concentrated on the nature of each separate aspect, discussed some of its characteristics as they pertain to visual perception, and demonstrated their application in photographic art.

It is our belief that conscious awareness of these qualities increases the range of impressibility. The process of assimilating an understanding of shape, line, and texture, and the way they interact in contrast and rhythm, tends to make one more sensitive to their perception in nature. Having been deeply exposed to an art force, we become so conditioned to its presence that we cannot avoid sensing it, even when it is partially hidden or disguised. We perceive qualities that elude others who have not developed such awareness. A greater appreciation of what can be seen in life and in the personal interpretations of life that others have made becomes clear.

The possession of greater impressibility usually promotes strong initiative to explore both outwardly and inwardly. Outwardly, creative people seek, in selected manifestations of life, the unique qualities of form, beauty, and interest that remain undiscovered and unseen by others who look for little more than self-evident reality. Inwardly, they submit to self-questioning for the purpose of exposing deep, unrealized inner feelings instead of merely providing clear images of obvious things. Every artist aims to express his individual reaction to a situation in a way that has never been done before.

The study of photographic composition may be approached through analysis of whole pictures. It has been our experience, however, that, without a thorough understanding of the elements and principles, analysis is ineffectual. For anyone who is unfamiliar with the essence of perception, it is almost as confusing to state what makes a picture successful as it is to discover the qualities in nature that make it worthwhile as a subject.

Consequently, our approach has been one of synthesis. Having examined an influence, we apply it directly to whole pictures and discuss the interaction of previously learned factors. We trust that as a result of understanding how each of the elements and principles function, you will be able to respond to whatever you discover and to use it to express the reaction you receive from the subject.

BEN CLEMENTS
DAVID ROSENFELD

Art and Photography

Photography has matured and established itself as art.

Automatically this statement may provoke purists to challenge it as false or at least presumptuous. They will argue that photography is the product of a machine, while art is anything but mechanical.

Art, it is said, is the visual expression of man's emotional reaction to some aspect of life, whereas machines are completely lacking in emotion. Only when there is complete freedom to change, to combine, to eliminate, and to reorganize the various parts of the subject, so that a completely new pictorial entity is formed, can art be created. The photographer, they say, is able to record only that which exists before him, thereby limiting the possibilities for change to a few mechanical variations. He can wait for a change in natural lighting or provide artificial light; he can select an angle of view; and he can substitute lenses to change perspective.

CONSTANT CHANGE OF ART FORMS

That these arguments are unconvincing and misleading is made clear by the very concept of art itself. Traditionally, art has been associated with certain materials and processes, which were the only ones available in earlier times. Over thousands of years, people learned to take various coloring materials from plants and minerals, to mix them with gums and water or with oil and varnish, and to make pictures by applying the coloring materials with brushes to a surface.

Art forms, however, are constantly changing. Adventurous experimenters have invented new materials and devised new techniques. They have discarded old ways of working and

1

revived others from the distant past. In recent years, new media have found their way into accepted art production: acrylics, collages, assemblages, environmental projects, and happenings, to name only a few.

The essence of art is only partially concerned with materials and processes; its most important features are based on one's ability to extract the fundamental visual qualities of a subject and record them in such a way that they have a stimulating effect on the observer.

Brush, paint, etching needle, crayon, and proof press are merely media of art. They can give no guaranty of art success anymore than T square and triangle can produce architectural excellence. In the hands of an artist, they are tools that may help to produce art; in the hands of a dullard, they produce only meaningless marks.

So it is with the camera. As a medium of the artist, it can help to produce a particular kind of art. But no amount of technical knowledge, craftsmanship, and care can make the camera produce art when it is guided by a nonartist. *The camera, then, is a sensitive tool that responds to the thinking of the person who operates it.*

Students of painting and sculpture need to spend years in the study of their crafts, drawing, painting, and modeling, before they acquire the means to express their art ideas. Simultaneously, they need to develop an understanding of art itself; otherwise their works are merely visual documentary records of people, places, and things. Unfortunately, many artists become so completely absorbed in developing the means that they lose complete sight of the end, the expressive part of art, which is its real function.

Students of photography too need to spend years perfecting their craft, studying lighting, camera techniques, film characteristics, and processing. Many are content to practice photography at this craft level, providing excellent factual records and serving a purely functional need. Others, responding to the urge to go beyond utilitarian satisfaction, seek to explore the mysteries of art. A considerable number have succeeded in the attainment and have received proper recognition from fellow artists, museums, galleries, private collectors, and industry.

Every discussion of art leads to the question that has baffled philosophers ever since man consciously became aware of pictures, sculpture, and environmental appearance. WHY IS ONE PIECE OF WORK CALLED ART WHILE ANOTHER, SIMILAR IN MANY RESPECTS, IS NOT? Many theories and explanations have been presented, only to be followed by an equal number of disputes and contradictions. A substantial part of the problem revolves around three fundamental confusions:

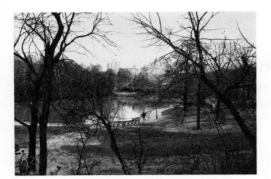

PLATE 1-1

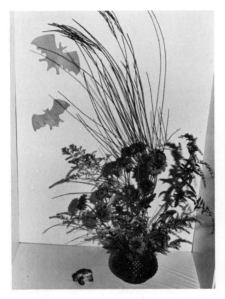

PLATE 1-2

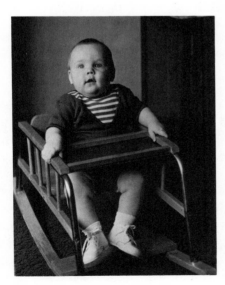

PLATE 1-3

1. the similarities and differences between art and nature,
2. visual thinking and word ideas,
3. art and craftsmanship.

ART AND NATURE REPRESENTATION

Since the 14th century, artists, responding to the search for scientific reasons behind every human activity, made a close study of nature and continually kept adding more naturally and scientifically correct details to their work. Anatomy, perspective, lighting, three dimensionality, and draping were given so much attention that unsophisticated spectators came to the conclusion that art was a way of imitating nature. Here was an easy clue to the understanding of pictures and to the determination of their value. Those that reproduced the subject matter with slavish correctness were good. Any departure raised suspicions of ineptitude.

The movement toward scientific observation and naturalistic representation continued until the latter part of the 19th century when it went as far as it could go with Impressionist painting. The Impressionists succeeded in representing the dazzling effects of atmospheric light so successfully that one could determine the season, the time of day, and current weather conditions from the picture.

At about the same time, photography was developed and came into wide use. Now the "little black box" could do with ease what so many artists struggled to attain for centuries. It could capture all the details, all the gradations, and even all the unpleasantness to be found in nature. This marvelous invention made it relatively easy for anyone to make a picture.

Relieved of their burden to record verisimilitude, artists turned to the search for the more essential qualities of art. Their experiments have led us to some important conclusions about the relationship between art and nature.

Nature has a beauty all its own; it defies being captured. A picture of natural beauty will not automatically result in a beautiful picture.

Few people would hesitate to consider the subjects of the photographs in Plates 1-1 to 1-3 as beautiful.

Central Park in New York has been enjoyed by residents and visitors for a whole century. Its varieties of hills and depressions, rocks and trees, winding paths and reflecting lakes have made it an oasis for those who seek nearby relief from the pressures of urban life. Even the ever-heightening massive buildings, which surround each border, provide an interesting contrast.

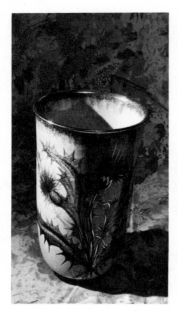

PLATE 1-4

Over the years, Central Park has provided inspiration for thousands of fine paintings and photographs. Many of them are exhibited and admired in museums.

The flower arrangement won first prize in a competition sponsored by an important flower club in the New York area.

The child is the winner of a "beautiful child" competition.

Each of these subjects has intrinsic beauty as a subject. Yet the picture of the subject, properly focused, exposed, and printed, is uninteresting. No amount of cropping, dodging, or superimposition can provide what they lacked in the taking—a recognition or discovery in the mind of the photographer of pictorial elements over and above the intrinsic beauty of the subject.

The results may be equally disastrous when we photograph beautiful man-made objects.

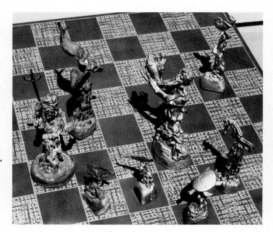

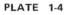

PLATE 1-5

PLATE 1-6

The Chinese vase is a fine example of antique porcelain. Its form, surface, and glaze are as perfect as it is humanly possible to achieve.

Frank Eliscu is the former president of the National Sculpture Society and the author of a number of highly respected books on various aspects of sculpture. His bronzes are commissioned to adorn government buildings, office building lobbies, banks, and fine private homes. This chess set by Mr. Eliscu, cast in silver and made up in gold plate on bronze from wax originals, is superb.

At a time when most city skyscrapers are condemned as ugly glass cages, the Seagram Building in New York, designed by Mies van der Rohe, has received unanimous praise from critics all over the world. Its fine design of space, intelligent use of bronze for surface color and texture, and its magnificent plaza have inspired many photographers to make fine pictures.

Here again, confronted with beautiful subjects that are technically perfect in exposure, focus, and printing, unimpressive pictures have been produced. As in the previous examples, the vital ingredient of artistic thinking was lacking in the mind of the photographer.

Conversely, nature, people, and things, not beautiful in the ordinary sense, can be made beautiful in pictures.

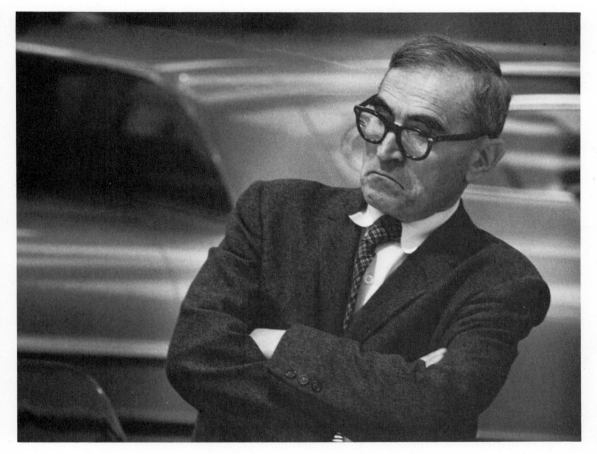

PLATE 1-7

PLATE 1-8

PLATE 1-9

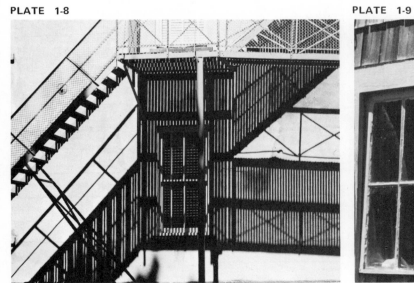

We need to distract ourselves from the appeal of the picture to recall that each of these subjects seen in nature under usual circumstances is not particularly attractive. On the other hand, the combined result of the artist's inner vision and craftsmanship have produced a picture from the subject that commands interest and attention and might be called beautiful.

ART IS CONCERNED WITH ABSTRACT VISUAL QUALITIES

Subjects need not necessarily be ugly to ensure pictorial success. Beautiful subjects can frequently yield beautiful pictures. The point is that pictorial effectiveness is completely dependent on the artist's discovery of and feelings about the abstract visual qualities in the subject and his ability to extract them in a way that permits the spectator to see what the artist saw and to react with similar feelings.

PLATE 1-10

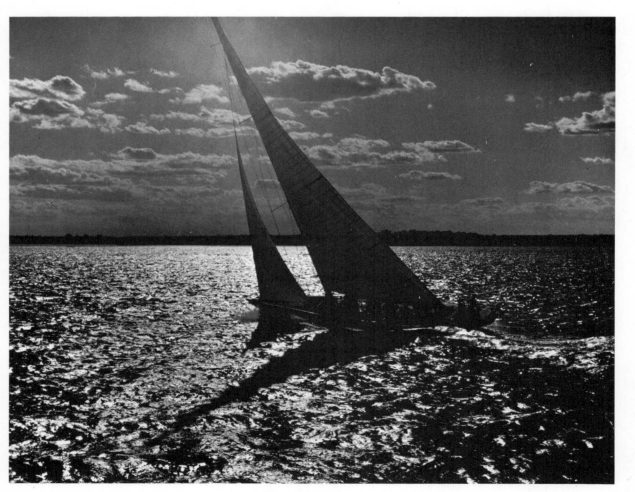

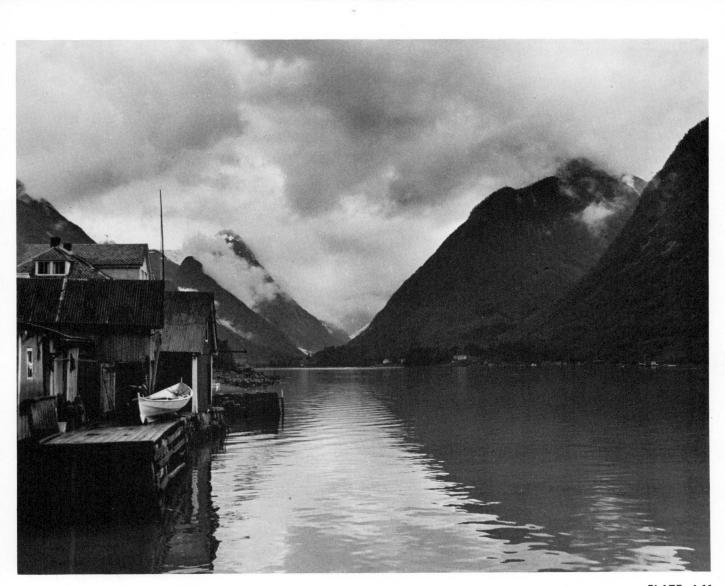

PLATE 1-11

PLATE 1-12

From an artist's point of view, nothing in nature is either beautiful or ugly. It is the artist who has the power to discover the essence of the beauty and to reveal it to others.

It should be apparent then that art qualities have very little to do with mere natural appearance. The inherent beauty of the subject does not necessarily equate with the attractiveness of the picture. Art is composed of certain abstract qualities that set it apart from a mechanical imitation of nature. Verisimilitude should not be considered either a starting point or a criterion of artistic merit. In fact, the most effective pictures are those that subordinate the natural forms and aim for highly simplified and boldly expressed lines, tones, shapes, and textures. Art is a matter of extracting these essential visual qualities, making them dominant, and either eliminating or subordinating those constituents that do not contribute to the central idea established by the artist.

These visual qualities exist all around us; they are so much a part of our daily lives that most of us pass by without perceiving them. Every subject, regardless of its banality or magnificence, contains them in almost infinite quantity.

Sometimes they are fleeting and exist for an instant; at other times they remain inanimate, deceptive in the superficial ordinariness that masks deep mysterious interests.

PLATE 1-13

PLATE 1-14

Discovering these lines, tones, shapes, and textures in the subject and putting them together in the finder so that they result in an arrangement truly satisfying to the photographer and later in the print, so that they are made clear to the observer; this is what composition is all about.

While there is much that happens in a picture that cannot be explained and is almost in the realm of magic, there is still much that can be made apparent. Some photographers are born with the sensitivity to discover the mystery intuitively in the most unlikely places; others need to be made aware of the underlying visual elements and thereafter discover them without too much difficulty. Most need an organized program of study to sensitize their awareness of these visual qualities, thus developing the ability to recognize them.

Composition is a thinking process of making order out of the chaos that nature presents and of organizing many diverse elements into a comprehensible unit. It is a process of reaction to those elements and of finding the way to organize them so that they communicate to others the excitement, the reverence, the awe, the wonder, or the sympathy that the photographer feels. At times, the expression should aim for tranquility; at other times, strength and stability or perhaps dynamic activity. The subject itself will reveal to the photographer what the mood should be.

Through composition, a photographer clarifies his message and directs the attention of the viewer to the elements the photographer found most important and most interesting.

There are no secrets in either the procedure or the language of composition. There are no lists of rules to learn. The understanding and practice of composition require the application of a few obvious, commonsense principles that have been known and used successfully through several thousand years of art.

There are no convenient tables, digests, or manuals of procedure such as we have found so helpful in technical matters. A number of years ago, the solution to composition was thought to have been codified in a compilation of basic compositional forms that included the pyramid, the circle, and the radial wheel. It was evident that some old masters had used similar devices in some of their paintings. There have been many excellent paintings and photographs, however, where any attempt to analyze the composition in terms of basic format necessitated explanations that were more apologetic than apparent.

Photographers who have tried to put together compositions to conform with these patterns have found that they either lead to stereotypes or impose a strained self-consciousness on the final picture. These patterns add little more to our accomplishments than a vocabulary of terms that we can call upon to impress our listeners.

Even if composition could be neatly organized and presented in encyclopedic form, it is questionable whether it would really be useful because the dull sameness that would inevitably result would be boring indeed.

On the other hand, the development of composition solely through intuition may lead to many rewarding pictures, but too often this approach is hit or miss. It does not ensure that the thought the photographer sought to express will be conveyed to the viewer.

PSEUDO ART IN PHOTOGRAPHY

In relating art and photography, there is a danger that those with a little knowledge of both photography and painting will confuse the two media of expression. Lacking the ability to perform satisfactorily with paints on canvas, they seek to achieve arty effects with the camera that are reminiscent of Corot and his imitators—soft edged, sentimental, misty, and pictorial. These highly flattering "Impressionistic" scenes have been shown for years in local and national salons, and devotees may still be found hunting for old "recipes" that explain how to manipulate negatives and prints to produce these effects.

With the emergence of the Geometric, Abstract-Expressionist, Pop, and Minimalist styles in painting, there has developed a younger breed of pseudo artist photographers who are guilty of the same offense to photography. They, however, choose to imitate modern painting instead of old. They too manipulate the image by splashing chemicals, applying paints, and imposing foreign materials to achieve the superficial effects of abstract art.

PLATE 1-15

11

Absolute purism can be obvious and repressive, but there is so much that can be and has yet to be done through the photographic channels of optics, light, and chemistry that there is no need to resort to imitation. Those experimenters who prefer not to be bound by the straightforward use of the camera, lens, and negative and print techniques may explore photograms, multiple exposures, light modulators, and photo collage.

There can be a world of difference between abstract art and the abstract visual elements. Abstract art is a stylistic development of painting and sculpture that began as a reaction against the march of scientific realism. At first line was strongly emphasized and then color combinations were devised for their esthetic effect rather than for the representation of nature. Subsequently Cubism, followed by various forms of abstraction, was developed. Anyone who thinks that Cubism or abstraction may justly be called modern may be shocked to learn that Cubism dates back to 1908.

In a sense, the motivation behind abstraction was to prove that a vast variety of paintings could be created using only the abstract elements of line, dark and light, color, shape, and texture with little or no reference to the subjects of the world of reality.

Now that this thesis has been proved satisfactorily and the fatigue of long exposure has set in, it appears that current art ideas are again becoming involved with realism—a realism much different, however, from that of past styles. This realism tends to emphasize, very strongly, the same abstract elements that are basic to every work of visual art—photography as well as painting, graphic arts, and sculpture.

These abstract elements have been responsible for the success of every art form since man first began to decorate his environment, his clothing, and his tools. They have continued to be the dominant force of the art of every civilization throughout the world.

Although some aspect of nature has always served as a model for man's art, the degree of esthetic success has always been directly related to emphasis of the elements—line, shape, color, volume, and texture. Good art generally results from interpreting nature in terms of these elements. Bad art almost always results from the practice of merely imitating nature with little or no regard for the elements.

For any one art to imitate another, consciously or unconsciously, is to negate its value as art. The photographer who sets out with photographic materials to produce that which has been done with paint or some graphic process places himself in an inferior position, making his art (if it can be called art) inferior.

To produce a photograph that resembles a painting, a lithograph, or an etching is a violation of the integrity of the medium of photography.

PLATE 1-16

VISUAL THINKING AND WORD IDEAS

Artists deal with sights; musicians, with sounds; and writers, with words. It is a mistake to permit one form of expression to be fulfilled in terms of another.

Probably because the major part of our education has been accomplished with words, we try habitually to read literal meanings into pictures. A feeling of curiosity persists regarding the hidden sentimental or moral intimation of the picture or perhaps the romantic story behind its origin. Believing that the literary content is the art itself, we seek the "other words" to explain the artist's message either to ourselves or to others.

There are, however, no meaningful "other words." The artist's message is purely visual. Whatever meanings are present in the picture must be seen and cannot be read.

Verbal explanations of even the artistic qualities of a picture tend to exaggerate the importance of one quality and to distort the delicate relationship of all the parts as a working harmony. At best, they may oversimplify the artist's motives.

Commentaries on a geometric painting by Mondrian usually point out that it consists of verticals and horizontals which intersect to form rectangles of varying size, some of which are filled with solid black and others with a solid red or yellow. All this is obvious to anyone who will take the trouble to look. Moreover, anything that may be said about one painting by Mondrian can apply with equal vagueness not only about other Mondrians but also about pictures by other artists of the same period. Yet each is an entirely different picture.

What has been accomplished by the commentary actually is a general statement about Mondrian's objectives, his way of working, and the principles of an art movement. Little can possibly be said to increase the appreciation of any individual picture. People who find pleasure in looking at a Mondrian are provided no key to justify their pleasure. Those who dislike the work have little to convince them to change.

So it is with photography. The picture must impress by its visual qualities alone. Searching for anecdotal significance in the subject or in its treatment has nothing to do with its art values; it serves only to confuse.

The following photographs impart their message through the sense of sight exclusively.

PLATE 1-17

PLATE 1-18

PLATE 1-19

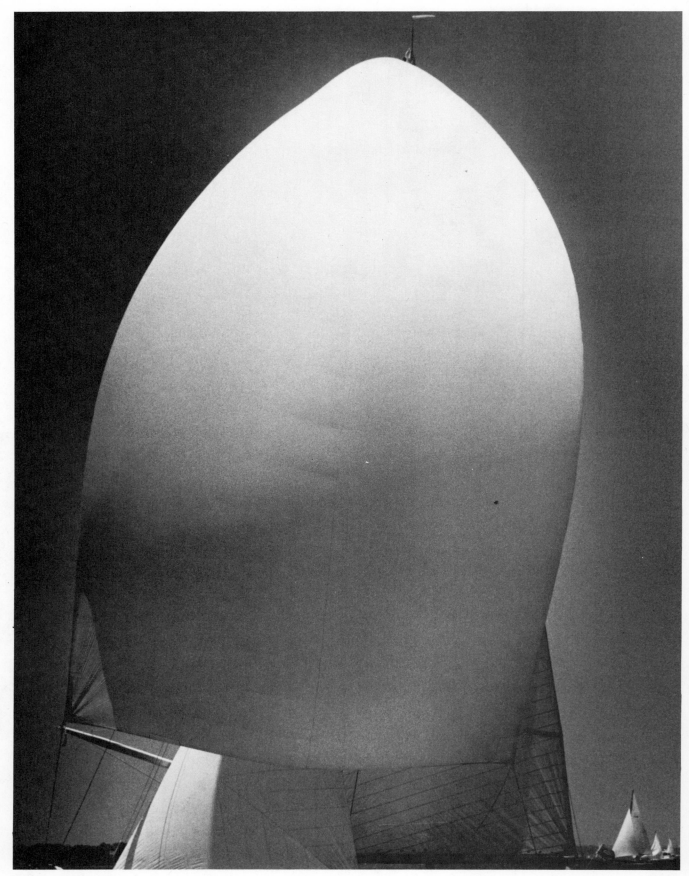

PLATE 1-20

They did not originate with word ideas, and no verbal reaction is expected. The pictures express all there is to say without the need for a supplementary text.

Adults need to redevelop the basic pleasures a child experiences when looking at exciting lines, shapes, colors, and textures.

ART AND CRAFTSMANSHIP

It is easy to understand why craftsmanship may often be confused with art so that sometimes it might even be taken as a synonym for art.

The first attempts at any activity are always frustrated by an obvious lack of coordination. Tools seem ungainly, mishaps occur, and the whole procedure is spoiled because of a deficiency in skill. Observing facile workers perform exaggerates the relationship between smooth execution and excellent outcome, leading to the false conclusion that they are the same.

One cannot be an artist without being a highly skilled craftsman at the same time. If the ideas in a piece of work are good but the execution reflects underdeveloped skill, the message will fail to reach its goal. Both interesting idea and consummate skill are necessary to produce the impact that is expected in a work of art. It does not necessarily follow that the highly skilled craftsman is an artist. The analogy of a cabinetmaker may clarify this point.

It is possible to produce a cabinet using fine wood, fitting all the joining parts squarely and accurately, and varnishing and rubbing the finish to an impeccable degree; yet the end product could be ugly.

Similarly, a photographer may produce a picture that is technically perfect so that it may be admired for its flawless exposure and processing. It may even be competent in composition. Yet the picture as an entity may be completely uninteresting to any but the most involved spectators.

The artist photographer is expected not only to be a superb craftsman but also to experiment constantly to improve his craft. He may even reach an advanced stage, as did 20th-century painters, where he can take such liberties with craftsmanship that he may make use of skillful, intelligent, and bold procedures that are sometimes associated with the crudeness of poor craftsmanship.

A provocative characteristic of many artists is the desire to disprove anything that has been considered essential or dogmatically true. Artists have reversed perspective, taken liberties with proportion, invented impossible situations, introduced conflicting lighting from presumed natural sources, and upset established color harmonies. Iconoclasticism is a feature most artists seek to acquire if it is not a part of their original traits.

Each of the following photographs defies an important principle of photographic craftsmanship, in the final result gaining a more challenging, pleasing, and attractive impact.

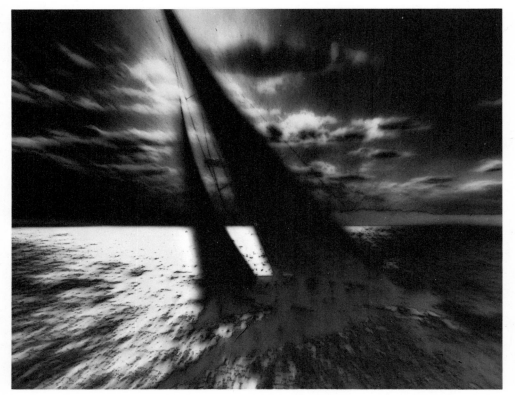

PLATE 1-21

PLATE 1-22

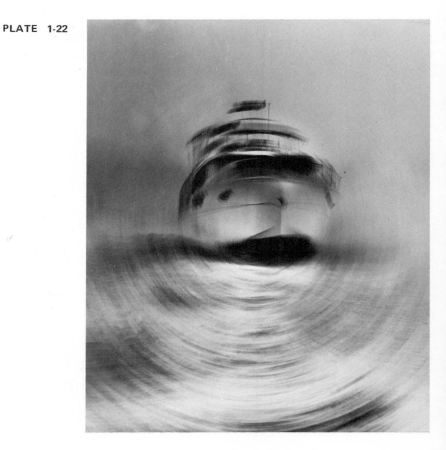

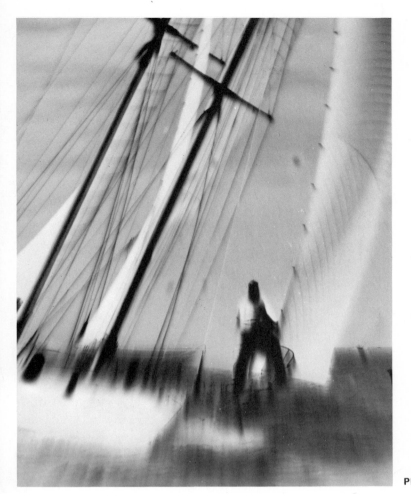

PLATE 1-23

PLATE 1-24

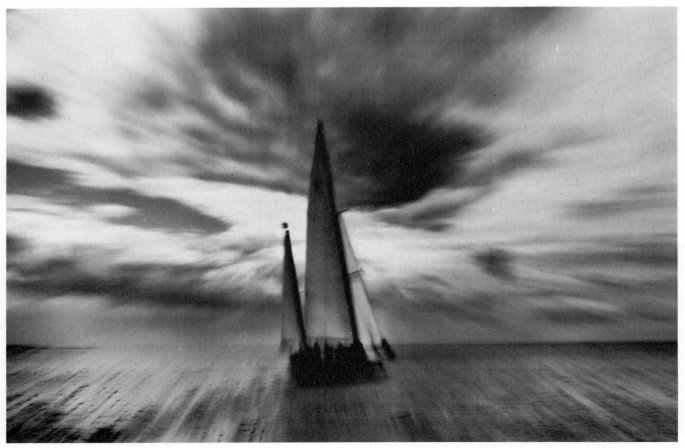

The Shape of Things

Of all the constituents of composition, shape is perhaps the most essential. So many great pictures owe their success to either the dramatic impact of a single shape or the subtle interplay of several shapes that one could easily conclude that shape alone is the fundamental quality of composition.

On the other hand, many fine pictures have been made in which shape is an unimportant factor. This is the recurrent theme of art as opposed to craftsmanship; there are no fixed standards. As soon as it appears that any one principle is essential, someone comes along to prove definitively that art may be produced by eliminating that principle or even by working antagonistically to it.

Nevertheless, shape design is sufficiently important to warrant very close attention by photographers. Let us deal first with the situation in which a single shape dominates the photograph.

Students of painting and sculpture have the advantage when studying shape design in their ability to create any kind of shape easily with pencil or clay. The photographer must discover his shapes in nature. More important than the means of working is the sensitivity one develops to the perception of shapes, both natural and man-made. An effective way to develop this sensitivity is to draw with a pencil. Very little drawing skill is required.

Let's start with the circle.

Figure 2-1

Photographically, this circle could be a coin, a ball, a pizza pie, or a dish.

20

Nothing in life is isolated; everything we encounter and everything we see and feel is experienced in relation to other things. The circle, the coin, or the pie take on different visual effects in relation to the frame we place around them. Although the frames in the following instances are rectangles, as most photographic frames are, an enclosure of any shape could be used.

Figure 2-2

The space enclosed by the frame is called the *field*.
The shape or object placed in the field is the *figure*.

FIGURE-FIELD RELATIONSHIPS

As soon as we place the figure into the field, a third and extremely important element of shape design is created. This one, called the *negative space,* is just as positive a factor to be considered as the figure and the field. In this instance, the dark area is the negative space.

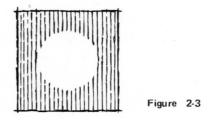

Figure 2-3

Its importance can be more clearly understood when we use the same figure and field but change the negative space by placing the figure in different parts of the field.

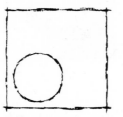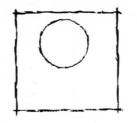

Figure 2-4

Each movement of the figure within the field has changed the shape of the negative space, thereby exerting a subconscious but enormously powerful effect on the appearance of the composition.

Too often photographers concentrate only on the figure and neglect the field. This is prompted by the apathetic acceptance of standard size negatives and papers prepared by manufacturers. Here is the same simple circle in a variety of fields.

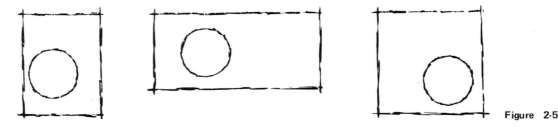

Figure 2-5

Each change of field has provided a different visual sensation as an enclosure for the circle. It has, in addition, created an entirely different shape of negative space.

Up to this point we have dealt with the circle only as an outline figure in a blank field. As artists, we must deal with the variations of treatment possible when we photograph a circular object.

Through controlled lighting we can

1. Emphasize the outline.

Figure 2-6

2. Emphasize its three dimensionality by lighting to produce a cast shadow on one side.

Figure 2-7

3. Emphasize the irregularity of its outline.

Figure 2-8

4. Emphasize the smoothness of its outline.

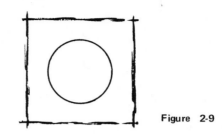

Figure 2-9

5. Emphasize its contrast of dark and light against the field.

Figure 2-10

6. Emphasize its surface pattern or texture.

Figure 2-11

Depending on the tone of the object and the degree of emphasis we wish to obtain, we may consider the following as variations of the foregoing arrangements.

1. Light object against a dark background.
2. Light object against a middle tone background.
3. Middle tone object against a light background.
4. Middle tone object against a dark background.
5. Dark object against a light background.
6. Dark object against a middle tone background.

Still further variations can be obtained by changing the size of the figure in relation to the field.

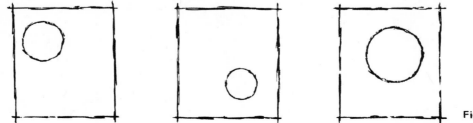

Figure 2-12

In photography, no one feature can be shown completely independent of all others. The interaction of tone, texture, and relative size is too important to be dismissed as lightly as we appear to be doing here. Our aim at this time is to separate the individual qualities that generate visual interest only for the purpose of concentrated study. In this way we can build greater understanding of the principle and heighten visual perception.

Now it would be wise for the photographer to select some circular objects and proceed to light them to produce interesting variations.

PLATE 2-1

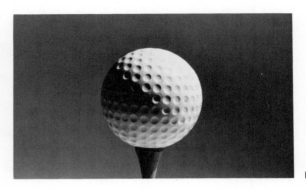

PLATE 2-2

In order to photograph a full circle it may be necessary to place the object on a floor, with the camera on a tripod or a stand directly above. Study the arrangements in the viewer or ground glass, concentrating on the relationship among the figure, field, and negative space. Meanwhile, keep in mind all the esthetic qualities of photography that you have developed to date.

It is not necessary, actually, to expose at this time, but if you find something that moves you, by all means take a shot of it and print. Some of the most interesting pictures are derived from such simple means as this. Then take an object that consists of concentric circles, or spirals and experiment with the visual effects you can get from them.

PLATE 2-3

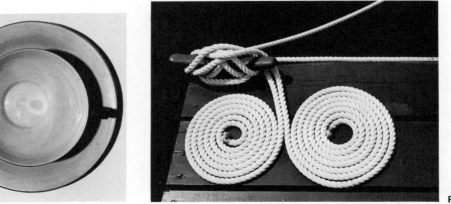

PLATE 2-4

Observe what happens when you take the circle in perspective, by bringing the camera closer to the level of the object. The resultant ellipse is remotely reminiscent in identity to the circle, but its design characteristics are notably different.

A circle has no particular direction; an ellipse or its cousin, the oval, has a long axis that imparts a sense of specific direction to the figure itself.

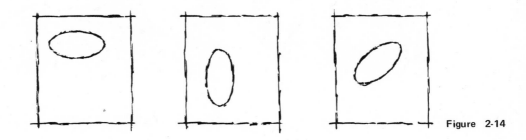

Figure 2-13

When such a figure is placed into a field, any change in its direction effects a considerable difference in the negative space, thereby compounding the impact of the change.

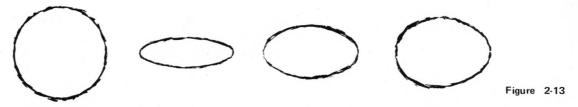

Figure 2-14

Very often, among man-made and natural objects, one can find segments of the circle combined with a straight edge or two. These provide greater variety of shape and direction and extend the possibilities for interesting design of negative space.

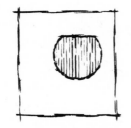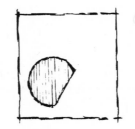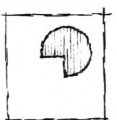

Figure 2-15

They also make the effect of change of direction more forceful. Compare, for example, the visual effect of the following.

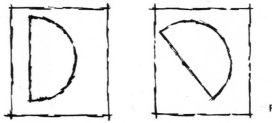

Figure 2-16

The one on the left expresses a feeling of static formality and sobriety, whereas the one on the right indicates instability, implied movement, and a casual quality.

SHAPE INVENTION

The opportunities for further variation are advanced when we begin to work with triangles. Again, start with simple sketches on paper, no larger than the ones reproduced here.

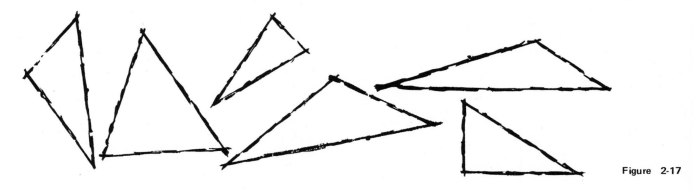

Figure 2-17

The variety is almost limitless because to begin with the following kinds of triangles are available as figures.

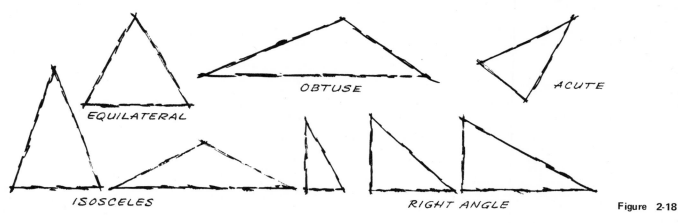

Figure 2-18

These may be arranged in a variety of field shapes, in different sizes, and in different directions.

A good learning procedure for the development of compositional sensitivity is to decide on a triangle of a particular shape and to cut several rectangles of different size and proportion, large enough to contain the triangles in various positions. Place the triangles in the rectangular fields, moving them around and evaluating the effects achieved by the different positions.

The procedure appears elementary, but the outcomes in terms of heightened sensitivity to interesting shape relationships are profound.

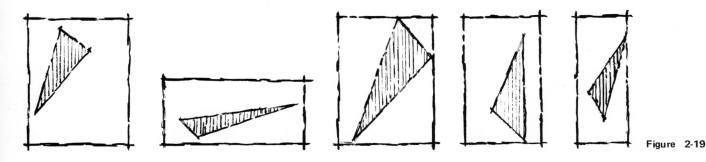

Figure 2-19

PERCEIVING SHAPES IN NATURE

In the process of working with these geometric shapes, you will find yourself seeing interesting images in the visual world that you must have passed without notice many times before. This newly developed awareness is the very essence of the photographer's most precious gift—his capacity to see beyond the superficial.

Later we shall be concerned with observing things and events that touch upon our lives and communicating our reactions and feelings about them. Our present concern is to concentrate on those aspects of photography which provide the beautiful and the magic and which make looking at some pictures a compelling experience.

In photographic practice, most often one does not bring a preconceived esthetic plan to a subject. Instead, because of extraordinarily acute sensitivity, the photographer responds instantly to the elements that make the subject impressive, and he derives from the subject itself the esthetic qualities on which to concentrate.

Consequently, you must prepare yourself to observe habitually and to form judgments of appreciation constantly. These are the backgrounds of experience that promote an instantaneous visual response to a situation that subsequently becomes a good picture.

Train yourself, therefore, not by just looking but by actual seeing. In the early period, as part of your training, set a problem for yourself and seek as many solutions as possible. This need not require a special allotment of time but rather can be done as you travel or walk, look from a window, or sit in a room. This may be just an exercise in seeing without the use of a camera.

Having just explored the functions of triangular shape, try to discover triangular shapes in your immediate environment.

PLATE 2-6

PLATE 2-5

PLATE 2-7 PLATE 2-8

Also, remember to look at rather than through negative shapes as you explore.

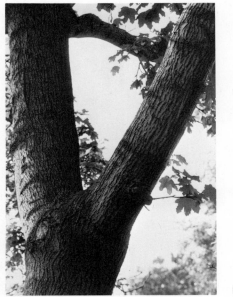

PLATE 2-9

As we proceed from the circle and three-sided figures to four-sided figures, the opportunities for even greater variety are increased progressively.

Everything we were able to do with the circle and triangle we may continue to do with the square.

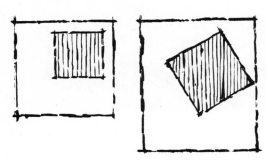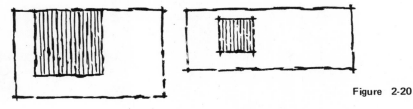

Figure 2-20

Rectangles have an infinite number of proportion variations and so can be composed in an endless series of arrangements.

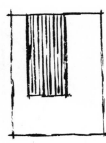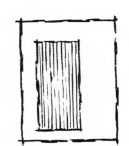

Figure 2-21

When you go out to observe or to photograph rectangles, you'll have no difficulty finding them in urban areas. The rectangle appears to be the dominant form for building the city, and its presence can be found everywhere.

PLATE 2-10

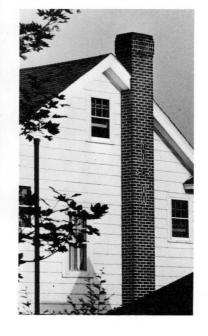

PLATE 2-11

PLATE 2-12

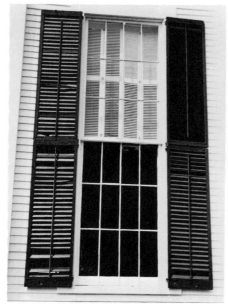

PLATE 2-13

Thus far we have been concerned only with regular geometric forms, which tend to give pictures a classic formal appearance.

Take the pencil again and experiment with the invention of interesting shapes, using four straight lines of varying size.

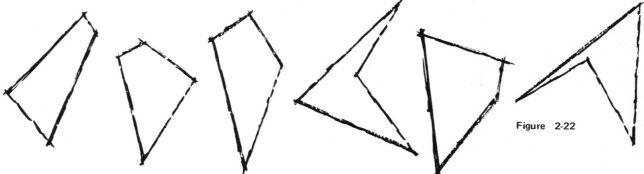

Figure 2-22

Notice how some are interesting, whereas others leave you unmoved. Look about the room in which you are working and you'll see shapes such as these in actual objects, in shadows, in negative space, or in backgrounds between two or more objects.

Try the same procedure, inventing figures with five straight lines. The more you work, the more inventive you will become. In each instance an infinite number of shapes can be created.

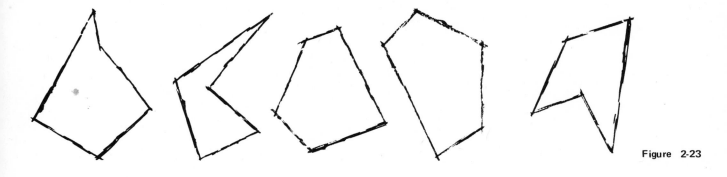

Figure 2-23

FREE FORM AND COMPLEX SHAPES

Much of the substance of art is concerned with variations of a simple theme. Designing or inventing four- and five-sided figures is a simple exercise in variation. The process becomes somewhat more complex when we invent variations of a C curve.

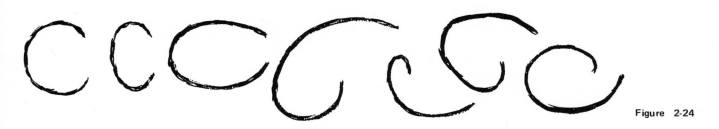

Figure 2-24

Now combine several straight lines with one C curve.

Figure 2-25

Then work with two C curves.

Figure 2-26

Some shapes are formed from combinations of C curves without any straight lines whatever.

Figure 2-27

Keep the shapes simple and uncomplicated. When they become involved, they tend to lose interest.
How many S curves can you invent?

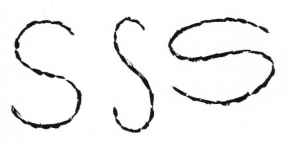 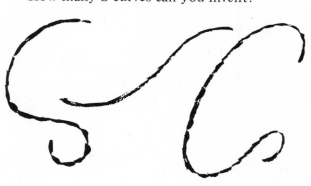

Figure 2-28

Now design some shapes with S curves and straight lines.

Figure 2-29

Then combine S curves and C curves.

Figure 2-30

In addition to line construction, many other procedures are recommended for inventing shapes.

SUBTRACTION

Start with a basic shape of paper such as a circle, triangle, square, or rectangle. Cut away smaller shapes from corners and sides—these may be straight lines, C curves, or S curves—until a satisfactory new shape results.

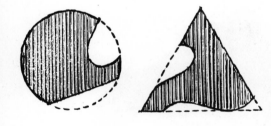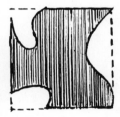

Figure 2-31

ADDITION

Select a variety of small shapes and combine parts of each to form an entirely new shape.

Figure 2-32

CUTTING

With scissors or sharp blade, make a series of free-flowing cuts in paper.

Figure 2-33

BURNING

Burn or scorch the edges and corners of a basic shape.

Figure 2-34

SCRIBBLING FREE FORM

Make a scribble and select a single shape or a combination of shapes. Cut away from the scribble or darken the area for identifiable contrast.

Figure 2-35

You'll be amazed at how your judgment and perception will improve after these few simple exercises. Interesting shapes that heretofore were hidden within the superficial appearance of commonplace objects and materials will be revealed and appreciated. The more you discover, the more you will seek and, consequently, the more you will become excited with your new-found awareness and vision.

PHOTOGRAPHING SINGLE SHAPES

This is a good time to begin photographing pictures in which a single shape is dominant. A word of caution, however, is necessary. There is always the danger that when you look through the viewer, the old habits of record-making objectivity may return. The feeling that the main purpose of photography is to capture every detail with infinite sharpness, and thus demonstrate the magnificent quality of your lens, is an obsession that photographers need to fight constantly.

In this instance, aim to discover an interesting shape and make it dominant. Having found the shape, very often in the most unexpected environment, adjust your position to one side or another, up or down, until the forms of the shape in the viewer satisfy you. Then concentrate on isolating the shape against a simple background, a process that may force you to make concessions and adjustments, to determine how much you are willing to sacrifice to achieve one or the other.

In order to simplify the background, you may have to accept a less favorable form of the shape. If the available light does not permit separation of the shape from the background with sufficient contrast, use artificial lighting to support the effect you wish to achieve. Often the background can be greatly simplified by shooting with a large aperture to limit the depth of field. This will make the background softer in focus and limited in detail.

While you may think about the figure-field relationship, it may not be possible to establish a firm decision at this time. Later, in the printing process, may be a more suitable time to experiment with a variety of placements, sizes, and fields to determine the most satisfactory one. The mere fact that it is thought about at all is an indication of advancement in the multifaceted thinking that is needed and that is being developed for artistic photography.

The amount of time required to produce one photograph is immaterial except where rapid change is taking place. There will be times when all the elements fall into place quickly and the picture can be captured in an instant. At other times, the shifting of position to obtain the best shape, the adjustment

between subject and background in terms of simplicity and sacrifice of sharpness, and the waiting for the most favorable light for effective rendering—all may take endless but fascinating hours.

PLATE 2-15

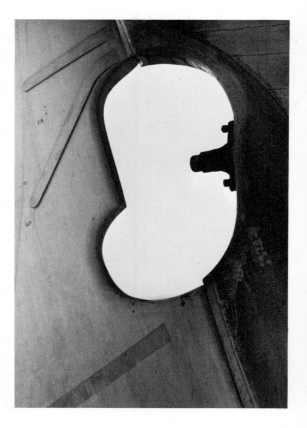

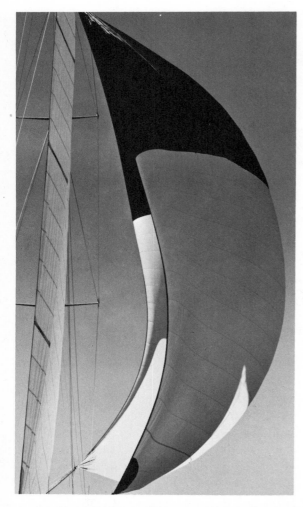

PLATE 2-14

PLATE 2-16

INTUITIVE COMPOSITION

Much of the material presented thus far has been controlled completely by intuition, by making spontaneous arrangements and adjustments in every phase of the design. In place of an accepted scale of values, every activity has been directed entirely by feelings and personal judgments.

Wholly intuitive considerations include

1. Design of the shape.
2. Design of the field.
3. Relative size of shape to the field.
4. Placement of the shape in the field.
5. Appearance of the negative space.

Indeed, much of creative art and consequently much of composition is intuitive. There can be no rules because rules

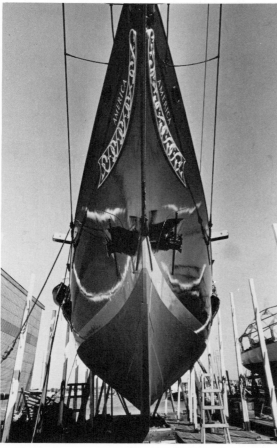

would stifle spontaneous personal expression and force all work into the cliché sameness that evokes boredom.

Many outstanding photographers have produced excellent compositions working completely from intuitive direction. Having been told by others and recognizing by themselves that they had produced art, they set out to analyze the criteria which govern art and to devise principles which would guide their future work.

Artists have been thinking about the same problem ever since pictures became a part of civilization. Especially during the past hundred years, much thought has been expended on the principles of design that act upon the elements of composition. Some of these, such as contrast of size, direction, dark and light, and dominance, have been hinted at in the directions for the exercises. They, plus similar principles, will be discussed more fully in subsequent chapters.

A clear understanding of these principles is most helpful in any compositional problem. It is particularly helpful in solving problems that involve combinations of two or more shapes. The fact that they are not fully understood on the conscious level, however, does not mean that they are not felt and expressed at all.

It is recommended, therefore, that the following problems in this chapter be undertaken on a purely intuitive basis. Later, when the principles are absorbed and understood, the current compositions and effectiveness of intuition can be reevaluated. It will be found frequently that the subconscious directs us to novel solutions that ultimately can be rationalized and verbalized in terms of deliberate knowledge.

COMPOSITION WITH TWO OR MORE SHAPES

While one can find occasional pictures in nature that are concerned with a single shape, many more picture subjects consist of combinations of two or more shapes. Again simple drawings and cut paper are good devices for creative experimentation.

Cut two rectangles of different proportions—one of black paper and one of white. Then cut from gray paper a number of fields of different sizes and proportions, all large enough to accept both figures.

Figure 2-36

First experiment with the placement of the rectangles not touching in the field.

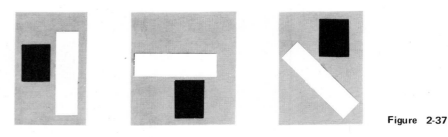

Figure 2-37

Then experiment with arrangements where the forms touch on edges or corners.

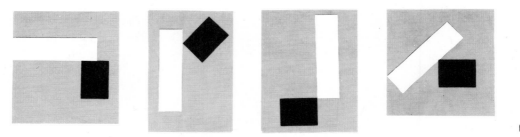

Figure 2-38

Subsequently, create arrangements that involve overlapping.

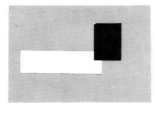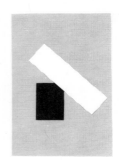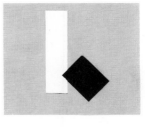

Figure 2-39

Now select different fields and continue experimenting with arrangements. Constantly keep in mind the changes in negative space that result from even the slightest shifting of any of the elements.

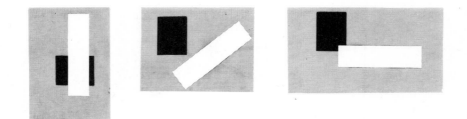

Figure 2-40

SPACE DIVISION

The following problem will demonstrate the intensity of thinking and exercise of judgment required to achieve effective breakup of space, using a number of vertical and horizontal lines to form varied rectangles.

Begin with a field.

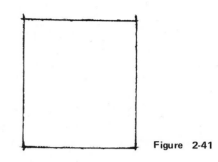

Figure 2-41

Add a vertical line so that the two resultant rectangles maintain good relationship with each other. One should be sufficiently dominant without overwhelming the other.

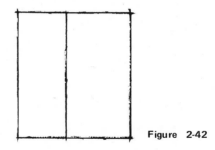

Figure 2-42

Add a horizontal line so that now four interesting rectangles result—all different and yet all harmoniously related.

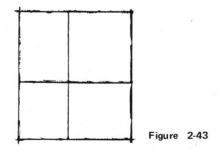

Figure 2-43

Continue to add single and double lines, vertically and horizontally, some extending to the outer edges of the frame, others extending to lines within the composition. Before drawing each line, consider carefully the shape of the individual rectangles you are creating and the interest of the total composition.

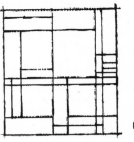

Figure 2-44

With a pencil, apply dark and middle tones to some of the shapes and experiment with further variation.

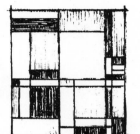

Figure 2-45

This procedure was developed by a 20th-century Dutch artist Piet Mondrian, who recognized the value of reducing art to its simplest terms. Most novices who look at Mondrian's work regard it as easy to produce. Those who follow his procedure (not copy his work) discover not only that it is much more difficult to create a satisfactory arrangement than they had imagined but also that the learnings from the exercise are profound and useful.

The previous design was composed by drawing intersecting lines, carefully spaced, to form rectangles that are varied and related in size, direction, and proportion. Our next composition is a variation of this procedure, but the considerations regarding varied and interesting relationships are much the same. The general impression gives the feeling one receives in any urban environment.

From black and white paper, cut a number of rectangles of varied sizes and proportions. Some of these may be duplicates or triplicates of the same shape.

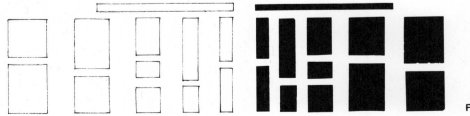

Figure 2-46

Arrange these shapes in a field of gray paper using horizontals and verticals. They may be separated or they may touch on corners or sides. As you place each rectangle into position, consider how it looks near adjacent rectangles and how it affects the appearance of the total composition. Above all, consider the shape and size of the negative space, which now becomes a gray area as each rectangle becomes a boundary.

Figure 2-47

The principles underlying composition with rectangles in verticals and horizontals in the two foregoing problems is sufficiently important to apply to actual photographs.

1. Collect a large variety of rectangular boxes and box covers, different in height, color, and proportion; they may be blank or imprinted. Arrange them on a floor or tabletop over a gray, white, or black base; paper or a tablecloth will do.

Photograph first with a bounce light that strikes the composition from directly above.

Shoot again with a direct light from an angular source so that the shadows, thrown by the higher boxes on the lower ones, create translucent rectangles that make the composition even more interesting.

2. Look through the doorway of one room into another and notice the variety of rectangles of furniture, pictures, windows, curtains, shades, mouldings, and flooring. Select a viewpoint that shows an interesting variety of these rectangles, with a minimum of perspective of converging walls. Expose and print.

3. Every urban community, shopping center, business area, or in fact every concentration of man-made structures is full of doors, windows, building blocks, signs, panels, and steps—all of which are rectangular in form. Select a subject from such an area that contains an interesting variety of rectangles. Expose and print.

PLATE 2-17

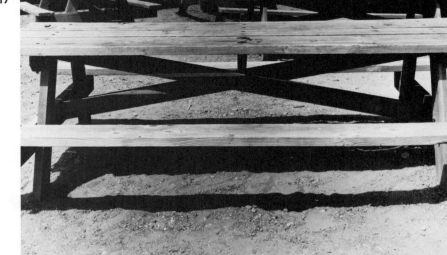

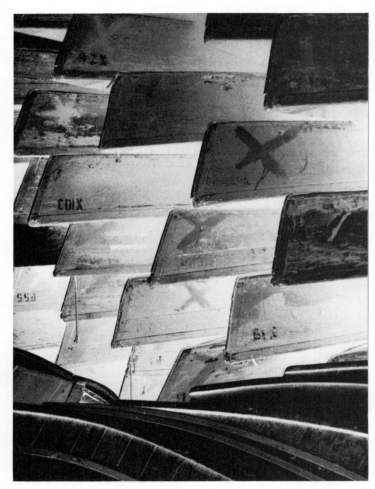

School of Art and Design

PLATE 2-18

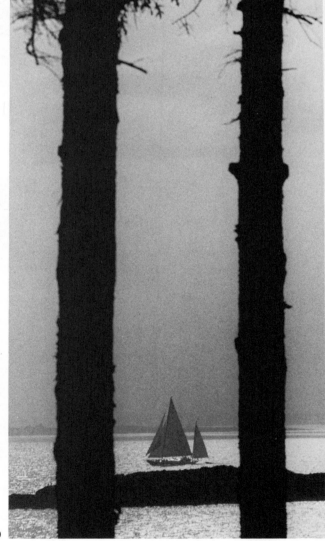

PLATE 2-19

STYLISTIC INTERDEPENDENCE OF THE ARTS

Each person working within the confines of any one art becomes so absorbed in the processes of that art that he loses some awareness to the interdependence of all the arts to form a culture. Art is a reflection of the social, political, and economic forces that prevail in any period. When these forces change, as indeed they do, the arts express that change.

In previous eras, significant changes were noticed first after several hundred years, then in a century, and subsequently in the 19th century in about every twenty-five years. Each change brought with it a substantial change in the manifestation of all arts. Music, theatre, dance, literature, and architecture, as well as painting and sculpture, were affected simultaneously and in similar ways. What was important to look at and hear in one generation became old-fashioned for some in the next. Of course many always preferred the older work to the "out-landish" new, and in most instances the conservatism was upheld by those who had the financial means to support it. Nevertheless, the new style eventually took hold and it too became old-fashioned in time.

During the 20th century, and especially in the latter part, the pace has quickened. No sooner have we become accustomed to one style of art than we find it superseded with another—none lasting more than ten years. Thus, photographs from twenty to twenty-five years ago have a dated look, far beyond the appearance of the architecture, interior design, and clothing they picture. Part of this dated appearance may be attributed to styles of composition.

In one period there may be a massing of large black areas, strong contrasts of dark and light, and soft edges. In another, the emphasis may be upon undulating curves reminiscent of plant forms. Still others may observe decay and destruction, the mysteries of psychic manifestations, the human appearance of nonhuman objects, the fascination with unrelated scribbles, and an absorption with details of the most commonplace and banal parts of life.

At this time, while studying the design of rectangular shapes, the student of photographic composition should make himself aware of rectangular shapes in every part of his daily life; in buses and trains; in interiors and exteriors; in libraries, stations, and stores; and in streets, signs, and construction sites.

In addition, he should observe what painters and sculptors are doing, how stores are being designed both inside and out, and above all what the artists who design printed pages for advertising and editorial material are creating. Artists who work for books, magazines, newspapers, and television (preparing announcements and advertising) and poster designers have

had a long experience in working with rectangular shapes. Frequently, ideas for photographic use may be derived from them. If nothing else results, then an appreciation of what is good and current can be assimilated.

COMPOSITIONS COMBINING
REGULAR AND IRREGULAR SHAPES

Design an irregular shape or select one from your previous experiments, and draw it in pencil so that its size will be important within the field. Experiment with a number of placements until you are satisfied with the position.

Figure 2-48

Add other invented and geometric shapes, always keeping in mind the appearance of the parts to each other and the effectiveness of the entire composition. Add pencil tones to the shapes so that the effects of black, white, and gray are obtained.

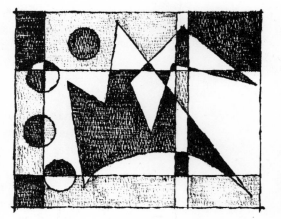

Figure 2-49

Again, a similar procedure with cut paper permits greater flexibility in shifting the shapes to reach a more harmonious organization. Cut black, white, and gray paper in geometric

and invented shapes. Vary the sizes and shapes. Combine these in a rectangular field, recutting if necessary and shifting until you are satisfied with the composition. Then paste the elements into place. After completion, place the composition on a wall, and study the interplay of shapes, tones, and negative space. Make mental notes on the harmony of the total composition: which parts were most effective, which parts need improvement, and what you can do to improve them.

This self-evaluation is an important process of creativity. It never ceases and provides the basis for ever-improving sensitivity, originality, and composition.

The intention of these experiments has been to heighten appreciation of shape design, geometric and irregular, and to realize the impact these shapes exert on composition. While pencil drawings and cut paper have been advised as preliminary experiences, the main objective has been to develop keener sensitivity to esthetic forms in nature and civilization. Subsequently, when confronted with the overwhelming chaos of detail that nature provides, the photographer will be able to select those elements that in his personal judgment support the visual idea he derives from his subject. In the following chapters, the principles concerned with harmonious and expressive arrangement will be discussed.

PHOTOGRAPHS OF SHAPES

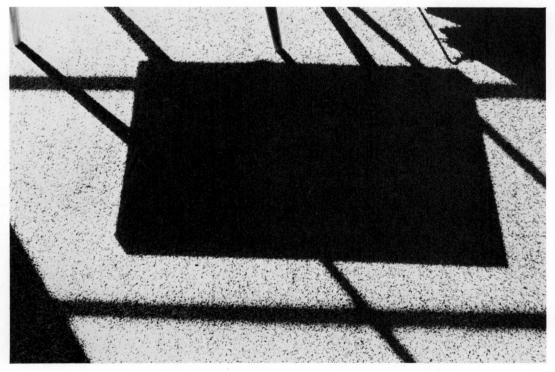

PLATE 2-20

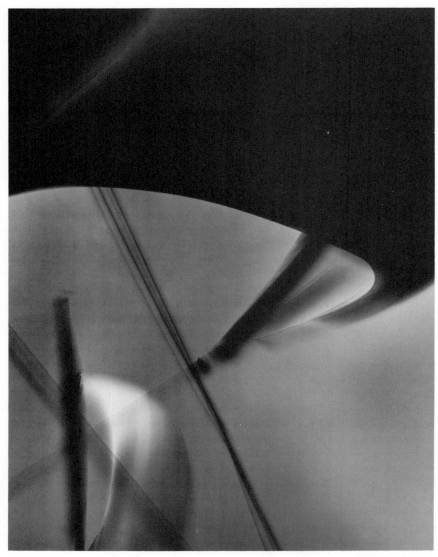

PLATE 2-21

PLATE 2-22

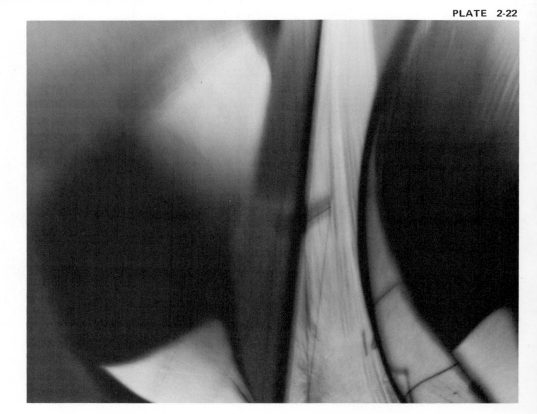

PLATE 2-23

Line
the nonexistent reality

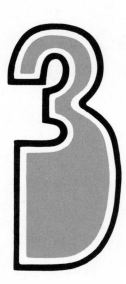

Line is so much a part of our visual experience and thinking that it's difficult to accept the fact that line does not exist at all in nature. It is an invented convention, a convenience used to establish the boundaries of edges of solid objects and the joinings of surfaces. Very likely it was the first means of visual communication in early civilizations.

Because it is so much a part of our daily lives, writing, and drawing, we accept line without hesitation as a clear and distinct way of expressing facts, ideas, and feelings. There is a definiteness of direction, length, and feel about a linear statement that gives great satisfaction to those who use lines in pictures and to those who view the pictures.

PERCEPTION OF LINE IN NATURE AND MAN-MADE OBJECTS

If lines do not exist in nature, how then, is the photographer to use them in his art? All around us are objects whose breadth is so fine that their perception in a photograph may well be taken for a line: telephone and electric service wires, television antennas, the twigs of trees and the stringy portions of plants (especially reeds and tall grasses), clotheslines, boat riggings, and bridge cables.

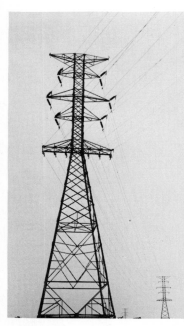

PLATE 3-1

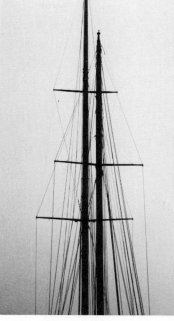

PLATE 3-2

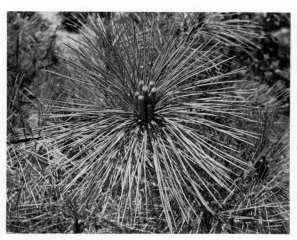

PLATE 3-3

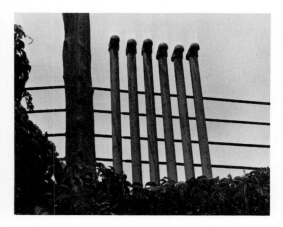

PLATE 3-4

Some shapes are sufficiently thin in relation to their length that they too might be considered as lines—bolder lines, actually, but lines nevertheless. Among these are flagpoles, telephone poles, lampposts, thin trees, ropes, garden hoses, narrow roads, fences of various types, thin clouds, ripples in water, skeletal structures of plants and animals, the skeletal frameworks of both wood and steel construction, thin streams, and railroad tracks.

PLATE 3-6

PLATE 3-5

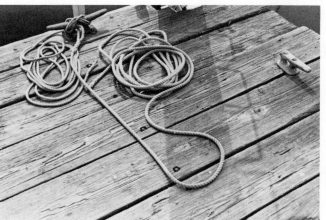

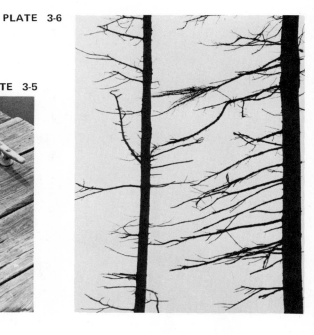

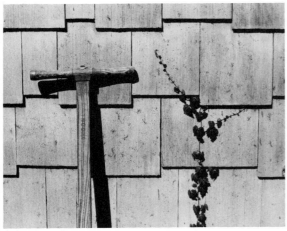

Thin shadows, such as those cast by plank or shake siding of houses, cracks in walls and floors, window frames, and the joints of brick and stone walls, as well as the shadows cast on the ground by trees and poles, are frequently fine enough to photograph as lines.

PLATE 3-9

PLATE 3-7

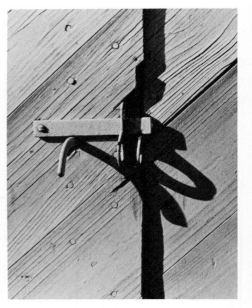

PLATE 3-8

Line is also produced indirectly along the edges of shapes and forms, the joinings of walls to ceiling and floor, the silhouettes of natural and structural forms, the emphatic shaded edges of a figure or an object, the folds of cloth, and the contours of plowed fields.

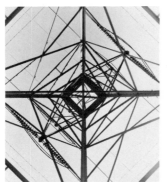

PLATE 3-12

PLATE 3-11

PLATE 3-10

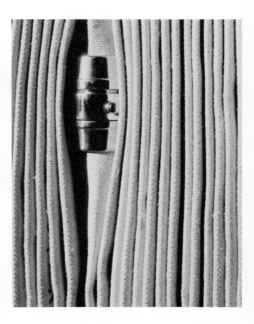

Indeed, the list is so long that one could easily make a specialty if he cared to do so of photographing manifestations of linearity.

UNDERSTANDING LINE QUALITY

The qualities and the subject matter for fine photographic composition exist in great abundance and can be found everywhere. We must constantly increase the capacity of both our perception and feeling and improve our ability to apply this perception to individual needs. It is essential that we condition ourselves to be sensitive to the visual components of the subject. When we look at a boat, sail, bridge, tree, house, or figure, we need to cast aside the normal identification of these objects and see them as organizations of shapes, lines, textures, darks and lights, colors, and volumes. The development of this capacity for observation calls for penetrating scrutiny combined with strong personal involvement.

VOCABULARY OF LINE

Before you go out to seek lines in nature, it is essential that you become capable of responding to the rich variety that is available. A good way to build a storehouse of appreciative response is to experiment by drawing lines of different character. While most of the following are drawn horizontally, they may very well be applied to vertical, diagonal, curved, and combination lines.

You may be assured that anything you invent will have a counterpart of some sort in the world of visual experience—either in natural or man-made forms.

The possibilities are endless; here are a few for a start:

Begin with a regular, mechanical line.

Figure 3-1

Making it heavier appears to endow it with confidence.

Figure 3-2

Break it into a series of short, rapid, aggressive strokes.

Figure 3-3

Roughen it further,

Figure 3-4

or give it a slight dainty ripple.

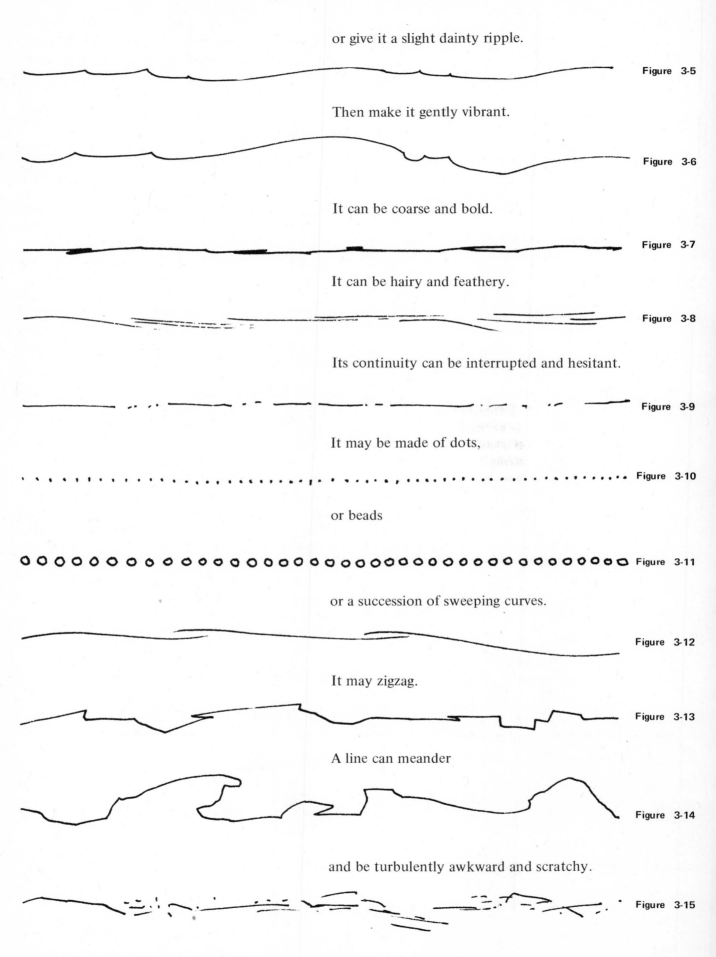

Figure 3-5

Then make it gently vibrant.

Figure 3-6

It can be coarse and bold.

Figure 3-7

It can be hairy and feathery.

Figure 3-8

Its continuity can be interrupted and hesitant.

Figure 3-9

It may be made of dots,

Figure 3-10

or beads

Figure 3-11

or a succession of sweeping curves.

Figure 3-12

It may zigzag.

Figure 3-13

A line can meander

Figure 3-14

and be turbulently awkward and scratchy.

Figure 3-15

It can be sensuously undulating,

Figure 3-16

modulated, attenuated, gliding,

Figure 3-17

and wave formed.

Figure 3-18

It may swell, flatten, and break

Figure 3-19

or express serpentine movement.

Figure 3-20

There is even a sensation of line where no actual line exists. This occurs when a finger, an arrow, or any pointing device directs the attention to a specific feature some distance away.

There are shallow curves,

Figure 3-21

deep ones,

Figure 3-22

spirals

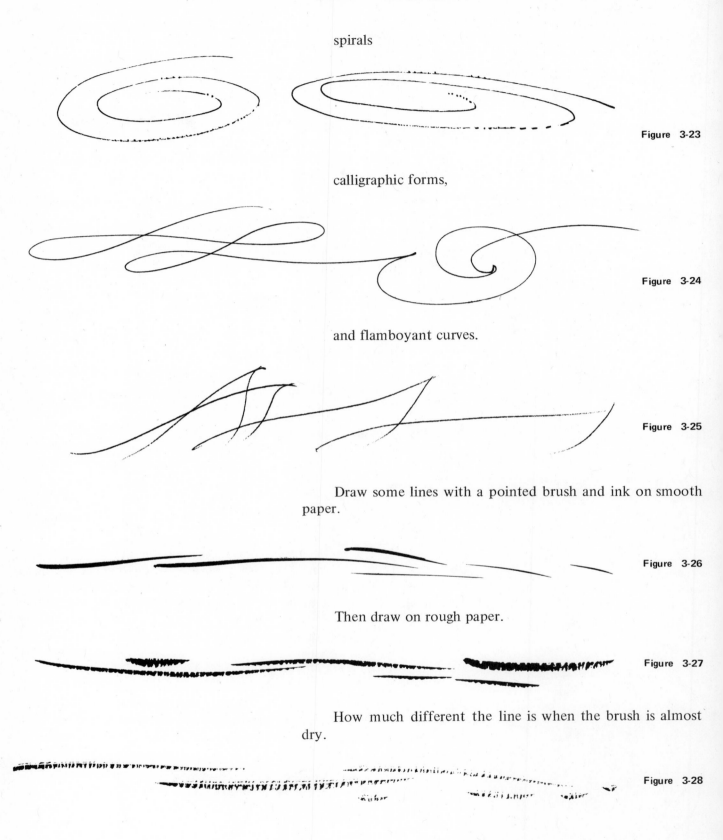

Figure 3-23

calligraphic forms,

Figure 3-24

and flamboyant curves.

Figure 3-25

Draw some lines with a pointed brush and ink on smooth paper.

Figure 3-26

Then draw on rough paper.

Figure 3-27

How much different the line is when the brush is almost dry.

Figure 3-28

Collect an assortment of implements not normally considered as drawing tools. These may include twigs, feathers, the pointed end of cloth, a length of string or chain, wire, bone, twine, leaves, and the smooth or rough edge of cardboard and wood. Dip each of these into ink or paint, and experiment with the creation of lines. Each implement will produce a different quality and a different feeling, engendered by both its physical nature and the movement over the particular surface.

Figure 3-29

As you form these marks, notice how forcefully the eye is guided along the direction of the line, responding to its abruptness, timidity, or boldness, the swell of its curves, or the grace of its movement.

Now, fortified with a substantial measure of the vocabulary of line, you are ready to go out into nature to seek and discover expressive lines in your total environment. At first the pickings will be meager, but as you gain experience in seeing, the rewards will come more rapidly. In some situations, the linear qualities will be revealed with no more than a superficial glance. At other times, deep penetrating search may be necessary. You may even be compensated with worthwhile subjects for serious photographs.

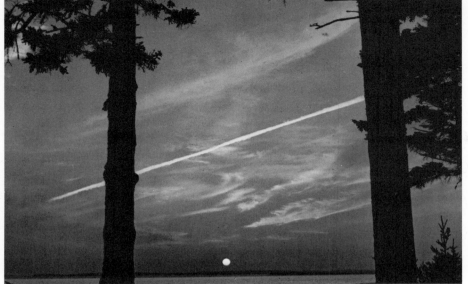

PLATE 3-13

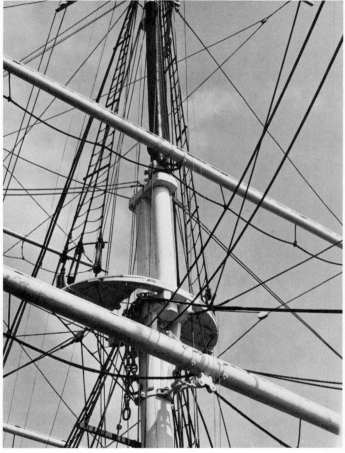

PLATE 3-15

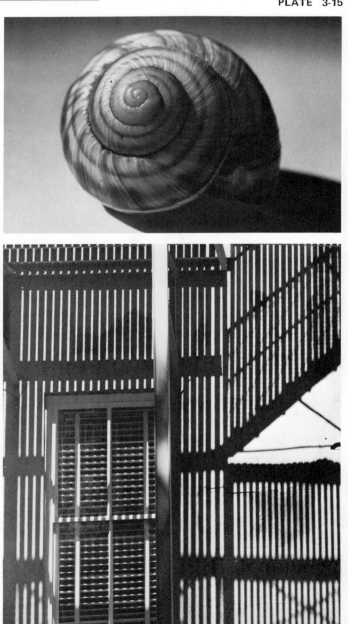

PLATE 3-14

PLATE 3-16

PLATE 3-17

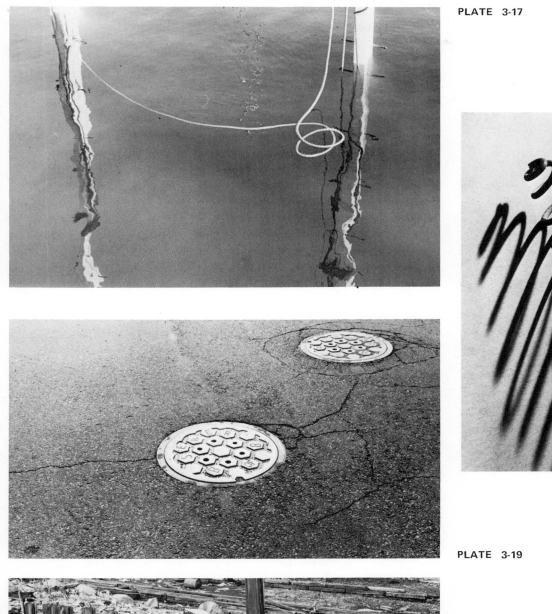

PLATE 3-18

PLATE 3-19

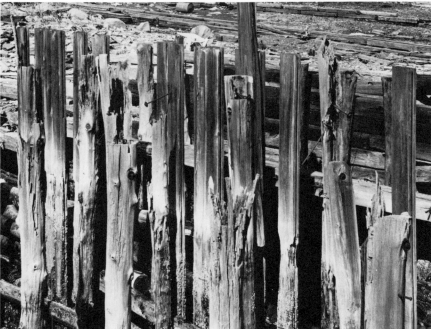

PLATE 3-20

Much of what we have noted in the study of SHAPE may be applied to line. No one component of a picture may be perceived as a separate entity except for specific isolated study. Anything and everything within the picture space takes meaning from all the other units, including the negative space and the field.

In each of the following, the field and the vertical lines are the same; only the placement is different.

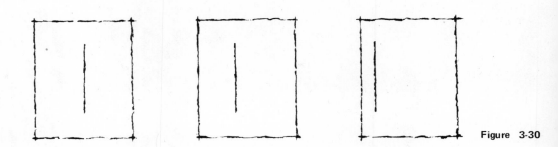

Figure 3-30

In the first, the line is centered so that the distance from the line to the left and right borders of the field as well as the ends of the line to the top and bottom borders are equal and static.

In the second, the distances between the left and right have been changed to produce a varied relationship. The space on the right is moderately dominant.

In the third, the line is so close to the edge that a stronger involvement is effected with the left border than with the picture space. The dominance of the picture space is so great that the line itself is rendered ineffectual.

Any slight lifting or lowering of the line produces a significant change in the total effect.

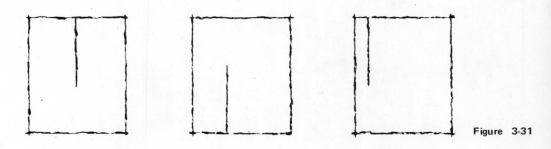

Figure 3-31

Similar significant changes result when the same length of line is placed horizontally in the same field. Note too how different the picture becomes with the horizontal placement.

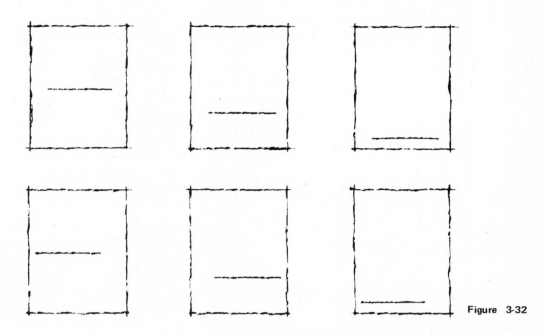

Figure 3-32

Even more varied impressions occur when the field shape is changed.

Figure 3-33

Now, with a pencil or pen, draw several horizontal and vertical lines within different field shapes to create interesting relationships. Disregard resemblance to anything you may find in nature—even avoid thinking that such an organization is reminiscent of any subject you may have seen.

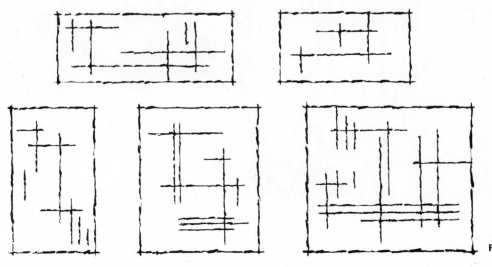

Figure 3-34

As we go beyond the single line, we lose interest in the singular character of each line and are forced to sense the relationship of the totality.

Don't be misled by the seemingly elementary or obvious nature of the visual ideas in these studies. Often the most complex wisdom is implied in the simplest statement. Again, the aim of these studies is to sharpen your perception and to develop acute sensitivity to linear arrangement so that when you come upon a subject that manifests these principles, you'll be able to recognize them and come away with a worthwhile picture.

Set an assignment for yourself—to be alert for subjects that emphasize horizontal and vertical lines in interesting, juxtaposed relationships. Seek subjects in which the line is dominant. While you may find some that can be expressed totally in line, the likelihood that some shapes and other visual elements will be included in the composition is to be expected.

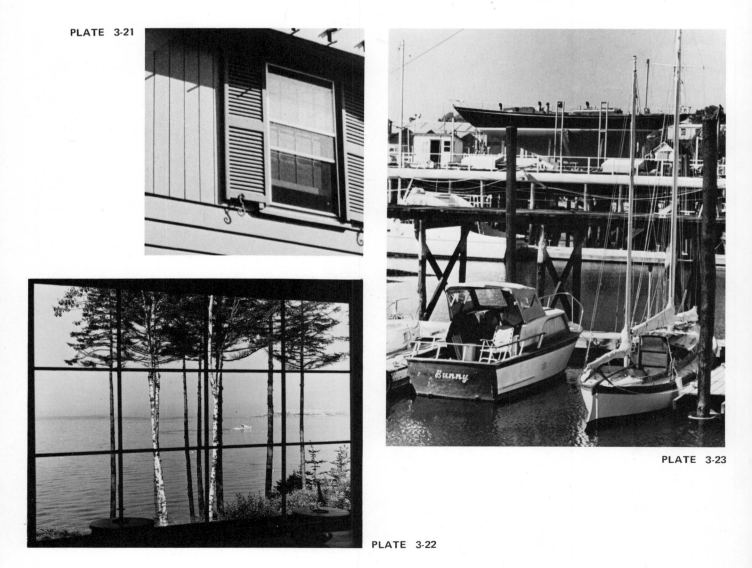

PLATE 3-21

PLATE 3-23

PLATE 3-22

Gradually add diagonal and curved lines to your resources, continuing to experiment first with studies in pencil and pen and later on an observation field trip.

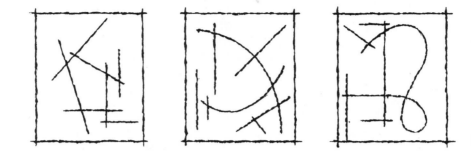

Figure 3-35

PLATE 3-24

PLATE 3-25

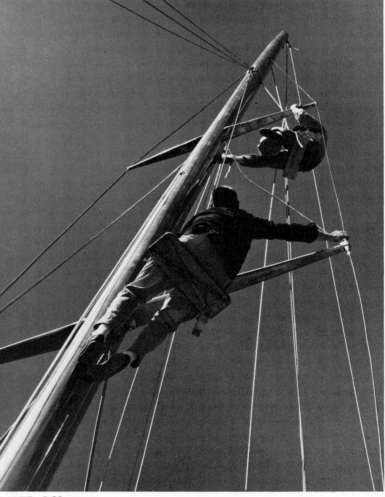

PLATE 3-26

SYMBOLIC ASSOCIATION OF LINE

Primitive man used symbols as a form of spontaneous visual language to express ideas and feelings for which no spoken language had yet been invented. Such symbols are so deeply rooted in our heritage that contemporary psychoanalysts place great importance on the relationship between symbolic association and suppressed communication. Through symbols, they discover hidden longings, needs, and fears in their patients.

As a result of past experiences, specific feelings become related to certain objects or phenomena. In turn, these objects have become associated with a characteristic formation. Consequently, traditions have been established that connect the symbolic association of lines with their position and direction.

Verticals represent life, dignity, timelessness, power, and resistance to change.

Horizontals tend to signify quietude and repose, the calm of the sea, death, the earth, and the sky.

Diagonals imply action, danger, collapse, uncontrolled motion, and emotion.

Jagged diagonals are associated with lightning, abruptness, and destruction.

Circular and swelling curved lines symbolize fluid motion such as the sea, grace, erotic interest, growth, and fertility.

Combinations of verticals and horizontals suggest man-made structures.

While there are some whose heightened sensitivity, education, and experience cause them to respond to these symbolic associations, it doesn't necessarily follow that most viewers would invariably react in a similar manner. If the photographer is creating pictures for specific viewers who can be expected to interpret the symbols with predetermined meanings, his selection and interpretation of subjects can be guided by the particular representations. Oriental civilizations particularly have established strong traditions in the philosophic meaning of lines in their calligraphy, decorative design, and pictures.

Nevertheless, photographs of poetic and religious significance frequently result from isolation and emphasis of symbolic lines. After many centuries of association, triangular pediments, round arches, pointed arches, and the cross immediately summon a religious response. Seen in its normal environment with an endless assortment of lines and shapes competing for attention, the religious significance is lost in confusion. Isolated from its surroundings and stripped to the most basic simplicity, a spiritual impression becomes clearly evident.

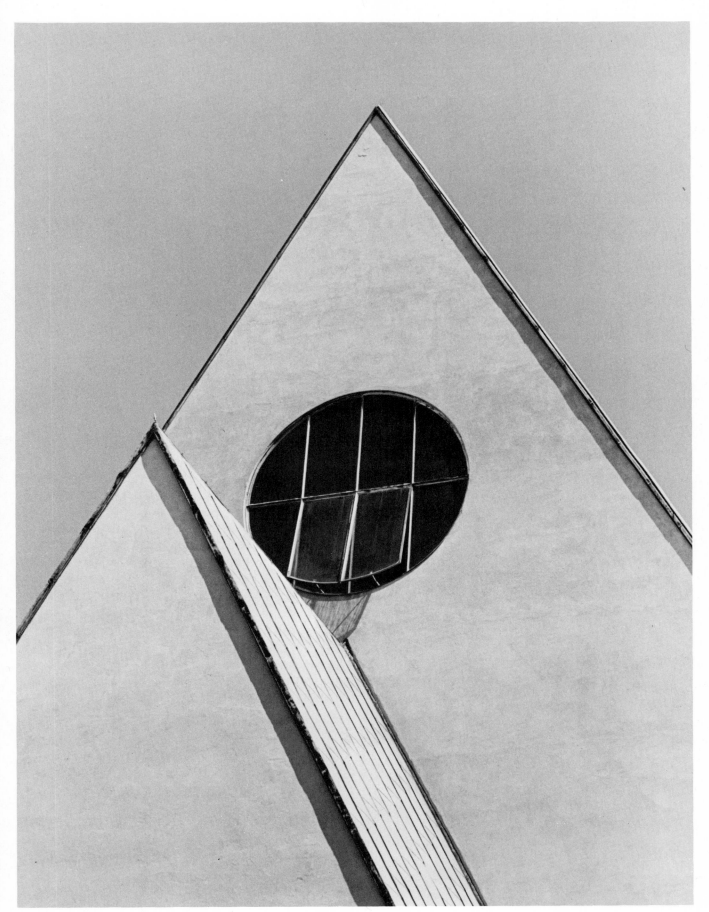

PLATE 3-27

63

LINE AS A CONTOUR OR EDGE

There is still another manifestation of line that is less obvious than the types of line previously discussed; this deals with the sense of continuous movement around the outline of a shape or form.

The perception of form is not limited to vision alone; much is associated with the sense of touch. Often two or more senses are combined into a multisensory response that adds greatly to the picture's expressiveness. This type of problem poses a challenge that advanced photographers find difficult to resist.

For example, the sight of a pineapple recalls the memory of its feel to the fingers, even when the fruit is not touched. This is not only a matter of prickly texture but also a perception of the mass of the pineapple.

An apple and a pear may have the same texture, but the "form feel" of each reveals a distinct difference. Our eyes and our fingers, acting in concert, are enticed to follow the form around the edges and explore the satisfying movement of its contour.

When the lighting is such that the form as a whole is clearly separated from the other forms or from the background, we become keenly aware of an obvious distinctness around the edge. The consistently sharp boundary gives the observer a sense of definiteness; the edge is there to see and even to follow kinesthetically with the fingers. Modeling, shades, and shadows are present but they never challenge the superiority of the edge. Actually, the emphasis of the edge tends to provide a flattening effect. While no specific line is evident, a sensation of linearity prevails. The nature of this felt edge is often beautiful in itself, depending of course on the contour interest of the subject.

PLATE 3-28

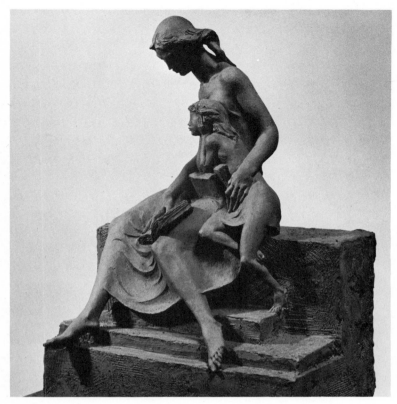

PLATE 3-29

The converse of this principle may help to clarify its understanding. When the lighting of a form emphasizes its three dimensionality and patches of light and shadow intensify the depth of form, the sense of boundary around the form is diminished. The feeling of continuous edge is lost, and in its place we see edges as alternately sharp and indistinct, lost and found. The effect is similar to the camouflage markings nature uses to obscure the outlines of insects and animals for protection.

PLATE 3-30

The type of shadow lettering shown below commands attention because it suggests three dimensionality. Imagination completes the missing parts of the seemingly raised letters and impels us to feel the hint of a highlight opposite each shadowed edge.

Figure 3-36

Applied to photography, one can achieve fascinating results by controlling the light so that the subject and background are similar in tone. By adjusting the light to produce a narrow line of light on one side of the subject, a similar three-dimensional effect can be achieved.

This, of itself, is not especially important. The narrow light, however, registers as an undulating line while expressing volumes and edges. It is the character of this line that becomes the esthetic part of the picture.

Through controlled lighting, one may create a dark line with equally interesting results.

Light and Dark
the essence of photography

Of the various structural elements in the visual arts, light and dark is by far the most endemic to photography. Since light and dark provides the only means by which everything in the image becomes visible, all the other elements—shape, line, texture, and volume—are actually specialized manifestations of light and dark. The very nature of photography as it exists today is dependent on the action of light as it passes through lenses and acts upon light-sensitive materials.

It is in the area of light and dark too that the photographer can exercise the greatest influence and control from the moment of exposure to removal of the print from the developer. Every nuance of the photographic process—film selection, filter selection, film exposure, characteristics of the film developer, film developing time—contributes to significant changes in the rendering of lights and darks and consequently in the pictorial expression.

Anyone who has practiced print control through dodging with an enlarger is aware of the spectacular difference that results from holding back darks from some parts of the print while "burning in" lights for greater detail and modeling. When the additional controls of paper contrast and developer strength are taken into account, the opportunities for control become enormous.

Basically, light and dark is but one dimension of color; the others are hue and intensity. Since this book is limited to composition in black and white, the study of light and dark is treated as a separate structural element.

PRINT QUALITY

From the earliest period of training, photographers are advised to aim for pictures that display a full range of gray tones, from light through dark, including small amounts of pure black and white. Every manual of photographic procedure admonishes the reader to be sure that both light and dark areas are richly detailed with variations and gradations of tone. This, of course, is essential to produce the sparkle that is the fundamental advantage of photography over the other visual arts. It is the heart of what is called *print quality*.

PLATE 4-1

FORM MODELING WITH LIGHT AND DARK

No graphic medium other than photography has the resources to represent the orchestration of progressive modeling with infinite transitions from absolute white through every value of gray into absolute black. None can challenge its capacity to render, on a plane surface, the illusion of elevations and depressions that constitute three-dimensional form.

The following portrait is printed upside down intentionally so that you may analyze the form instead of concentrating on personality features. Notice the depression below the eyebrows and the spherical nature of the eyeballs under the lids.

The nose is progressively elevated so that it rises at the tip to a height well above the surrounding cheekbone, only to return abruptly in its base plane to the level of the upper lip. The mouth follows the cylindrical structure of the underlying teeth, while each lip forms a convex curvature toward and away from the line of partition. Rising perceptibly from the depression below the lower lip, the chin attains its summit and then recedes, first gradually and then rapidly, into the plane of the lower jaw.

PLATE 4-2

No other graphic medium can record the imperceptible transition between light and dark that makes it possible to render the mystic envelopment of light and atmosphere, giving the feeling that the woods are bathed in air.

PLATE 4-3

No other graphic medium has an equal power of discernment to record qualities of transparency, translucency, and reflection.

PLATE 4-4

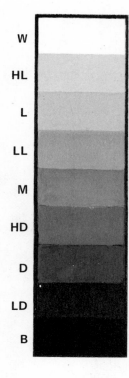

Figure 4-1

GRAY SCALE

The number of differentiated tones of gray that are possible of perception is infinite. Even the number of tones that may be recorded photographically is beyond counting.

In order to refer to an approximation of a specific tone, the following value scale has been adopted and is used for identification and notation.

As in practically every other phase of life, the need for variety in art is an established fact. Probably the most important reason for periodic change in art styles is that the continuance of any one feature over an extended time induces boredom. The mind becomes fatigued with the awareness of a constant single presence and seeks relief by changing to a feature with noticeably different forms.

A similar need for variety extends into the use of tone, especially when a number of pictures are seen within a single exhibit or publication.

When most pictures are limited to a value scale that consists mainly of middle tones with a few accents of HL and W and LD and B, the tonal scale repetition of itself will become tedious. The scale of values used in a picture or in a series of pictures is one of the factors that contributes to mood. In art, as in life, changes of mood are not only possible, they are highly desirable.

HIGH KEY AND LOW KEY

Pictures that consist predominantly of tones in the upper register of the value scale (W, HL, L, LL, and M) generally express a light mood. Such pictures are said to be in *high key*.

There is the danger that a high key picture that doesn't include traces of the entire value scale may appear to be underexposed or underdeveloped. The deeper tones of the value scale may be omitted if the range of grays between the W and M are sufficiently numerous to provide a complete gradation. Thus, if the range between HL and M consists of at least ten distinctly identifiable grays, then the high key picture will be acceptable in tonality.

PLATE 4-5

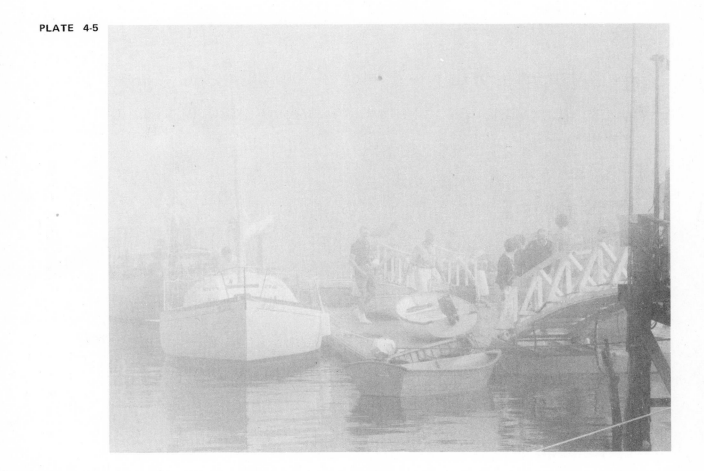

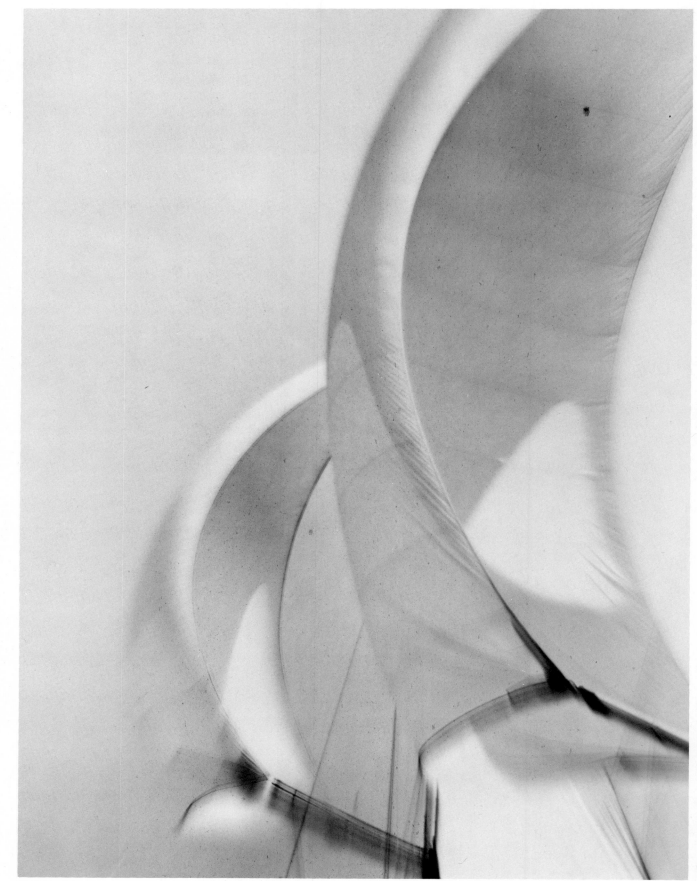

PLATE 4-6

Similarly, pictures that consist predominantly of tones in the lower register of the value scale (M, HD, D, LD, and B) contribute to a somber mood and are said to be in *low key*. Just as high key pictures sometimes require darks, low key pictures often need to have some lighter tones to be convincing of the intention rather than the accident of darkness. If the inclusion of lighter values would tend to interfere with the mood to be expressed, then a wide range of perceptibly different dark tones must be evident.

PLATE 4-7

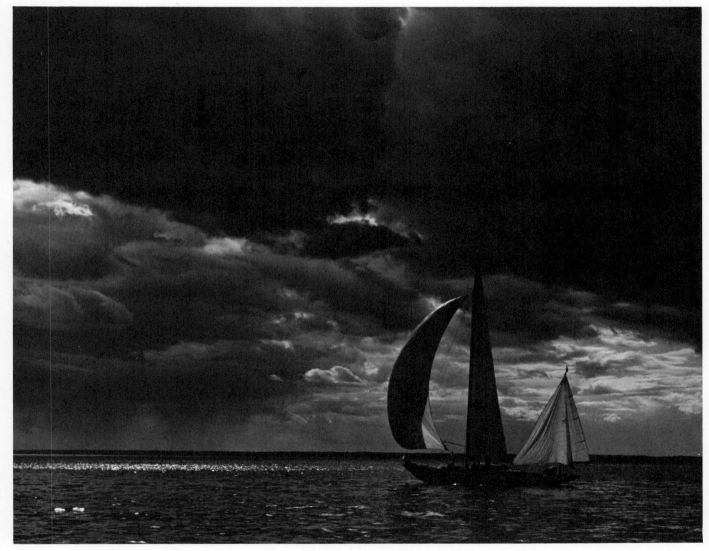

ASSOCIATION OF NATURAL VALUES

It is inevitable that we connect association of tone with objects and experiences as well as with moods. The relative differences in the color of a brick or concrete wall recalls a mentally established tonality of dark and light. Specific colors automatically register a consistent tonal association so that we expect to see an orange rendered darker than a lemon, an apple darker than an orange, and an eggplant darkest of all.

Our association for snow, milk, and bed linen is white; for rocks, it is gray; and for night, silence, void, and coal, it is black. Pleasant moods are associated with light tones; depression and somber moods, with near black; and bleakness, with gray.

While such associations may be valid most frequently, they cannot always apply. There may be situations when the rendered tone of an object suitably follows the normal association. Then the photographer needs to control lighting, filter, exposure, and printing to achieve this end.

In other situations, it may be more advantageous to sacrifice or distort normal association for either composition or expressive statement. A light object may thus be rendered dark or a dark object rendered light.

Extended into morality, light and dark have often been related to positive and negative, good and evil. During the early periods of history, God was light. Therefore light was the symbol of the intangible, the immaterial, and the spirituality of the soul, and it was represented by vast empty space and air.

In contrast, darkness was limited to the context of the grievous emotions—to depression and the deplorable.

When we stop to consider such associations, we may find that they are neither consistent nor justified. Isn't darkness the milieu of spiritual adventure, religious ecstacy, and mysticism? Aren't there many poetic experiences that are best represented in darkness? Even love and spiritual meditation, those activities of Life concerned with inner mystery, relate more significantly to darkness, or near darkness, than to the glaring brightness of midday. Strong daylight reveals too much to permit the incomprehensible to flourish. Dark churches are more fertile environments for religious meditation than light ones.

Spirituality seems to thrive during the dim vision of daybreak and twilight when luminous radiance and phosphorescent glow kindle the imagination to release mystery and the supernatural.

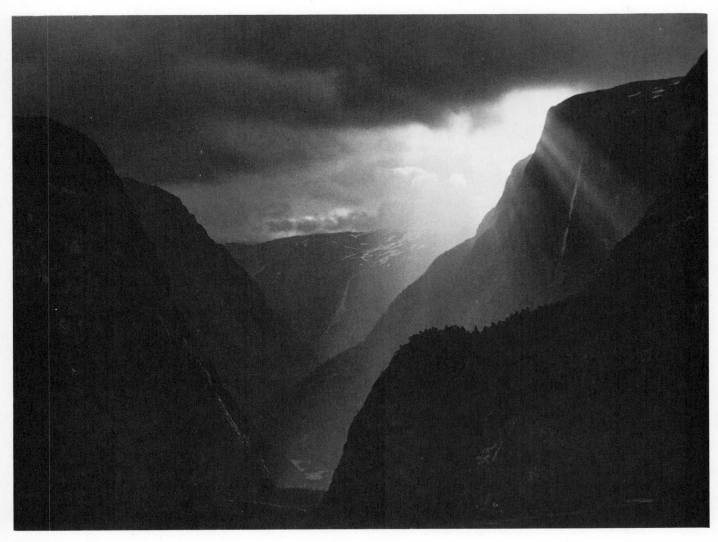

PLATE 4-8

The artist must feel as free to select his rendering of tonality as he is to express any other aspect of the subject. Slavish acceptance of conventions in art, no matter how firmly fixed they may be, is a hindrance to creativity. Surrendering to shallow naturalness, the least common denominator of public taste, leads to bland, stereotyped statements of neutral viewpoints.

Exaggeration is a vital ingredient of art. In the art of photography, the opportunities for exaggeration exist mainly in the control of light and dark. If it suits your esthetic purpose to emphasize the darkness of shadows on snow on a bright day, let them be dark. Burn them in if necessary. If the darkness of coal in a mining picture interferes with the qualities you wish

to accentuate, any means you chose to make it lighter is justified.

Most likely, the chances are that the literal rendering may result in a cliché picture, while the unorthodox will be appreciated for its novelty and boldness. The artist is supposed to possess and exercise unique vision and to be able to see beyond the commonplace and the accepted in order to stir the minds and emotions of others.

ESTHETIC USE OF LIGHT AND DARK—MOOD

Photographers need to develop a more extensive attitude toward the use of light and dark and to think of it as being more than merely functional in supplying the means of obtaining sufficient clarity for image registration. Besides clearly defining the components of a picture and enhancing the three dimensionality of forms through modeling, light and dark may be artistically expressive. It is an effective, independent element of design and one of the strongest means of conveying and supporting mood.

In order to obtain the appropriate atmosphere that envelops a particular subject and helps to provide the feeling you wish to convey, it is frequently necessary to deviate from realistic laws and think of light and dark as an independent entity. It is neither possible nor desirable to prescribe a reliable listing of ways to obtain mood through light and dark. Reactions vary according to each individual's background, experiences, personal traits, and values.

Although light may express warmth, it may also express chilling cold, pleasant distance as well as emptiness, comforting visibility, and frightening disclosure. Darkness may be attributed to quietude as well as loneliness and to rest as well as imminent danger.

In many ways, light is akin to music. It is capable of modulation to produce inflections and accentuations. All kinds of adjustments and adaptations can be generated in natural light. An enormous range of variations can be achieved with artificial light. The outcomes depend on the supporting components and the way they are used in the picture.

When the lighting is conceived to make the object as distinct as possible, making each individual form clearly separated by light and dark, the object itself is given more importance than the picture. We cannot help concentrating on the outlines that isolate the separateness of each object. Forms are so completely defined that our attention is distracted from

the totality of the composition. This situation develops most often in absolute front lighting or when a light silhouette is recorded against a dark background. It is found too in back lighting when a dark silhouette is recorded against a light background. The emphasis on contour satisfies the search for logical clarity and precision.

PLATE 4-9

PLATE 4-10

Conversely, when the arrangement of light and shadow is not merely the means for isolating each form as a separate entity, the total picture becomes more integrated. While light is the force that makes objects visible, it is also an instrument of dematerialization. The importance of continuous edge is suppressed; contour is minimized. Both lights and shadows from one form intermingle with lights and shadows of other forms in a unifying pattern. With light, halftones, and dark masses grouped into configurations that disregard the boundaries of the individual forms, the structures are pierced with an imprecise character that diminishes the influence of line and volume. Unifying movement is enhanced. The viewer no longer concentrates on separate parts but perceives the picture as a complete whole. The forms of the objects and the forms of the picture as light and dark masses are no longer identical.

PLATE 4-11

PLATE 4-12

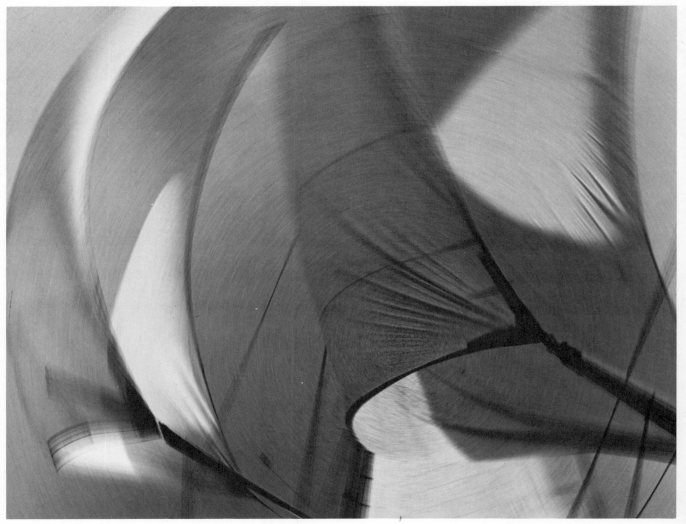

DISTRIBUTION OF LIGHT AND DARK

Grouping the light, dark, and halftone masses into irregular patterns which nullify form and line makes apparent another aspect which affects the esthetics of composition—the distribution of lights and darks throughout the picture.

A clearer understanding of the problem may result when we study, upside down, the following series of photographs of the same subject taken from the same position at different times of the day.

PLATES 4-13 THROUGH 4-18

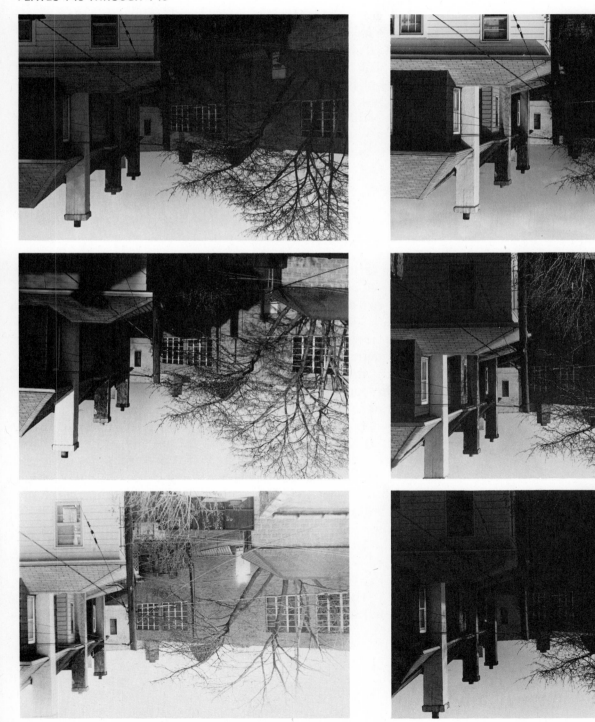

Turning the pictures upside down, as done with the portrait in Plate 4-2, prevents you from focusing on the constituents of the subject merely as objects. Very often the compositional quality can be perceived better when it is dissociated in some way from the subject. This must not be taken to mean that subject and composition need not be thoroughly interwoven. In an upside-down position, you can concentrate on the distribution of lights and darks as they affect the total impact of the picture.

Every successful picture has many appeals: one for subject interpretation and content, another for composition, and still another for print quality. Of course, there are many others. The great pictures are those that achieve the combination of excellence in the individual elements and in the way these elements interact.

The important lesson to be learned from the foregoing series of photographs is the need to view light and dark as more than just the means of obtaining the illusion of three dimensionality or for developing the most flattering representation of the object. Light and dark distribution has an enormous influence on the organizational appearance of the whole picture.

Generally, the greater the interest in giving an exact account of an objective condition, such as the effect of illumination on clear, realistic representation of the principal subject, the greater the probability that pictorial results will be limited to superficial appearances. Of course, flattering rendition is an important function of photography at times. Because it performs this function more effectively than any other graphic medium, it is respected.

Artistry, however, involves the total picture within the picture space and not just the satisfactory representation of the focal object. Just as unwanted supplementary subject matter may detract from effective appreciation of the subject, so can poorly arranged lights and darks detract from the effectiveness of the composition. Consequently the artist must go beyond limiting his light and dark judgments only to the principal parts. Equal consideration must be extended to every area of light and dark in the picture surface to determine what contributes to or hinders the total effectiveness.

Since each of the elements and principles of composition is an abstract idea, it is frequently necessary to examine its nature and potential in the totally abstract. The concept is more clearly stated and understood when the presence of recognizable objects is removed. This permits us to reflect on the isolated principle with greater intensity.

In each of the following figures, the same linear design is used. The vast difference among them is due entirely to the distribution of light and dark.

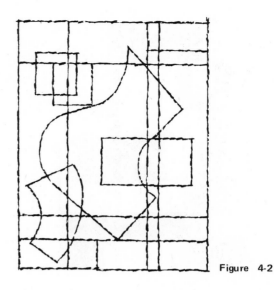

Figure 4-2

In the first variation we shall aim to give dominance to the big, central shape by making its forms darker than the surrounding areas. The tone will change at each boundary within the big shape. Although the same tone may touch on a corner, it will never touch on an edge. Through concentration of dark tones into one large mass, the eye is arrested there because it has greater attraction power than the rest of the composition. Attention is focused on the unified pattern of darkness, which overpowers the surrounding light areas.

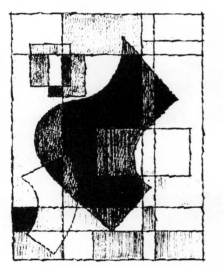

Figure 4-3

The same form can be made dominant by reversing the light and dark scheme, by rendering the big form light and the surrounding areas dark.

Our attention can be directed to any form by providing it with greater contrast, in similar manner.

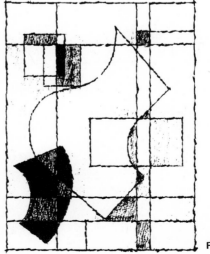

Figure 4-4

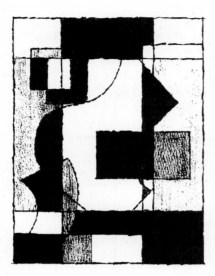

Lights and darks need not necessarily follow the shapes of the basic forms but can be placed arbitrarily. Several shapes may be integrated partially or totally. By grouping several small shapes that were formed by intersections of the basic shapes, we can create new shapes from the combinations.

Figure 4-5

It's possible to divide the composition so that approximately half is light and half is dark

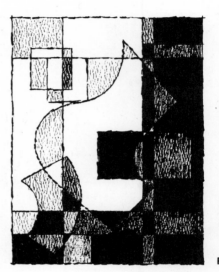

Figure 4-6

or to produce a gradation from light to dark.

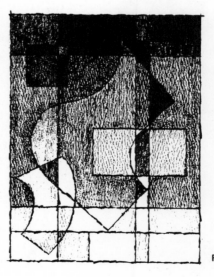

Figure 4-7

We may spot lights and darks so that high contrasts of dynamic interaction develop in different parts of the composition.

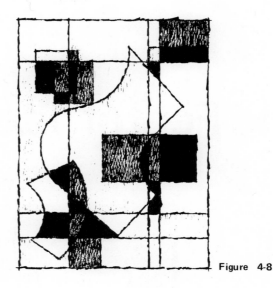

Figure 4-8

We tend to believe that the freedom to distribute lights and darks at will is given only to hand-drawn compositions. Not at all! While photographers cannot easily control every light and dark as they will appear in the picture, we do have more leeway than is generally assumed.

The foregoing series of photographs demonstrates the changes that can be produced through only a few normal changes of natural light. To this we may add the freedom to shift position.

In still life composition, we may substitute objects to effect tonal changes. Lighting may be adjusted not only to change tonality but also to exploit patterns of shade and shadow. The selection of backgrounds provides an opportunity to take advantage of environments as well as an enormous range of plain and patterned materials.

Tonality in portrait and figure compositions may be adjusted by means of clothing, lighting, choice of backgrounds, and the inclusion of supplementary content. Very often, a good picture requires much preplanning.

Finally, there is always available to us the great flexibility of print control.

Light and dark distribution is a powerful means of influencing the emotional impact of your expression. Calm or active, intense or soft, controlled or irregular—all these and more can be achieved through effective distribution. The potential is limited only by one's intuitive direction.

The Feel of Texture

Texture is everywhere; it is about as universal as anything can possibly be. Everything that exists is smooth, rough, shiny, rippled, bumpy, dry, slippery, gritty, fuzzy, wrinkled, grainy, or whatever. The list is unlimited.

TACTILE IDENTIFICATION

The concept of texture relates to the sense of touch, to the physical experience of surfaces in contact with the skin. Touching, or moving along the variations of a surface, provides us with another aspect of identification in support of seeing, tasting, smelling, or hearing. Very often complete identification depends on two or more senses acting together. For example, polished, mottled marble may look rough, but it feels smooth; the gleaming coat of a freshly groomed horse looks smooth, but it is bristly to the touch; the swish of taffeta adds another dimension to the crispness of its feel.

Often the sense of touch identifies the true nature of a material that deceives the eye. Plaster and wood are frequently painted to look like marble. The imitation is so skillfully done that it is visually convincing, but touching immediately reveals the pretension. The sense of touch explores a piece of cloth and evaluates its quality.

Through long experience we have developed a memory of texture identification similar to our sight, taste, smell, and hearing memory. Even when our eyes are closed and there is no presence of either odor or sound, we can recognize the feel of satin, wool, sandpaper, glass, metal, concrete, and paper. Babies are known to complain about the substitution of a familiar blanket simply because the texture is different although the color and weight may be the same.

THE IMPULSE TO TOUCH

There is an inner urge to touch things, a curiosity to experience texture for its own satisfaction, for sensual pleasure, or to support seeing. In early youth, the impulse is uninhibited, but social conditioning teaches us to restrain the instinctive drive as we mature. Although physical inclination is held in check, curiosity and desire remain strong. Our need to satisfy the tactile experience continues unabated.

Few of us can resist the temptation to caress delicate skin or glistening satin, to glide over fine fur, or to jiggle a handful of pebbles. It is not enough to lie in the grass and relish the earthy fragrance and soothing color; we reach out impulsively to fondle the blades and test their resistance. Those with rugged tastes enjoy wearing denim, tweed, and corduroy because the rough feel and irregular appearance express a unique state of mind.

EMOTIONAL RESPONSES TO TEXTURE

Textures affect us strongly, positively or negatively; they cannot be ignored. We enjoy, react, or respond to the nature of the surface. Tactile response is closely allied to the emotions so that we are gratified by some textures and repelled by others. They can be exciting and impulsive. To some, the feel of a frog, a snake, or a rotten fruit impels uncontrollable responses of revulsion; contact with a fresh rose petal is soothing. While these reactions may result from associative conditioning, the cause is beside the point. The fact remains that the reaction occurs frequently enough to warrant close attention.

INTERRELATIONSHIP OF TOUCH AND SIGHT

All the senses are closely interrelated. The glistening warty appearance of a sour pickle excites the taste buds and promotes salivation; the sight of a sliced onion recalls its sharp, tear-inducing odor. It is not necessary to heft a stone to determine its weight; we can "see" that it is heavy. We have only to look at fine beach sand to be reminded of drifting grains around fingers and toes. The sight of sharp, jagged stones is sufficient to initiate muscular contractions in the soles of the feet in order to counteract the memory of cutting edges pressing against bare feet. Looking at a seashell summons a feeling of its form and texture. Much of all physical experience is recorded through an intersensory blending that fuses the individual responses into a single whole.

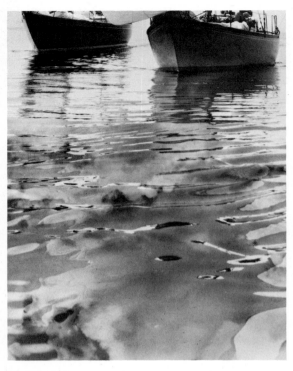

Even though the surface variation may be purely visual and there is no opportunity for physical touching, the appearance of a texture is sufficient to transmit a stimulus to the brain, and a sensory touch response is experienced. The tactile sensation is felt in spite of the fact that there is no contact with the fingers. Although there is no actual roughness, we sense an illusion of the surface qualities.

VISUAL TEXTURES

Any variation of light and dark that is within the possibility of visual discrimination creates a visual texture. Highlights, gradations, reflections, and shadows—all are texture relationships. Even a picture of a cloudless sky or a quiet lake implicates tactile qualities. Particularly sensitive people recognize texture characteristics in different kinds of light, varying according to the source and the nature of the environment through which it passes. Water is capable of producing a wide gamut of visual textures.

PLATE 5-1

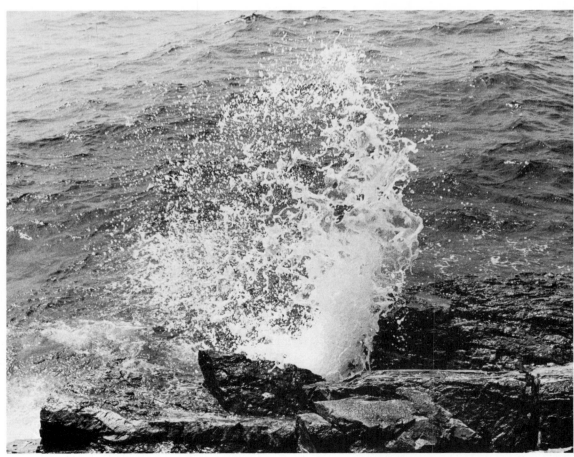

PLATE 5-2

PLATE 5-3

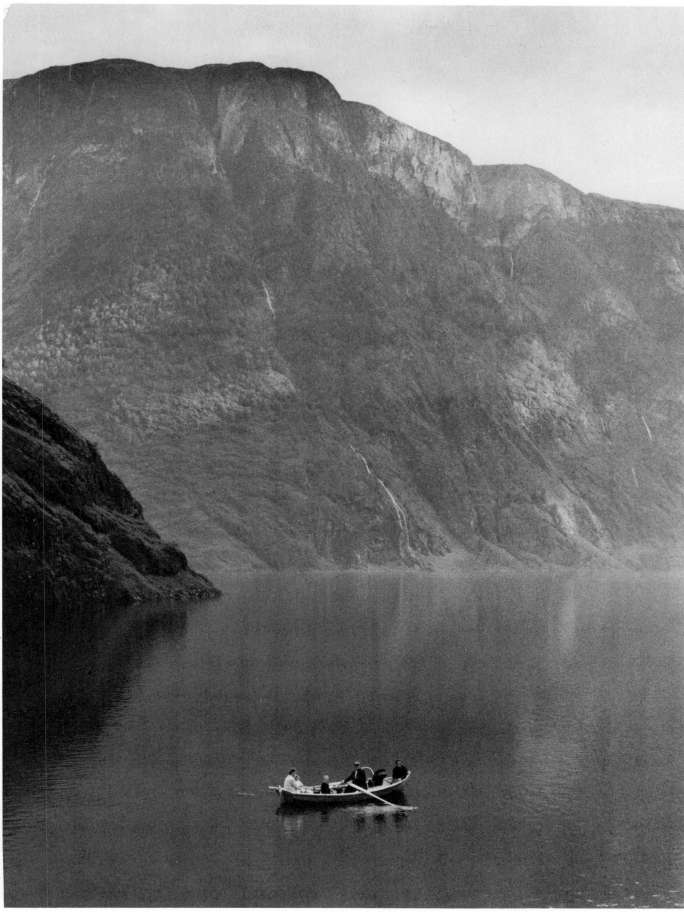

PLATE 5-3

Sheets of printed newspaper convey different textural responses beyond the physical character of the newsprint paper. Size of type, style of type, leading, ink opacity, column width, and paragraph length contribute to a notably different absorption and reflection of light. Each page of the same newspaper, varying with the density and nature of its copy, illustrations, and white space, communicates a distinctively different texture.

Sunlight coming through a net curtain and striking the newspaper so that patterns of the curtain's structure are reflected on the paper will create lights and shadows that alter the original visual texture completely.

Even a simple line, drawn in the same length and direction with the same implement on a different textured surface or with different implements on the same surface, undergoes noticeable changes.

Figure 5-1

It is not enough merely to establish a specific tonal value of dark and light; the nature of the component texture from which the sum of the value is achieved is as important as the tone itself. In the following diagrams, the shape, size, and tonality are much the same; only the texture is different. The resultant images are remarkably dissimilar in both visual identification and tactile response.

Figure 5-2

Because texture affects the visual image and the emotional state so strongly, photographers, like all other visual artists, cannot remain indifferent to its impact. They need to develop extraordinary sensitivity to the psychological relationship between touch and sight. An intimate understanding of the feel and substance of all sorts of materials is necessary for effective esthetic expression.

While it is true that artists usually have a head start in heightened awareness to those elements that convey visual ideas and relationships, they cannot depend on natural gifts alone.

They must seek constantly to expand sensitivity and to broaden the capacity to discover significant observations of life in order to provide meaningful interpretations that will excite the minds and feelings of others.

With little other subject matter interest, textures can create a power of suggestion that reveals a poetic state of mind. As he reveals the rich feel of tangible things, the photographer can release pleasurable excitement and beauty.

PLATE 5-4

TOOL TEXTURES

Here is a series of exercises that will augment your perception and appreciation of texture.

In pen or pencil, draw several squares, approximately one inch on each side. Fill the first two with circles of about the same size and density. Avoid making even rows.

Figure 5-3

Then, in the second, add some dots between the circles. Observe how different the resultant textures appear.

Figure 5-4

At this time, avoid relating these texture studies to anything in nature. Our purpose is to increase sensitivity to the variations that produce texture interest.

Any slight variation will produce a different effect. Instead of a random arrangement, this time organize the circles in rows horizontally and vertically.

Figure 5-5

Alternating rows of circles create another change.

Figure 5-6

Then use ovals instead of circles, one square in a random and the other in a regular arrangement.

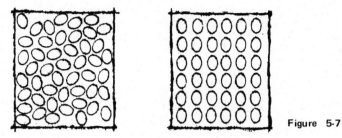

Figure 5-7

Experiment with different unit forms and combinations. Create a variety of textures using lines,

Figure 5-8

dots,

Figure 5-9

and scribbles.

Figure 5-10

See what happens when you work with different tools dipped in ink, such as a brush,

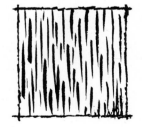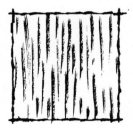

Figure 5-11

a stick,

Figure 5-12

a small chain,

Figure 5-13

or a feather.

Figure 5-14

Don't scoff at anything you have created, even if it seems bizarre. The chances are that at some time or other you will discover a reasonable facsimile in some aspect of nature.

TEXTURE IN NATURE

Creative awareness finds significance in the commonplace. One needs to become acutely mindful of the limitless physical textures that exist in the immediate environment. Even before you make a pictorial statement about these ordinary things, you will find that a few simple sensitivity exercises of observation, recognition, and physical contact will yield worthwhile rewards. Then you will be able to make a more personal commentary that will reflect greater sensory, sensual intimacy.

Begin with the textures in the room you occupy. Look at the wood furniture, and observe how the configuration of grain varies from one segment of wood to another. In some varieties of walnut, mahogany, and birch, a fine finish brings out a

semblance of translucency that penetrates into the depth of the wood, revealing a pattern of grain that seems to float below the surface.

What are the characteristics of other materials you explore that make it bumpy, grainy, smooth, powdery, gritty, flaky, dusty, gravelly, crumbly, fuzzy, or hairy? Through actual touching, experience the difference between cloth and leather, wood and paper, brass and iron, and a glossy painted surface and a polished one. Support your tactile examination with a visual one. There is no need to make written notes; the mental impression is the most important.

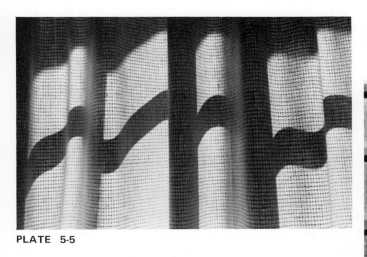

PLATE 5-5

PLATE 5-6

PLATE 5-8

PLATE 5-7

Then concentrate your attention on examining the special textures of a single class of objects, paper, for example. How many different paper textures can you collect right within your home? For a start, try newspaper, notebook paper, bond, coated magazine stock, letter paper, packing tissue, thin Bible stock, facial tissue, Kraft wrapping, waxed paper, freezer paper, gift wrapping, paper currency, photo paper, blotter, index card, composition paper, photo mat, book cover, candy wrapping, package label, wallpaper, and drawing paper. Run your fingers along the surfaces, compare their characteristics, and observe them in relation to the direction of light, using a 25-watt bulb in a reflector. What are the visual characteristics of each; what is its opacity or translucency; what is the unique character of its roughness or smoothness? At what angle would you light each to dramatize the interpretation you feel would express its nature best?

Crumple different kinds of paper, and observe how different the folds and hollows are in each; these too are manifestations of texture.

Select various pieces of cloth—dresses, coats, suits, sweaters, shirts, blouses, draperies, tablecloths, towels, scarves, and curtains—and compare their textures. Hang them or drape them and then play a light or two on them to explore the texture for its specific surface qualities, draping characteristics, and reflection factor.

Like most sensitivity exercises, these inquiries into texture will seem silly, oversimplistic. Yet, as you proceed, you will find yourself caught up in the fascination that textures provide, and as your understanding and appreciation grow, your curiosity and desire to investigate still further will increase. More and more of the significance of texture will be revealed to you, and you will explore in areas that ordinarily might have been neglected.

Although frequently a single texture, unassisted by other relationships, can provide sufficient motivation for an interesting picture, most often qualities of shape, line, and light and dark add esthetic interest that strongly supports the texture theme.

Select several fabrics whose textures appear to look well in combination and arrange them so that the surface interplay is dominant. Light them primarily to emphasize the tactile differences, and expose several negatives. Study the prints to determine wherein you succeeded and what you might have done to improve them in terms of your original aim. If you succeed in obtaining happy accidents, try to determine how you may achieve similar results intentionally.

Now you are better prepared to go outside to explore the textures that abound everywhere. They have become so much a part of our daily lives that except for those individuals who

make a conscious effort to rediscover them, they are absorbed into the blur of indifference and lose their visibility.

Compare the many textures used in the structure of walls and roofs of buildings—brick, stone, stucco, wood, tile, shingle, concrete, structural glass, metal, and slate.

PLATE 5-10

PLATE 5-9

PLATE 5-11

PLATE 5-12

Observe the interplay of light-absorbent and reflective textures within a single structure.

PLATE 5-13

Man-made streets, walks, and floors are a rich source for interesting surfaces from the very rough to the moderately smooth, from the random to the geometrically regular—rutted roads, flagstones, pebbles, cement with various aggregates, ceramic tile, terrazzo, macadam, asphalt, wood planks, and rugs.

PLATE 5-14

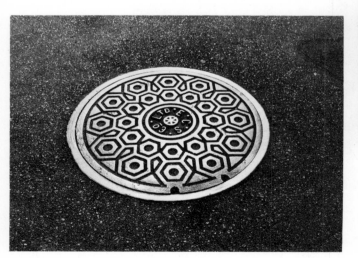

PLATE 5-15

PLATE 5-16

Now examine the fascinating floor of nature—sand, pebbles, leaves, stone, grass, moss, clay, damp and dry soil, snow—all intermixed with an endless variety of combinations.

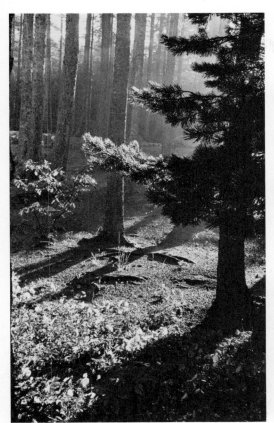

PLATE 5-17

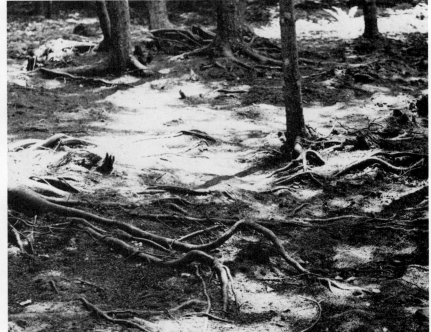

PLATE 5-18

Those who are unaccustomed to intensive observation regard the bark of trees as a generally rough outer layer with little difference between one tree and another. The discriminating recognize a dissimilarity that may have esthetic as well as botanical interest.

PLATE 5-19

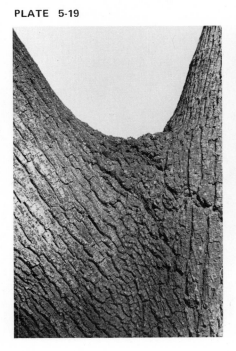

PLATE 5-20

The texture of the upper surface of leaves differs from that of the lower surface,

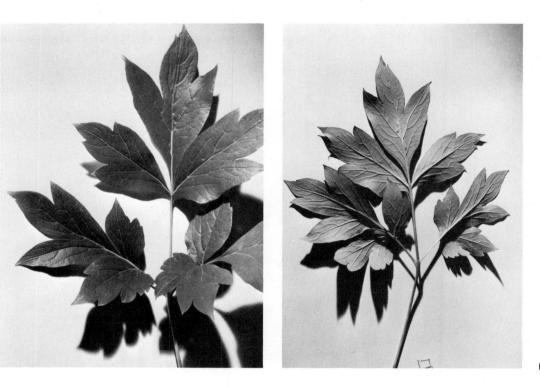

PLATE 5-21

PLATE 5-22

and the leaves of each species are different in texture as well as shape. When we get far enough away to see a cluster of leaves, a new texture relationship of mass develops. This has little pertinence to the texture of the single leaf.

PLATE 5-23

From a greater distance, the entire tree is seen and the texture of individual leaves or even clusters of leaves lose their focus of interest. The mass of foliage, now closely interwoven with aspects of shape, line, volume, and light and dark, takes on a texture that is similar to that of other trees of the same species. Seen against a tree of another species, the two textures present a challenging contrast. Size of leaves, density of foliage, flowers, fruits, nature of attachment, and index of light reflection contribute to the perception of texture.

Trees without foliage present an aspect of texture, too. Notice the lacy structure of twigs around the contour.

Continue your exploration by looking closely at the effects of weathering on old stumps, fallen logs, hollowed trees, moss, lichen, and fungi on trees and rocks. Weathering takes its toll from man-made objects too, and as it does, it brings out a glorious array of textures that are a delight to photograph. Observe rusted metal, peeling paint, rotting planks, decaying buildings, deteriorating docks, dilapidated fences, abandoned boats, and worn-away posters.

PLATE 5-24

PLATE 5-25

PLATE 5-26

One must constantly remain alert for visual textures not normally associated with the process of physical touch because they consist of large unit masses. These include crowds of people, fields of flowers, stacks of furniture, a group of houses, a flock of sheep, graffiti on walls and walks, dense trees covering a hill, lights and shadows caught on the surface of water, and cloud formations.

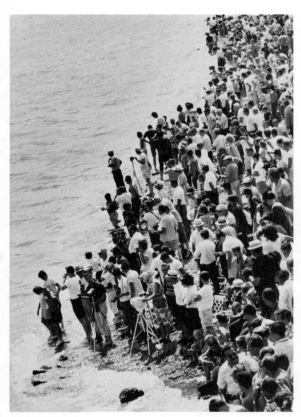

PLATE 5-27

PLATE 5-28

PLATE 5-29

Groupings of any kind of material, natural or man-made, are excellent sources for textural subjects.

Except for occasional happy accidents, every photograph echoes the thinking and feeling of the photographer. If, in your observation, you perceive your subject with several senses, your pictures will reflect a multisensory excitement that will make looking at them worthwhile. Since textures often are closely bound to touch, sounds, and smells, the more you permit complete involvement of all the senses, the more personal will be your creative vision, and the closer you will get to giving meaning to the character of basic reality.

Don't be content to record the objectivity of your subject, but try to find the means to exaggerate the qualities, textural and otherwise, that you consider most meaningful.

The Fullness of Volume

One has only to visit an auto show or a boat show to realize how responsive human beings are to interesting and beautiful forms. People react to the variations of proportion, concavity, and convexity with the same esthetic pleasure that previously was reserved for fine sculpture and architecture. It is a pleasure that goes beyond the requirements of functional transportation form, which may be designed especially for wind resistance and accommodation. One can easily understand why a prestigious art gallery in New York once displayed several fine automobiles as examples of outstanding modern sculptural art.

PLATE 6-1

For the same reasons, a milder but similar response is accorded to many of the utilitarian products of industrial design, including refrigerators, toasters, washing machines, television sets, food mixers, furniture, and all sorts of tools. At least as much as enjoying the convenience of their function, people respond to the beauty of their form.

This is no new phenomenon. Objects whose greatest virtue was form interest have been accorded high esteem since earliest civilization. At first, interesting stones, spears, throwing sticks, clubs, baskets, and clay pots became prized possessions. Later, in the advance of cultural history, sculpture, mounds, architecture, and furniture were added. Even though decorative elements were superimposed, the predominant concern was for attractive three-dimensional form.

SPACE AS A SHAPER OF MOOD

Early in civilization, primitive people recognized that the space in certain caves was conducive to specific moods. Some appeared exalting, giving rise to an air of magic and mystery. Others kindled a feeling of restfulness and comfort, sufficiently inviting to be converted into home. Still others hinted at danger or tempted exploration. Certain spaces emitted an air of melancholy, suitable to be set apart as tombs.

Space is the content within an enclosure. It consists of a quantity of gases, liquids, or void, contained within and adapted to the conformation of the enclosure. Because it is not solid and the dimensions change with the dimensions of the container, one would have difficulty including space in a definition of three-dimensional form.

For the artist, however, both space and form have common elements and considerations. Consequently, the term *volume* has been established to be all-inclusive.

REPRESENTATION OF THREE DIMENSIONS ON A TWO-DIMENSIONAL SURFACE

How to interpret a three-dimensional volume on a two-dimensional surface, such as paper, canvas, or plaster wall, is a problem that has occupied the minds of great thinkers for many centuries. Far more than any other medium, photography has provided the most satisfactory solution. There is, nevertheless, much to be considered in the expression of volume as an artistic sensation.

The pleasures inherent in beautiful volumes, aside from tactile sensation, are greatly appreciated understandably by

sightless people. Through the sense of touch, they can enjoy exploring conformations, responding to swellings and hollows, feeling thicknesses and twistings, and penetrating depressions and openings. Without seeing, they have an awareness of the character of space and react much the same way that sighted people do.

Since volumes are a visual as well as a touch phenomenon and since they have the power to elicit emotional responses, an understanding of the nature of volume is a necessary part of photographic composition.

MASS AND SPACE VOLUMES

Stone, wood, and concrete are mass volumes; cups, bowls, seashells, and rooms are space volumes. There can be, however, no hard and fast definition of terms, nor is it important to be precise. Stones, which in themselves are distinct manifestations of mass volume, can be built into walls to comprise a room, which becomes space volume. Glass bowls and ceramic vases, obvious examples of space volume, frequently have thick walls of varied conformation that may be considered separately as mass volume.

SHAPES AND VOLUMES

Often, people refer incorrectly to volumes as shapes. Shapes are flat, without perceptible thickness or depth. Volumes are especially noteworthy for their thickness.

A circle cut from a piece of paper is a shape, regardless of the texture or decoration applied to its surface.

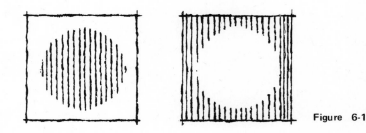

Figure 6-1

The outline of a spherical ball is seen as a circle from any angle of view. Under some conditions of light, especially back lighting and front lighting, the spherical quality is negated, and the resultant image is apparently two-dimensional—a circular shape reminiscent of the paper circle.

Under different conditions of light, the spherical nature is emphasized.

Courtesy Standard Oil Co. of N.J.

PLATE 6-2

It is revealing to study the gradations of dark and light that actuate the perception of a sphere instead of a circular shape and to understand what accounts for the representation of volume in place of flatness.

Notice how the highlight strikes near the edge of the left segment of each sphere in Plate 6-2. Although still light, the tone deepens gradually in all directions until at the left it extends to the edge. At the right, the deepening continues, becoming darkest at the lower right edge. This is the lower extremity of a dark curvature that is concentrated *near* the right edge. Reflected light from surrounding objects, bouncing back into the shaded area, makes the right edge luminous.

Similar effects proceed from the study of a cube or rectangular prism. Under certain light conditions, particularly from direct front or back, the prism gives the relative

impression of a flat shape even though linear analysis indicates that perspective normally associated with depth and volume is present.

PLATE 6-3

PLATE 6-4

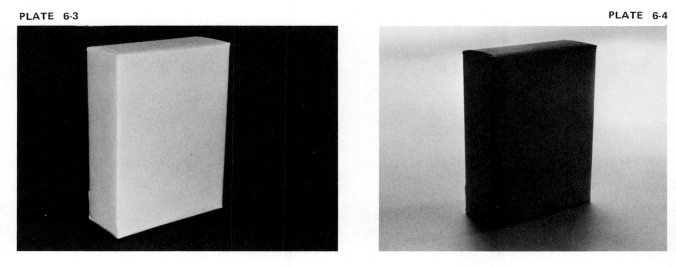

When lighting separates the tones, clearly revealing shaded planes in three different directions, the discernment of a distinct volume is perceived. Shadow helps to confirm the materiality and voluminous nature of the object.

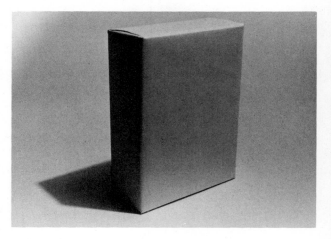

PLATE 6-5

In the case of the sphere, the gradation is continuous. In the cube or prism, gradation is discontinuous; abrupt change gives definition to the edges of planes.

Cylinders are volumes that combine features of both continuity and discontinuity. The contour of the ellipse, like the perspective lines of the cube, makes it difficult to hide completely the nature of its three dimensionality.

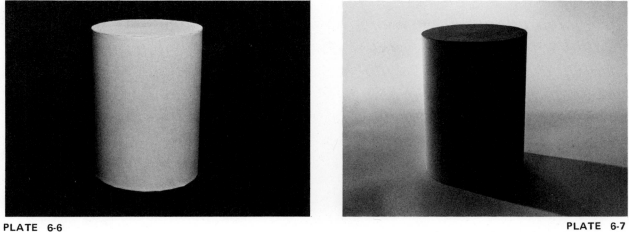

PLATE 6-6 PLATE 6-7

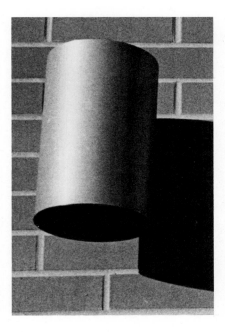

There is, nevertheless, a relative flatness in these figures that places them closer to shape than to volume.

When lighted to demonstrate its voluminousness, we perceive the continuity of the curved side surface and the discontinuity of the lower surface. Notice again that the highlight is near the edge of the light side and that the strongest dark is not at the right edge but near it. The edge is made luminous by reflected light from surrounding objects bouncing back into the dark.

PLATE 6-8

Looking at the shaded photographs of the sphere, the cube, and the cylinder, our eyes transmit to our minds a feeling of form that is similar to the sensation we would receive when touching the actual object. To us, living in the 20th century and accustomed to the representation of three-dimensional form on a flat surface, there is no special reaction beyond precise perception. One hundred and fifty years ago, the illusion of three dimensionality would have been deemed miraculous, similar to the illusion of depth first perceived in a stereoscope.

AMBIGUITY OF SILHOUETTES

The descriptive inadequacies of two-dimensional shapes become clearer when we realize that the same silhouette could be obtained from many different forms.

Figure 6-2

This need not prove to be an inadequacy for the photographer, who gains greater flexibility and additional opportunity for interpretation. Through lighting and juxtaposing apparent shapes with actual volumes, a greater range of interest can be established.

Technically minded photographers have an awareness to the flattening of volumes, especially in connection with the results obtained by the use of telephoto lenses. Pictures taken with long focal length lenses display a marked reduction of depth perception so that volumes tend to look like shapes.

PLATE 6-9

Conversely, short focal length lenses increase the perception of depth, sometimes to the point of linear distortion.

EXPRESSING THE NATURE OF VOLUME

In order to develop greater understanding and appreciation of volume, it is worth the effort to select various objects within easy reach and express their voluminousness. Vases, boxes, lamp bases, decorative objects, bottles, jars, wastebaskets, small radios, toys, children's blocks, etc., are excellent. Look for variety in silhouette and form.

Begin by studying individual objects to determine the angle of view that would best reveal its three dimensionality. If its conformation is not consistent, turn the object until you discover the combination of forms that, for you, expresses its mass most satisfactorily. Then light the form in such a way that the emphasis is not on the contour of the edge but rather on the form. Concentrate on the elevations and depressions that lie somewhere between the edges. Generally, one light source with a white cardboard reflector is all the equipment you will need.

When a satisfactory lighting has been developed, study it carefully in the ground glass or viewer, making adjustments in favor of volume. It's always rewarding to expose and print those studies that move you, not necessarily for exhibit purposes but so that you may be able to confirm your perception of volume and establish the means needed to record it.

PLATE 6-10 PLATE 6-11

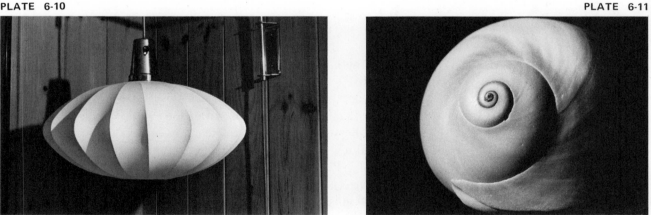

Until recently, the practice of sculpture followed the historical path of painting and thus was limited to representations of people, animals, and objects. Appreciation of sculptural quality was based mainly upon verisimilitude, factors of body movement, and the physical expression of emotion.

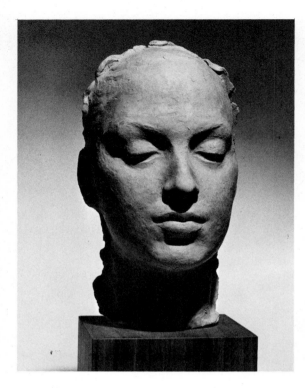

Many viewers, however, could not help reacting and becoming personally involved in qualities that they deemed separate and apart from sculptural quality. They had difficulty controlling the desire to touch not only the material and tool textures but also to pass their hands over and around to feel the interesting forms as they swell and diminish, submerge into concavities, expand from thin to thick, twist, and find their way through penetrations and perforations. Many found visual as well as tactile pleasure in the material character of stone, wood, ceramic, or metal, reacting to color, markings, and textures that could not be disguised.

PLATE 6-12

Modern abstract sculpture satisfies these impulses while intentionally ignoring the previous requirements of verisimilitude. In the stone sculpture by Bronka Stern in Plate 6-13, we can sense how the artist has tempted our eyes and hands to caress the surfaces of their constantly changing curvatures. It is an exploratory experience to glide into nongeometric depressions and then suddenly to ascend a billowing swell and travel through a tunnel. The tactile silhouette varies capriciously as we roam over its exterior, yielding to the temptation to continue along new directions, constantly veering in response to inner impulses.

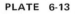

PLATE 6-13

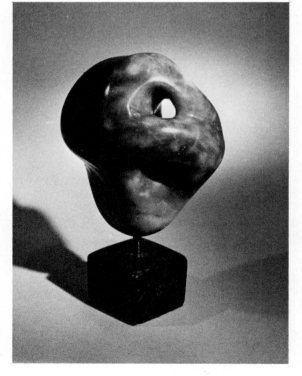

Before a photographer can express the visual pleasure inherent in beautiful volumes, he must learn to appreciate them first, if possible, through touch and then through visual examination. While modern abstract sculptures are an excellent medium for orientation, they are not easily available, and a gallery attendant would react violently to the sight of a visitor taking the liberty of touching sculpture on display.

Pebbles and small stones, which may be found in endless variety, can permit pleasurable indulgence in the development of sensitivity. Look for pebbles with holes and with forms that appear different as you view the mass from different angles. Some may combine deep indentations with voluptuous convexities or dents, dimples, and pimples. Others may incorporate bold flat planes with rounded masses. It is not easy to avoid being diverted to admire qualities of tone, texture, and reflection, so limit the extent of your diversion and continue with the study of form.

After you respond to the feel of the various conformations, select a stone about the size of your fist and proceed to study its form through touch and through visual examination. This will give you a feeling about the character of the stone and establish within your mind the particular parts of the form about which you may care to make a photographic statement.

Now place the stone on a simple background and light it for further study. Change the tone of the background until you find one that is not so contrasty that it tends to overemphasize the outer silhouette nor so similar that the object fails to come away sufficiently from the background.

Start with one light source, using reflectors to modify shadows. Thereafter, if necessary, add a second light. Aim to translate the form, about which you had a feeling, in terms of lights and darks. When you have achieved the lighting that expresses the idea you perceived in your touch examination, check it carefully in the viewer of your camera. When thoroughly satisfied with your expression, expose the film, process, and print.

PLATE 6-14

In the course of turning and lighting the stone, you are likely to come upon new discoveries of form, equally and perhaps more exciting than the one with which you began. By all means, follow through on new ideas. This is the nature of creativity. It requires appreciable time for orientation to the problem and to develop sensitivity and understanding of deep insights in simple things. After the barrier is crossed, the time spent in preliminary study is rewarded not only with one but with many worthwhile solutions.

PLATE 6-15

Now go out into a field or park and search for interesting volumes in tree trunks, limbs, and exposed roots. As you get close to some trees, the trunks that appeared to be simple cylinders from a distance display endless variations of form. Some of these are due to the inner attachments of limbs to the bole. Others, more distinctively different, are due to the ravages of weather, insects, animals, and disease.

As in modern sculpture, you will find formations, depressions, and penetrations that are visually exciting. Remarkable photographs can be made that emphasize little more than the changes in conformation and accompanying texture.

PLATE 6-16

Unfortunately, photographers have been conditioned to be so subject matter conscious that they miss the essence of the visual experience in both phases, appreciative discovery and photographic expression. They limit their observation of the tree to general identification, as one of a number of varieties:

willow, oak, elm, apple, pine, or maple, with trunk, branches, and leaves characteristic of the family. Many remain insensitive to the particular stimuli each individual tree can provide.

The same tree may serve as a subject for a multitude of emotional, spiritual, intellectual, and design experiences. It can provide endless shapes; a myriad of lines, volumes, textures; and tonal arrangements that might well occupy the better part of a lifetime to express fully.

This does not apply only to a tree. Practically any object in nature or of man's making has properties that can be exploited to achieve great photographs. What you bring to the subject is more important than what the subject brings to you. The greater sensitivity you develop to react to interesting shapes, lines, volumes, and textures, the less you will find it necessary to search for interesting subject matter. It exists all around you.

VOLUME EXPRESSION THROUGH CONTOUR LINES

Shades and shadows are one way of expressing conformation in volumes. Another way is the showing of contour lines on the surface of an irregular or discontinuous form, such as a large stratified rock.

Figure 6-3

When they are evident, as in the rock in Figure 6-3, the movement of the contour lines, coming forward and backing away, expresses the path of projections and depressions. Sometimes the combination of contour lines and surface shades and shadows provides a more forceful expression of volume than either could individually.

Driftwood is another excellent material for studying volume. Water erosion has softened the forms, making them more subtle. Depressions, tunnels, and holes are made more emphatic. Frequently, exotic silhouettes emerge from the washing away of extraneous twigs, adding fanciful linear patterns to the display of compound volume perception, compound because the forms can be expressed through both

light and shade and the contour lines in the wood. These lines result from checking in the process of drying after long immersion in water.

PLATE 6-17

VOLUME RELATIONSHIPS

The fascination inherent in studying volumes in individual objects increases as we begin to explore how volumes relate to each other.

Collect seven or eight boxes, each different in size, proportion, or geometric form. In order to avoid complicating the study with tone and texture differences, wrap the boxes with the same or similar papers. It may even be worthwhile to construct some of the boxes out of cardboard yourself; these are useful in all kinds of photographic experimentation. Effective box forms can also be made by covering wood blocks with paper.

Now combine the boxes into interesting arrangements for which the basic aim is a pleasing relationship of volumes. Start with two or three, adding and changing boxes as you see new possibilities. Set off large against small, tall against short, horizontal against vertical, rectangular against cylindrical. Note how effective the use of several boxes of the same dimensions can be.

PLATE 6-18

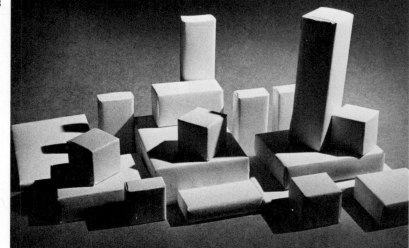

Place one box on top of the other with a change of axis. Allow some to lean, thereby producing an additional change of direction and consequent penetration of space.

Figure 6-4

Create combinations that appear to invite the viewer to walk around the composition rather than aiming to be effective only from the front. By all means, avoid becoming complicated.

This is a form of play that sensitizes photographers to awareness, invention, and discovery. Very often, the most exciting pictures are derived from such simple means and activities.

When you arrive at a pleasing arrangement, apply light, expressly for the manifestation of depth. Experiment with shadows thrown by one object on another. Determine how the shadow of a rectangular box on a cylinder can accentuate the roundness of the cylinder. Whenever you develop a composition that seems particularly effective, study the grouping in the viewer, adjust, and expose.

Look around for other geometric objects such as beach balls, funnels, pyramids, and bowls, and combine these with the previous objects. Emphasize the differences of one volume as opposed to another. In the lighting, continue experimenting with the effects created by the shadow of one volume cast upon another of different conformation. Determine the manner in which the shape of shadows affects the representation of bulkiness. Make changes in size, position, and direction until you achieve a composition that is satisfying, especially in terms of volume relationships.

Expose, print, and study your results in the print. Very likely you will have learned so much from these experiments that you'll be encouraged to continue. By all means, do!

Subsequently, still life objects consisting of decorative boxes, vases, flowerpots, fruit, eggs, and pots and pans may be combined into compositions. Potatoes, cucumbers, squash, gourds, pumpkins, green peppers, and melons are fine subjects for the study of volume. If you maintain the objective of concentrating on the interplay of voluminosity rather than on the appropriateness of combination from an interior decoration

or culinary sense, your compositions and the pictures you shoot from them will have greater appeal. A variation of the above, which may have practical application, is to start with a general subject such as food, music, art, stationery, fashion, books, or hardware and to create a composition based on equipment related to the topic.

VOLUME IN OUTDOOR SUBJECTS

It is a small step now to proceed from still life compositions to combinations of man-made objects that are such a familiar part of our environment that they are hardly noticed. At first, look for geometric forms; then as you gain more confidence and experience, seek the nongeometric. An excellent place to find such material in the city is on rooftops, where all sorts of geometric structures related to access, smoke discharge, water storage, and air conditioning are situated. Buildings, parts of buildings, parapets, balconies, and towers provide backgrounds of forms.

Factories and industrial buildings are frequently built into odd-formed combinations of geometric structure; gas storage plants, inflated domes, farm buildings (especially cylindrical silos with conical roofs), railroad equipment, buildings, and towers are all excellent subjects for volume composition. Commercial and recreational waterfronts provide fine possibilities.

PLATE 6-19

PLATE 6-20

You have probably noticed as you experimented with lighting the volume composition that the most effective direction of light to express three dimensionality is from an angular source. Applying this to your study outdoors, if you're aiming for an expression of volume, you may have to do your shooting in either midmorning or midafternoon. That is when the light from the sun is directed in angular rays.

Everything we see or touch is three-dimensional. The slenderest wire and the thinnest piece of paper have perceptible thickness or volume. It would be impossible to list even a small fraction of the myriad subjects that might serve for volume study.

117

VOLUMES IN NATURE

Clouds are of special interest to photographers because they provide remarkable variation in form as well as emotional stimulation. Clouds can be perceived as lines, broad general tonality, wisps of light or dark, textures, and large flat shapes. In cumulus and cumulonimbus they represent strong billowing volumes. At any time, it's possible to find a concentration of any one variety or a combination of many, supplying the photographer with an excellent inventory from which to select.

PLATE 6-21

Land formations too can be interpreted as shapes, lines, tones, textures, and volumes. The fascination inherent in combining volumes of still life objects can be directed easily toward boulders; sand dunes; stones, abraded and modeled by wind; gullies; gorges; and glaciated valleys. Aside from the usual physiographic photographs intended for science study, one can discover uncommon volume compositions for outstanding pictures.

PLATE 6-22

Under similar conditions of light, trees and shrubs can be interpreted into three-dimensional forms that the artist who is aware of volume potentials can compose photographically.

DEEP SPACE AND FLAT SPACE

No discussion of space, as volume, should omit the subject of deep space, sometimes referred to as linear and atmospheric perspective.

Linear perspective is perceived most clearly in the convergence of parallel lines, such as roads and railroads, as they recede into distance. It is also shown in apparent decrease in size of objects—the farther away, the smaller the object.

PLATE 6-23

Atmospheric perspective is a manifestation of blurring detail due to distance. The greater the distance between the viewer and the object, the denser the curtain of air through which light from the object needs to penetrate. Distant objects appear to be bathed in air much like fog.

Photographers have the opportunity to compose pictures displaying dramatic contrast of near and distant volumes. Unfortunately, this is an aspect of photography that has been overexploited and routinized into a formula. Consequently many photographers, working in a more current pictorial idiom, tend to avoid this phase of space representation. The subject has not been exhausted, however, and anyone with a fresh viewpoint, which emphasizes a more abstract representation of the interplay between near volumes and deep space, may be rewarded with excellent results.

In the current modern movement, which involves photography along with painting, sculpture, and graphics, preference is strongly indicated for representation of flat space.

IMPLIED VOLUME

Thus far, all the volumes under consideration have been tangible.

Consider, however, the movement of a propeller or fan that at rest consists of two or more clear and distinct blades. In motion, the appearance of blade structure is lost, and we see instead a vague cylinder with a depth equal to the pitch of the blades. A similar effect can be noted in a revolving door or a carousel.

Even though the volume is implied through movement rather than either solid form or contained space, it is, nevertheless, volume that can be recorded photographically. Its virtual existence and ephemeral nature can be useful in arriving at extraordinary compositions.

Take a wire coat hanger, twist it several times unevenly, and suspend it from a string. Now give the string a sufficient number of turns so that the twisted wire will rotate as the string unwinds. Expose at low speed while the frame is rotating.

PLATE 6-24

Next, as the string unwinds, push it gently so that it combines a pendulum action with the unwinding process. Expose at a speed that will permit the entire sweep of the pendulum to be covered.

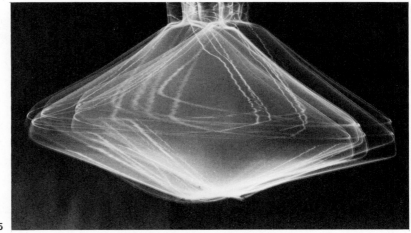

PLATE 6-25

Later, substitute an elastic string as the attachment and combine bouncing movement with both the unwinding rotation and the sweep of the pendulum.

PLATE 6-26

After these preliminary experiments, you'll probably develop many ideas for wire constructions specifically for rotation, revolution, and many other combined movements. All sorts of variations can be achieved by the addition of wires of different thickness, suspended shapes and solids, and reflective materials such as glass pendants. With delicately balanced mobile construction, rocking and revolving actions can be introduced as a supplementary variation.

Plan a trip to an amusement park where you may see adaptations of implied volume in the various rides. At night, when structural members appear to be superseded by light, fantastic compositions are possible. Combinations of several implied volumes, or implied volumes set against tangible volumes, increase the opportunities for creative expression even more.

VOLUMES IN PORTRAIT AND FIGURE

It is no mere accident that pictures of human beings, in portrait and figure, continue to be among the most interesting subjects in photography, as in any other medium of the visual arts. Looking at representations of familiar people and strangers has given interest and pleasure since cave dwelling times. Variations in individuals, as well as interpretation of form and expression, are almost infinite.

We are all very much alike in so many ways and yet so remarkably different. The combinations of form and proportion, concavities and convexities, and textures and tonalities are not only unique in each of us, but they also change with every action and with every thought, mood, and emotion that occupies our minds.

The experiences of the foregoing in this chapter will be helpful in the expression of volume in a portrait. Again, you must not be diverted from going for the objective of volume: not flattery, character, likeness; not even expressive emotion or texture—but pure structural form.

Start with a thin-faced, middle-aged model whose features are sharply defined. Look for such details as clearly evident angles where the forehead meets the temple, projecting mounds under the hairs of the eyebrows, distinctly globular eyeballs set in deep sockets, a prominent nose with precise planes in front and sides and with clearly conspicuous wings, cheekbones raised well above the mass of cheek, and a clearly defined chin. While it may appear to be a tall order to fill, you will have no real difficulty finding such models.

Study the head to determine the viewpoint that emphasizes most effectively the particular aspects of form this model possesses. Light carefully to emphasize the three dimensionality of the parts. Aim to make the entire head and the features too as geometric as possible. You will probably find that a focusing spotlight or a photospot will be adequate for the kind of light you need to define the forms. Other types of reflection, however, or supplementary lighting may be necessary to model the more subtle qualities of form for which you are likely to aim. No lighting plan can be prescribed; each combination of forms is sufficiently different to require a

unique solution. As long as you are determined to obtain a dramatic representation of volume, you will find the means to achieve it, after some trial and error.

Expose and process the film. In the printing you will need to keep in mind what your primary aim was and consequently to exercise print control to that end.

PLATE 6-27

Study your result. Notice what a different kind of photograph you have produced! The thinking that guided selection of model, the posing, and the lighting will be clearly evident in the picture.

Turn your print upside down, and examine each individual form bottom side up. Does the base of the nose appear as a shelf-like projection, almost coming forward out of the print? Do the eyes appear surmounted on a globular curvature? Is there a feeling for the cylindrical formation of teeth around which the lips are formed? Does the chin protrude sharply from the neck? Can you distinguish the modified flat plane of the forehead joining sharply with the plane of the temple? Is there a distinct awareness of the cheekbone extending from below the outer angle of the eye back to the ear, forming a marked intersection of the plane of the cheek with the front plane of the face?

From this point, you may select any model and proceed in much the same way. It is important to identify in your mind the nature of the forms that constitute the model's head and to light so that these forms become conspicuous.

Remember that this is only one of many approaches to portrait photography. In each, one begins with an entirely different reason for shooting the picture and aims for a different set of outcomes. The expected result and the reasoning behind it determine the procedure to be used.

Draped and undraped figures are equally excellent subjects for volume expression. Each segment of the torso and limbs can be related to a near geometric form.

In order to obtain heightened expression of volume, pose the figure in a twisting position. When head, shoulders, and hips are shown so that each is turned in a somewhat different direction, the figure interest is guided around from front to side to back. Thus, another aspect of implied volume is induced.

Remarkably effective pictures can be produced when a small part of the figure is shown in which the positive volumes of the figure are set off against the negative volumes of intervening space. These in turn are contrasted or given rhythmic movement in relation to volumes in the background.

Principles of Design

THE ORGANIZATIONAL MEANS

Occasionally, confusion exists between the function of the visual elements, which have just been examined, and the principles of composition, which are given attention in the following chapters. The elements—shape, line, light and dark, texture, and volume—may be regarded as parts of the picture, in much the same manner as we look upon the objects that make up the subject. The principles—contrast, rhythm, dominance, balance, and unity—are the ways an artist organizes the various separate parts into a single complete picture.

Throughout history most artists have used these terms in their discussion and analysis of art and in the education of artists. Some have consciously avoided labels for any component of art, but while they shunned the actual terms and used means that were somewhat different, their goals were similar. Others substituted different words for the same qualities, using mass sometimes for shape and sometimes for volume, tone for light and dark, and movement for rhythm. Still others felt the need to include space and motion among the elements and proportion, variety, and scale among the principles.

The terms themselves are unimportant except as a point of reference; their qualities are essential. Perhaps in time new and more precise terminology may be devised and universally accepted. Meanwhile, artists have the liberty in their own practice and discussion to signify the elements and principles with any names they see fit. Regardless of the terms used, it is impossible to imagine visual perception without the equivalents of shape, line, light and dark, texture, and volume.

In a sense, the qualities of the elements (not the terms) are the vocabulary of visual communication, just as words are the vocabulary of verbal communication. Under special circum-

stances, in verbal communication a single word, by its sound or meaning, can convey an idea sufficiently so that no other words are needed. So, too, one may express a visual idea with a single shape or line or volume. There are times when such extreme succinctness is not only possible but also extremely desirable.

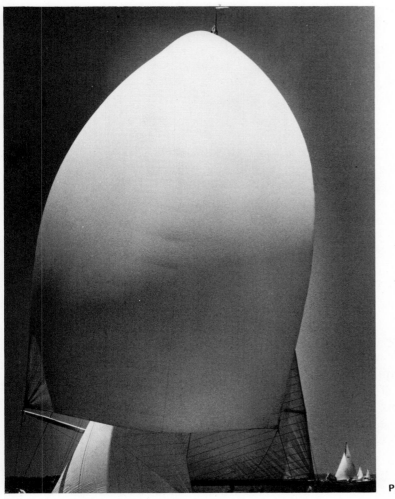

PLATE 7-1

Most often additional words are needed to enlarge and deepen the meaning. Then the words must be organized in some formal order to ensure that the meaning intended by the writer is neither lost nor distorted. Thus, sentence and paragraph structure and other principles of grammar become necessary, not as ends in themselves but as premises of organization to promote clarity.

The analogy is appropriate for the visual elements. Shapes, lines, textures, and volumes used in combination are capable of supporting each other for increased effectiveness. Unless they are directed by an organizational premise, the artist's idea may fail to make its point. The principles, contrast, rhythm, dominance, balance, and unity, are the

operational process the artist uses to bring all the design elements together into a harmonious combination. The whole process—selecting elements that express the idea and arranging them in relation to the principles—is pictorial composition.

THE OPERATIONAL PROCESS

"Composition" and "design" may be used interchangeably; both have the same meaning. In some situations, design has come to mean decoration, the invention of a patterned unit that may be used alone or in multiples, or a surface embellishment that is applied superficially to the basic structure. The more accurate concept of design is its original meaning of intention—the intention of an artist to arrange visual elements in a way that will make his idea clear and attractive to others.

Composition is not an easily adapted ritual for success that may be applied after contemplation. It is not a remedial formula that may be prescribed in regulated doses for an ailing picture nor is it a measurable quantity that can be used to establish a qualitative value. One does not conceive of the visual idea as one problem and the composition as another. Both are so completely interdependent that it is impossible to separate one from the other.

So much mystery has enshrouded the principles of composition that the process has been given more significance than it merits. They are simply ways of using the elements to gain attention and hold it until the artist's statements of reality and attitude are communicated, as an idea, to the observer. If one has to make a choice, there is no question about the greater importance of idea and expression over principles.

The operational process can be, nevertheless, an attractive feature in itself. Not only does the artist deal with ideas, he must also present the ideas in a uniquely interesting way. In past epochs, subject matter completely overshadowed pictorial organization. Today organization itself has become sufficiently important to stand alone as the primary interest of the picture.

In the photograph of a subject, the photographer directs your attention to features in the subject that have stirred him, partly because of intrinsic interest or content and partly because he has discovered lines, shapes, tones, textures, and volumes in a combination that is particularly attractive. The picture may not be noticed or the feelings of the photographer may not be communicated if the organization is poor. The various elements need to be seen more clearly through contrast; the viewer's interest has to be guided around the picture in rhythmic movement; a sense of singular unity is necessary to avoid idea confusion; and only one feature in a picture may dominate; otherwise perplexity takes hold.

The principles of composition were not contrived as an arbitrary exercise to achieve elite status but rather grew out of the responses people have to orderly arrangement. They were derived from the teachings of successive generations of artists to their followers and from examination of outstanding art works over several thousand years. Artists, primitive as well as contemporary, used them as the means to control the establishment and retention of interest. Certainly they are not narrow, precise rules that place limitations on the artist's performance. Through their use, shapes of various sizes and attraction value, dissimilar tones and textures, and diverse objects are interrelated to permit the central idea to dominate.

Without these controls, the many demands for attention by different attractions in the picture would lead to chaos.

The device of isolating a single feature for concentrated study is an unfortunate necessity. Differences among the elements are not so clear and distinct as would appear from casual examination. At what point does a line become heavy enough to be considered a shape?

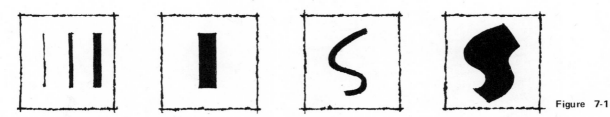

Figure 7-1

How many lines need to be combined before line identity is lost and texture and tone appear?

Figure 7-2

When a line meanders and crosses upon itself, is it still a line or has it become a shape?

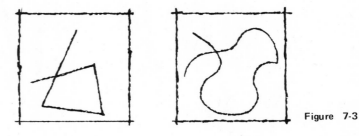

Figure 7-3

How much gradation is necessary to convert a shape into a volume?

A similar problem exists with the study of the principles of design. Concentrating upon a single principle to investigate its potential, it may appear that the principle is a separate and distinct entity. Actually, all the individual parts of the composition operate in a unified correlated manner so that any single feature may take on several identities. Composition is a complex interrelationship which results in a cohesive unity which may appear deceptively simple.

The photographer has the option to exploit a single principle as the dominant interest in the picture. For example, he may chose to select a group of many lines, shapes, or volumes and direct attention to their rhythmic relationship or similarity.

PLATE 7-2

Or he may concentrate on two lines and emphasize their diversity through dramatic contrast.

PLATE 7-3

The time it takes to combine the various parts of a composition into a fused entity varies according to the photographer, the subject, and the controlling conditions. Sometimes the fleeting nature of the subject imposes speedy cognition and reaction. Heightened sensitivity, through awareness and practice, prepares the photographer to perceive and perform instantaneously. At other times, hours of adjustment and waiting for light conditions to become right may be necessary before the film is exposed.

PRECONCEIVED COMPOSITIONAL PATTERNS

As in every area of activity, there are writers and teachers of composition who have formulated a procedure of operation that artists may consciously apply to the construction and analysis of their compositions. They provide specific directions intended to yield specific results.

Such a procedure may work well for the artist who devised it, but it is bound to be too personal a way of working to impose upon others. The information-hungry seeker of understanding may be attracted by its neat methodical approach only to realize eventually that thought processes are being channeled into preconceived, alien patterns. The procedure becomes little more artistic than "painting by number" into presketched areas.

Instead of immersing himself into personal involvement with the source of visual excitement, the learner looks for specimens that conform to models forcefully committed to memory. Instead of exploring the commonplace with the feelings of wonder and naive curiosity which lead an artist to interact with his surroundings, he is led to search for subjects which portray transcriptions of spectacular natural phenomena and whimsical man-made happenings.

The sources of visual excitement in normal experience are unlimited. One needs to penetrate beyond surface details that give recognition to the subject in order to discover the visual qualities of the separate parts and the effect that one part has upon another.

When you come upon a subject that excites your attention, cast aside all conscious remembrance of successful pictures you have seen and noted. Let your observation explore the selected area until you react to a feature that appears worthy of more intense examination. Don't attempt to make the subject conform to an idea that lingers in your mind; rather, let the subject express its unique qualities to you. Above all, concentrate on the relationships of abstract elements and seek the means to isolate these relationships from the surrounding space.

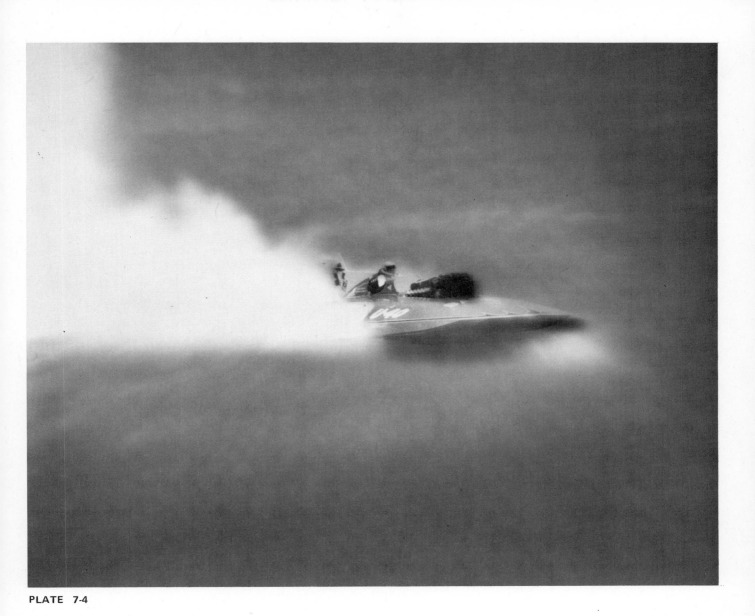

PLATE 7-4

PICTORIAL DISSECTION

An even more frustrating approach to the study of pictorial organization is the unraveling of complex analyses. Sometimes in words, most often in directional lines and swirling planes, the compositional analyst explains his personal reactions to a picture, expecting that others will find understanding in the same manner.

Just as each of us responds differently to the qualities and moods of nature, so are we moved differently to pictures that express these qualities. Even though the artist has limited the expression of a picture to his own interpretation, the selective eye of the viewer continues to work at selection. This is proved by the fact that many analysts have committed their linear dissection on the same pictures and arrived at different patterns and conclusions.

The analytical lines are a disturbing element that interfere with wholesome viewing. If the picture cannot be appreciated in the way it was delivered by the artist, no amount of linear analysis and verbal rationalization will clarity it. If the owner of a print derives satisfaction by indulging in a graffiti exercise, that is his personal privilege. To impose his indulgence on others in the name of intellectual or educational interpretation is an abuse of pedagogical license.

THE PSYCHOLOGICAL APPROACH

There is much to be said in favor of studying psychological findings relating to the science of perception. In fact, each of the underlying principles of visual organization can be explained scientifically. Produced mainly by Gestalt psychologists, the concepts and language are expressed in unfamiliar terms that need intensive study to follow.

While it is true, however, that the artist needs to understand his own responses and how other people respond, deep scientific study can be confusing, especially in the earlier stages of compositional study. It gives the artist an overconcern with reasoning that takes attention away from creating. The objective becomes more clinical than inventively productive.

Highly advanced artists, confident of their goals and procedures, can concern themselves with deep psychological and philosophical insights and grow from the enriching experience. Those who are not so confident may find that such consciously applied knowledge restricts intuitive impulse.

Cloaked in the factual environment of science, the principles take on a semblance of rigid arbitrary rules that confine rather than aid creativity. Art needs the enchantment that grows out of the unanticipated and the unexplained. Reason is the mainstay of science; it is not in any way a necessary part of art. Art, expressing thoughts and feelings, need not even be logical.

Art is a humanistic experience. Each artist has to depend on his own intuitive judgment rather than on the perception of others. Neither consciously applied information nor psychological postulates should influence esthetic decisions. In the end, each artist is guided by what he feels is right.

The development of visual perception can be improved through guidance, not only in awareness to the presence of visual elements but also to some of the processes of organization.

It is to this end that we proceed with the following.

Center of Interest

One of the reasons why professional photographers are more likely to produce better pictures than nonprofessionals is that the professional usually begins with an assignment. A picture about a specific idea is needed for a particular purpose. It may be necessary to illustrate a selected segment of a news story or to photograph a product in use or even to make or support a sociological statement. The ultimate function of the picture is made clear to the photographer before he sets out on his assignment.

Sometimes the assignment is so definite that a comprehensive layout is provided to ensure that the picture will fulfill the functional requirement completely. Most often, the client has sufficient confidence in the photographer's judgment to select the details of the subject so that only thorough understanding of the intended outcome is necessary.

Nevertheless, the specific topic, idea, or object to be portrayed is uppermost in the photographer's mind as he prepares for the picture, and it remains uppermost while he takes it and as he prints it. His evaluation of fulfillment is in terms first of the satisfactory presentation of his assignment and second of the creative supplementation of artistry that will make the picture attractive beyond its functional requirement.

ESTABLISHING THE SINGLE PRINCIPAL IDEA

Each picture should have only one principal idea or topic. Everything else in the picture must be subordinate. Wherever possible, these subordinates should function cooperatively to

133

contribute to and focus upon the principal feature so that it and it alone is emphasized. Subordinate elements must be arranged to remain as background.

A picture without a clearly dominant center of interest is bewildering to the viewer. Subconsciously, if it is not verbalized, the viewer asks, "What do you want me to look at? What is there worth seeing?" The viewer must understand the picture quickly and be able to recognize immediately what is intended to be important.

When the principal feature is a single object that fills most of the picture space or one that stands out boldly because of dark and light and texture, there is no problem.

PLATE 8-1

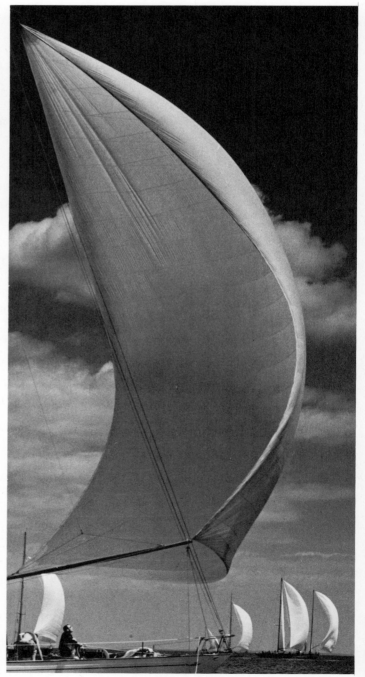

PLATE 8-2

The principal feature need not necessarily be a person, place, or thing. It could be a shape, a line, or a texture that is part of something or a relationship among a number of things.

PLATE 8-3 PLATE 8-4

In the photograph in Plate 8-5, however, no effort was made to decide upon a worthwhile center of interest, and none was achieved. So much of the significant form of each part is hidden from view that the subject displays little intrinsic interest capable of achieving dominance. With such understatement, the parts could serve well as subordination. Besides, there is no striking shape or line to compensate for the lack of subject attraction. Consequently, the viewer will find little in the picture worthy of provoking attention beyond a rapid glance.

PLATE 8-5

It cannot be emphasized either too often or too strongly that each picture must start with the establishment of the principal feature in the photographer's mind. If it has not been assigned, it must be selected by the photographer. There is no point in proceeding until this all-important decision has been made. If no clear determination has been fixed at the outset, there is little likelihood of a clear expression of idea in the finished picture.

SELECTIVE VISION

The principal feature must be seen clearly, as center of interest, in the camera's viewer or ground glass. In the excitement that accompanies the discovery of a subject to be photographed, we are likely to overlook distracting elements that may cancel the impressiveness of the chosen feature. This is due to a condition known as *selective vision*.

All of us are burdened with selective vision; we tend to concentrate on that part of the subject which interests us and to shut out surrounding details which are physically present. It's as though we wish them to disappear or to become subdued. Since they don't register impressively on our minds, we imagine they will not register on the picture. Which photographer has not been shocked to discover objects in a picture of which he was not even aware at the time of exposure?

PLATE 8-6

SUBORDINATION

Every subject, regardless of its complexity or simplicity, includes many elements and objects, each of which has pictorial potential. Which one, and only one, should be selected to be the principal feature of the particular picture about to be photographed? It is a common failing to look at a subject, to regard everything that is in or near it as intrinsically worthwhile, and to get "all of it in." This attitude of subject matter inclusiveness is the root cause of most visual confusion. Something must be sacrificed!

Sacrifice is a component of artistry that is difficult to achieve. If only one element, object, or thought may be emphasized to attain dominance, then all others in the picture must be either discarded or deemphasized. If items of strong interest potential are permitted to remain at full strength, they will challenge the power of the selected element. Even if the subject includes only two dominating interests, the distraction is sufficient to destroy the picture's effectiveness.

In a situation where it is not possible to subordinate one of the interests, the only solution is to make two separate pictures.

ISOLATING THE SINGULAR EXPRESSION

The admonition, to avoid the temptation of "getting it all in," is often misinterpreted to mean that interesting compositions can be accomplished only with close-ups. Not at all! The center of interest only needs to be a clear and distinct unit or idea. It may be a whole object, a part of one, or a combination of many objects that function together in some unified way. It may be one of the abstract elements or a combination of several.

Unity may be determined by an encompassing shape that brings together all the parts within the picture as one interconnected form, separate and apart from surrounding forms.

PLATE 8-7

The shape may be further isolated from surrounding forms through light and dark or texture.

The center of interest may be an interesting line such as a tree branch or a crack in pavement or traffic lane lines painted on a roadway;

PLATE 8-8

or it may be some unusual action or thought.

PLATE 8-9

Panoramas, a whole town on a hillside, a group of buildings, a crowd of people, or a herd of cows—each can be and has been the principal feature of many fine photographs. If they are unified through shape, tone, line, or idea and are adequately isolated from the background, they are suitable centers of interest. Sufficient subordinated background must always be included to provide worthwhile surroundings in which the dominant exerts its supremacy; otherwise the center of interest will lose its position. Either the sense of isolation is lost due to the lack of sufficient background against which it can isolate itself, or an unintended part of the mass takes over as center of interest, using the remainder of the mass as background.

In Plate 8-7, the houses, towers, and lighthouse combine to form a grouping that functions as the center of interest. No single feature emerges sufficiently from the group to attract attention to itself so that the entire grouping becomes the unit. Isolation is accomplished by the large area of unimposing space around the unit. Although it is not lacking in detail or subordinate interest, the surrounding area takes its place as background.

A closer cropping of the same picture in Plate 8-10 removes the surrounding space and, consequently, the sense of isolation. Now, because of its central position, dominating height, imposing shape, and bold tonality, the lighthouse becomes the center of interest.

PLATE 8-10

Let us return to Plate 8-5, which failed pictorially because it lacked a center of interest.

From a greater distance, the building emerges in shape, detail, and light and dark to assert its importance. While the three foreground boats point toward it, the lines from each boat pick up the visual movement and conduct the viewer directly to its commanding position. With a definite principal feature and subordinate elements to support its dominance, the picture is worthy of capturing and holding attention.

PLATE 8-11

From a closer distance, it may be possible to focus on some of the details barely visible at the base of the mountain. A group of buildings on a dock,

PLATE 8-12

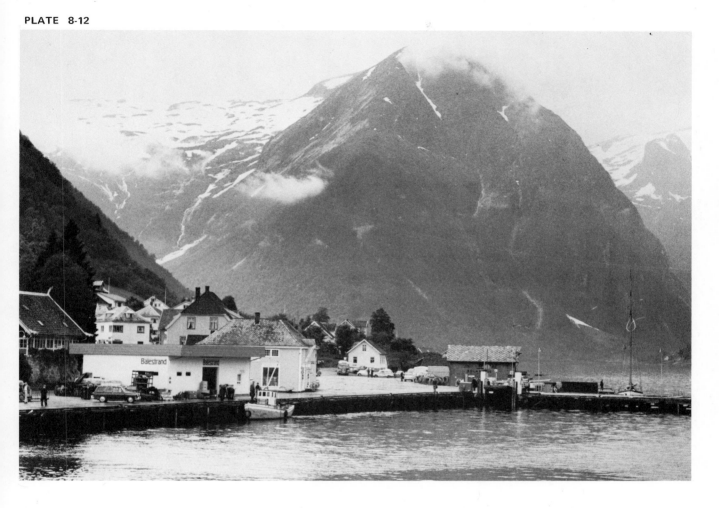

a single tree, or a group of several trees, because of attractive shape supported by strong contrast of light and dark against the background, create strong visual interest.

PLATE 8-13

From another viewpoint, one may be caught up in the rhythm of a number of tree trunks in which the repetition of the dark vertical forms creates a linear beat. Each of the intervals between the trees forms a similar pattern with slight variations so that a contrapuntal harmony between units and intervals is established.

PLATE 8-14

Coming closer to concentrate on a single feature, one may discover a fascinating combination of shape and texture in tree bark, fungi, and moss. The resulting abstract patterns are remarkably stimulating,

PLATE 8-15

as is the linear movement of a single branch, twisting, bending, and dividing into smaller branches and twigs.

At some point, it may be possible to discover some stone steps or other vestige of a man-made structure that had been abandoned some years ago and is now almost completely covered with vegetation. A visual poetic statement can be made about the rapidity of nature's action in reclaiming the land.

Distant shot or close-up, it doesn't really matter in the selection of center of interest. It is the habit of thinking and establishing a principal feature around which the picture is built that is important. Just as the thought idea must precede the spoken statement, so must the center of interest be established before the visual statement is made. The lack of idea in one results in empty meaningless words; in the other it results in a cluttered image of insignificant objects. Ambiguity can be as distressing in a visual image as it is in a written or spoken idea.

It is an attitude of isolating from any given whole the one feature that is worthy of a special statement. In a portrait, it might be something about the eyes, the nose, the mouth, or the shape of the head. One could easily feature the pattern of hair, the shape of shadow along the nose, or a line of light on the edge of the face. An animated expression, the flowing angular movement between the head and neck, the texture of aging skin—all are worthy of consideration as center of interest. In a figure, one could concentrate on the expressive character of a posture or a gesture that reveals more about one's attitude toward life than any number of words.

It has become cliché to assert that the subject matter worthy of being selected for center of interest in pictures is infinite. It is, however, a cliché that is absolutely true. As long as the idea is sufficiently clear in your mind, you will find a way to express it, even when such an important matter as relative size cannot be used for support.

There can be no question that the center of interest in Plate 8-16 is the brad being positioned on the loft floor, even though the brad is the smallest single object in the picture. Everything else is either subordinated or helps to direct attention to the brad. The focus of the lofting technician's head, the direction of the arm and hand holding the brad, the grasp of the thumb and index finger, and even the other hand and the hammer held in it point in the direction of the brad. There are other brads in the picture, but instead of drawing attention to themselves they indicate how the center of interest will be used to spot projected points in establishing the line of curvature. A particularly helpful factor is the brad's light tone against the dark background of thumb and shadow.

PLATE 8-16

COMPOUND CENTER OF INTEREST

Frequently we are confronted with a situation where two or more features in a subject need to be stressed with equal emphasis. The solution is not difficult if the two units are linked through elements of close similarity. Then the two should be combined to function either as a related idea or as far as possible as a united form.

In Plate 8-17, the related idea is obviously a boat race. Elements of visual similarity are the direction of masts and mainsails, jibs filled with the wind, and the design of the hulls.

Neither one of these boats can dominate completely in the composition shown. Even though the one on the left is favored slightly by size and position, they combine to form the single unit that dominates the picture. Substantial subordinated background permits the combined unit to dominate without challenge.

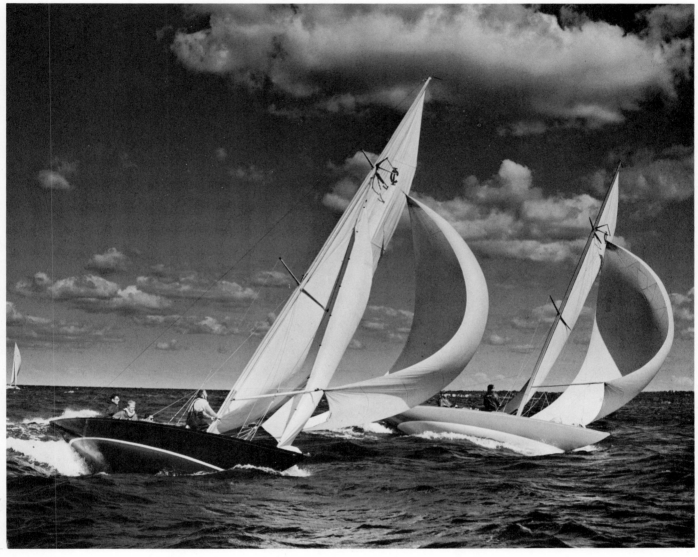

PLATE 8-17

To understand more fully how fragile this dominant relationship can be, first cover a small part of one boat and then the other. Notice how the center of interest shifts to the one that remains uncovered. Any reduction in background through cropping would shift the center of interest completely from a

compound one of both boats to the ballooning jib in the center of the picture. You will find that in order to combine two or more units into a single center of interest a relatively large area of background is needed to isolate them. The greater the area of subordinated background, the better chance there will be to unite the multiples into a single center of interest. Of course the closer they are to each other, the greater the likelihood of combination into a single unit.

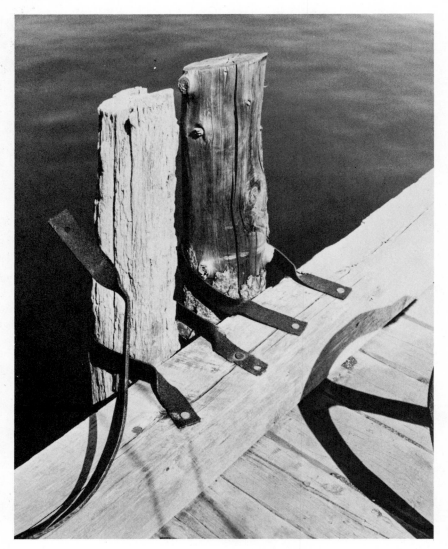

PLATE 8-18

Having selected the principal feature to be the center of interest, what means are available to reinforce the selection and make it truly dominant?

Three factors, occasionally acting alone but most often in combination, may be called upon for support—placement, size, and contrast.

Placement
in the Picture Field

PLACING A SINGLE ISOLATED OBJECT

Let us assume that you've discovered a subject that stimulates your interest. After subsequent exploration, you have established the central idea on which to focus your expression. Even the shape of the field for this picture has been determined. Now the problem arises as to whether there is any segment of the field that is more effective for placement of the center of interest than any other.

Standard directions advise in favor of placing the central idea somewhere near the center of the picture area. There are arguments for and against the use of this central position.

We shall consider first the placement of a moderately dark object against the simple light background. In this instance, our subject will be the turtle carved in stone by the late sculptor Albino Cavallito.

For the purpose of our experiment, we shall set the sculpture on a sand base, with light pebbles and leaves to vary the texture. The procedure can be done with one negative that has ample space all around the turtle so that cropping from any direction will shift the placement to any part of the field.

PLATE 9-1

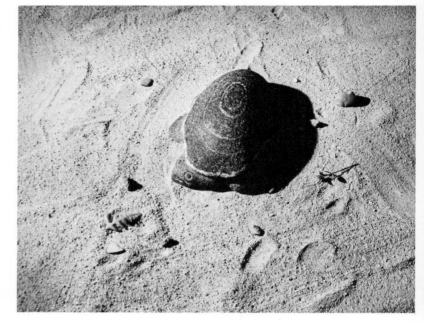

Size, like every other aspect of art, is relative. Since there is no other object in the picture whose size we know and can use as a basis of scale for the carving, we have no way of determining from the print in Plate 9-2 what the actual size of the carving may be.

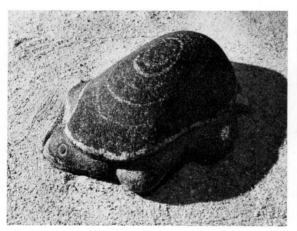

PLATE 9-2

The carving itself is only six inches long. The photograph gives the impression that it is considerably larger. In order to present a more accurate impression of the actual size, we shall print the object smaller in relation to the format of the frame.

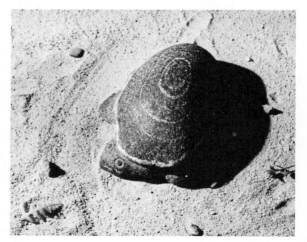

PLATE 9-3

Now let's experiment with different placements.

PLATE 9-4

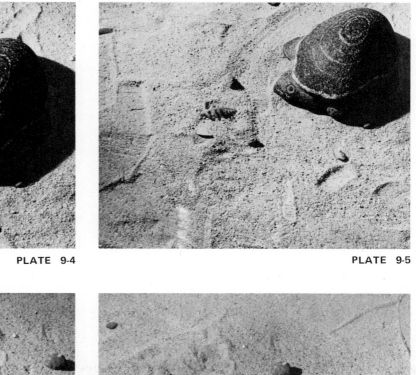

PLATE 9-5

PLATE 9-6

PLATE 9-7

PLATE 9-8

PLATE 9-9

Forget the "rules" you've been exposed to and observe these placements with an unprejudiced mind. Disregard what you may have learned about such matters as balance, and evaluate the impressions you receive from the arrangements themselves. Simple as they may be, each one expresses a somewhat different statement with regard to movement, suspense, and mood. Certainly, from this point of view, some may appear more effective than central placement.

We must learn to observe for the purpose of realizing new impressions. Instead of looking merely to confirm standard information or to apply orthodox theories, it's important to look to make personal judgments. Creative activity cannot be confined by the past; it has to be released from preconceived notions that may interfere with individual experimentation. Sometimes it's wise even to defy established concepts.

All the placements shown are still restricted in that the format of the frame is dictated by standard commercial proportions. The opportunity for greater variety and expression results from experimentation with other formats.

PLATE 9-10

PLATE 9-11

PLATE 9-12

PLATE 9-13

PLATE 9-14

PLATE 9-15

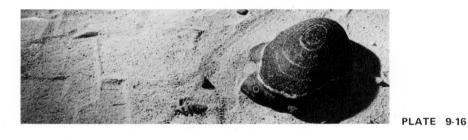

PLATE 9-16

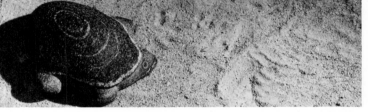

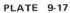

PLATE 9-17

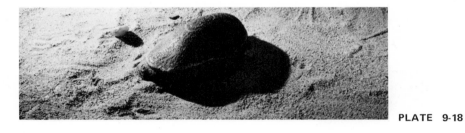

PLATE 9-18

PLACEMENT IN PORTRAITURE

The problem becomes somewhat more complex when we consider compositional placement of a portrait to establish center of interest. The portrait differs from the small object in that it cannot be completely isolated in its lower part from the figure.

Here again the situation applies to a form against a very simple background. As in the previous study, for the purpose of making the experiment clear, we shall keep the general tonality of the head moderately light against a middle-toned

background. This time the background will be an interior, which may provide an environmental as well as a textural relationship.

In order to maintain absolute interest on the head instead of any part of the background, the portrait will be placed well in front of the background so that with an open lens focused on the head the background will be soft in focus.

Since adequate space is needed for shifting the center of interest as we continue to experiment with placement, a print from our full original negative will look like this.

PLATE 9-19

A standard, straightforward portrait arrangement from this negative might look like this, with the head fairly well centered.

PLATE 9-20

While there is nothing seriously wrong with this placement and proportion, and for many situations it may be the best solution, it is nevertheless obvious and pedestrian.

Through experimentation with different formats and placements we may arrive at something like the following.

PLATE 9-21

PLATE 9-22

PLATE 9-23

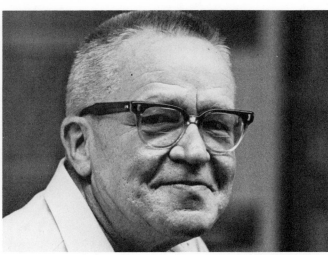

PLATE 9-24

PLATE 9-25

PLATE 9-26

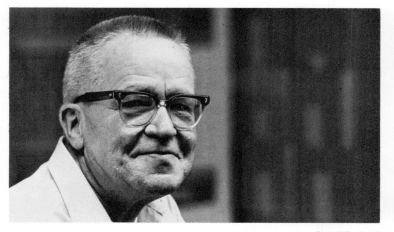

PLATE 9-27

PLATE 9-28

PLATE 9-29

PLATE 9-30

There is little danger that any part of the background may usurp the center of interest position because of several factors:

1. The moderately light tone of the head stands out in fairly strong contrast to the consistently dark and middle tone of the background.

2. The sharp focus of the head draws attention away from the soft focus of the background.

3. The play of modeling, form, and texture on the head attracts attention.

4. Subject matter interest in characterization is in itself a potent force of attraction.

Consequently, we may ignore the principle of centering the main interest in situations where the idea object is so powerful a force in relation to the other parts of the picture that its attraction value is overwhelming. The center of interest is directed to the object, no matter where it is placed.

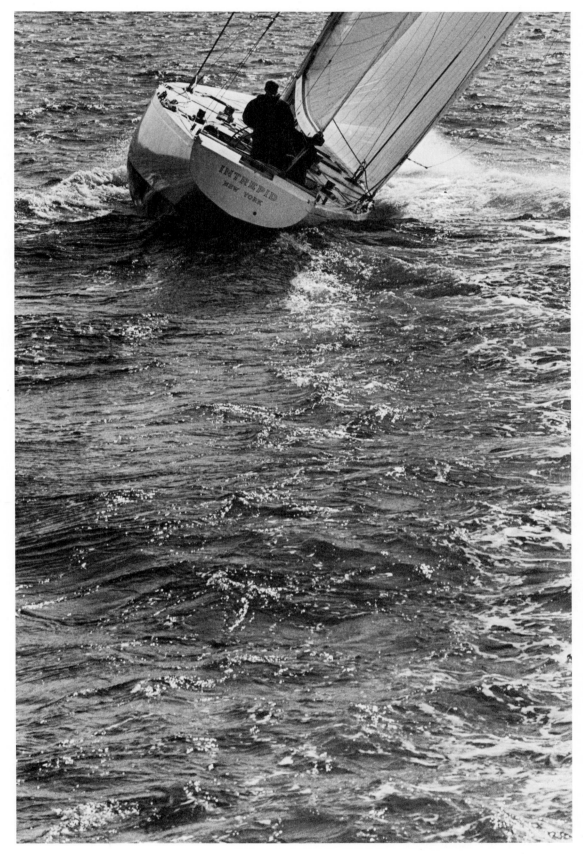

PLATE 9-31

PLACEMENT TO EMPHASIZE IDEA INTENTION

The problem is significantly different when there are two objects of equally attractive force in the picture. Let us illustrate with two figures against a simple background.

PLATE 9-32

The solution of placement for center of interest depends entirely on the specific idea you wish to express.

If you wish to emphasize the idea that the meeting of the two people is more important than the significance of either as an individual, then both must be shown with approximately equal importance. Background space around each must also be approximately the same and an ample amount of background is needed to bring the two together as a unit.

PLATE 9-33

Now, suppose that the cordiality of the handshake is the most important part of the idea. Then it is necessary to come closer to the handshake in order to make it large enough to dominate. Some sacrifice of figure parts will be required to eliminate or diminish distracting elements.

PLATE 9-34

If the handshake were made larger in relation to the figure, more of the figure individuality might be lost than would be intended. There may be instances, however, where such a composition is more expressive of the basic idea than the previous one.

PLATE 9-35

Notice what happens when the handshake is brought down lower in the composition.

PLATE 9-36

Since the direction lines of the arms lead to the handshake, it still retains its dominance as the center of interest. Most people, nevertheless, would consider the previous composition to be a more effective means of bringing attention to the handshake. Surrounded by unimposing background and supported by the direction lines of the arms, with the figures forming a frame for the shape of the space in which the handshake occurs, the juncture of the two arms becomes an irresistible force of attraction.

In the event that the idea requires the emphasis of one individual over another, some further adjustments in composition need to be made.

PLATE 9-37

The composition is shifted so that the figure to be emphasized is shown with space or background all around the upper section; the other figure is partially cropped out of the picture. Thus, greater attention is given to the figure on the left, but the handshake remains as the center of interest.

Similar emphasis can be given to the figure on the right by shifting the composition in the opposite direction.

PLATE 9-38

If you go back now to reexamine all the previous illustrations of this series in terms of the relationship between idea intention and placement of the principal feature, a guiding principle will become obvious. In order to establish emphasis on the selected center of interest, it was necessary to place that part somewhere near the center.

We may conclude, therefore, the following:

1. When there are no strongly competing objects in the picture, the center of interest need not be placed near the center of the field. It may be placed wherever it appears to be most effective.

2. When additional objects included in the picture tend to compete for attention, placement near the center gives the principal subject an opportunity to maintain greater attraction value.

3. Subordination of supplementary objects results from placement close to the frame and from partial cropping out of the picture.

It will become apparent from understanding of other principles of composition which follow in subsequent chapters that there are several additional factors that influence decisions of placement.

The previous examples were simplified illustrations intended to clarify the point of placement. Let us see how these understandings may be applied in a picture that includes considerably more subject matter and idea possibilities.

Here is a group of bridge players. If the intention is to state nothing more specific than that, it is essential that the group be brought together as closely as possible. Since the table presents physical limitations for closer grouping, we must resort to a large area of background to give the effect that they are close.

PLATE 9-39

In order to make the distant player dominant, she is placed near the center and the two side figures are cropped. The foreground figure will not challenge the dominance even though it is larger and equally centered. This is due to the fact that the attention value of a back view is usually considerably less than one that shows the face.

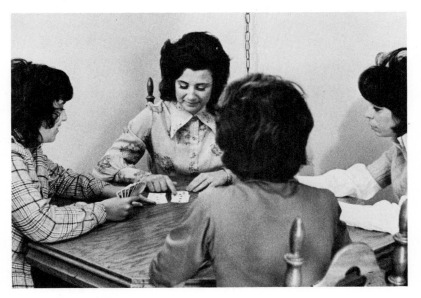

PLATE 9-40

With the three other players grouped to one side, the right figure is isolated and emphasized.

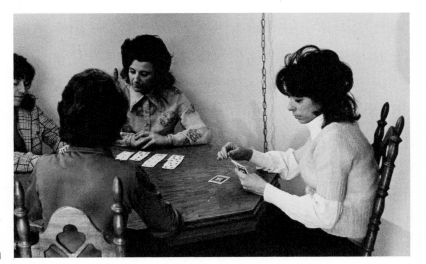

PLATE 9-41

Now the left player is made dominant, partly because of her placement and partly because the attention of the play is focused on her.

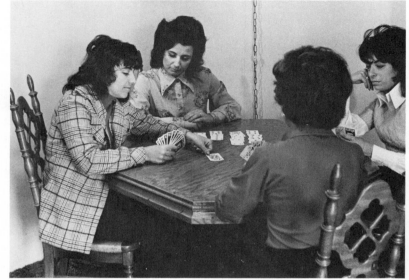

PLATE 9-42

Here the emphasis is brought to the foreground player and the way she will play her hand in relation to the dummy. Cropping the other figures almost completely out of the picture makes them completely subordinate and removes all chance of distraction from the selected dominant.

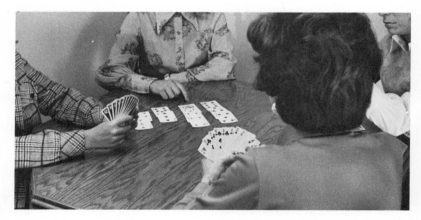

PLATE 9-43

In each picture of the foregoing series, center of interest was achieved entirely through application of the conclusions stated on page 158. The feature to be emphasized was shifted as much as possible toward the center of the field. Remaining figures were either shifted toward edges or partially cropped to subordinate their importance.

POINTERS FOR EMPHASIS

Few of us can resist the commanding force of a pointing finger; our interest follows along the path of its direction until it reaches the intended objective. Arrows have a similarly compelling grip on our attention. Both are used frequently as graphic symbols to direct attention to a point of focus.

Figure 9-1

No matter how insignificant it may be or the number of impediments we put into its path or in what position of the field it is placed, we are propelled to the person or object that is pointed out, and it becomes the center of interest. The power of the directing force is overwhelming.

Figure 9-2

Sometimes, when photographing man-made objects, pointing forms and arrows can be found and utilized to direct attention to the element that has been selected to function as the center of interest.

PLATE 9-44

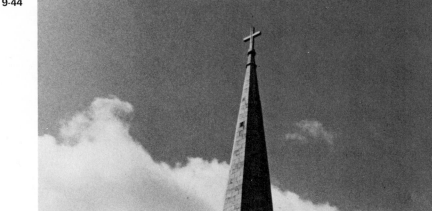

Many additional devices exist that have a striking directional effect. Any angle or any shape that comes to a point or diminishes in size similar to a point will conduct the viewers attention to the spot where the edges meet or toward the direction of its movement.

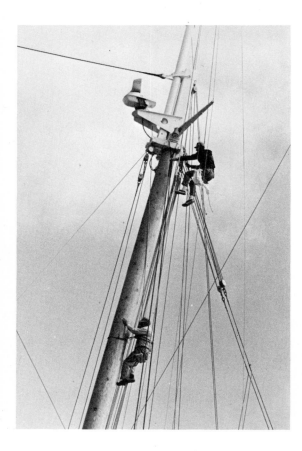

PLATE 9-45

When two or more lines cross, the attention is focused on the point of crossing. We cannot avoid being attracted to the crossing because, in a sense, four or more arrow shapes are pointing to the same spot.

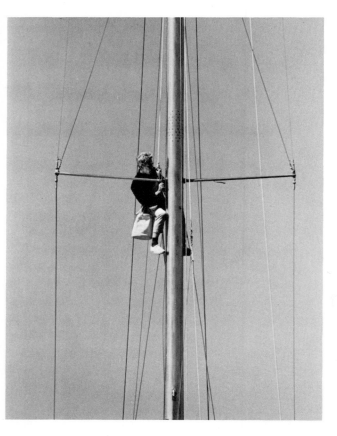

PLATE 9-46

A strong line, either curved or straight, tends to conduct the viewer along its path and toward the element that may be found at its terminal.

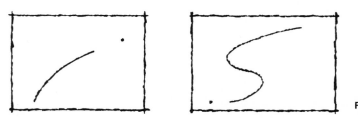

Figure 9-3

This is even more effective if the line begins at or near the edge of the picture.

PLATE 9-47

Contrast
the exploitation of dissimilarity

Contrast has much more extensive significance than the narrow one most photographers attribute to it. They regard contrast as only the degree of difference between darks and lights, as derived through the use of properly related paper grade and negative density.

In composition, contrast refers to the effective exploitation of any kind of dissimilarity. Differences in size, shape, direction, texture, and many aspects of content are as much a part of the application of contrast as light and dark.

Contrast, through dissimilarity, is the most effective means of directing attention to the principal part of the subject and making that part dominate as the center of interest over all the other parts. As we have seen in the previous chapter, it functions along with position to attract the viewer's eye directly to the core of the idea we wish to express. Other principles of composition either guide the viewer around to the remaining features or hold the picture together.

Pictures that lack the various types of contrast are dull and monotonous. In fact, the solution to the problem of those pictures that appear "muddy" or uninteresting is to emphasize contrast in as many manifestations as possible. The old, dependable remedy of bringing sparkle to a flat picture by making the lights lighter and the darks darker is a specific application of contrast.

Contrast is closely allied with change—any change that results in a meaningful difference. Since most art is derived from the source of nature, and nature is always in the process of change, it is difficult to avoid experiencing change and recording it in photography. The changes in nature, however, are so diverse, so profuse, and so confusing in their simultaneity that the artist, as director, must find ways to cast subordinate elements into roles that support the central thought. There-

after, the viewer will have no difficulty recognizing the selected center of interest as outstanding.

In order to achieve contrast, the change must be clear and conspicuous. Under certain conditions, especially in an environment of similar elements, even slight changes may result in effective contrast.

It's difficult to avoid noticing the replaced window sections in both the upper and lower windows of Plate 10-1.

PLATE 10-1

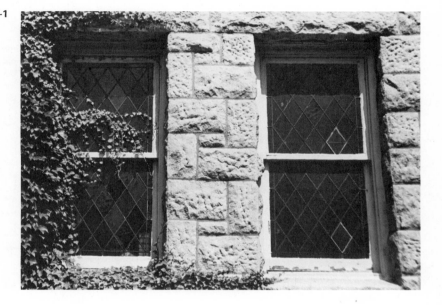

Most often the change must be in direct opposition to the surrounding elements; otherwise the only visible difference will be an ineffectual variation.

The following diagram has been designed specifically as a device to demonstrate the need for contrast and the dramatic change that results from its application. All the squares are the same and are arranged in precise, orderly rows. The absolute similarity and order generates monotony.

Figure 10-1

In a situation like this, we may select any square to be made dominant. Suppose we choose the one in the third row from the left and the second from the top.

CONTRAST OF SIZE

For many, the first change procedure that comes to mind in the emphasis of this square is to make it larger. This will automatically result in contrast of size.

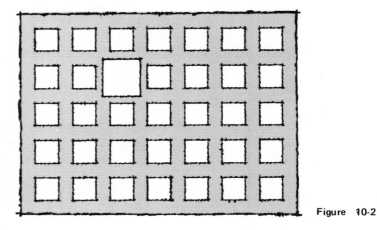

Figure 10-2

There can be doubt about the greater attraction value given to the larger square. More has been changed to increase pull on the attention than is readily apparent. The all-important, ever-present matter of negative space has changed all around the enlarged square. Where previously uninterrupted, even rows of negative space existed, the enlarged square has presented an obstacle to continuous movement. Jutting out, it interferes with the evenness of the rows of squares. All of these, separately and together, contribute to creating a dissimilarity that forces primary attention to the changed area and insists that attention keep returning to it over and over again.

In general, therefore, we may state that one way to achieve contrast in a composition is to show it larger than all other objects.

PLATE 10-2

PLATE 10-3

The object does not necessarily have to be physically larger than the others. In fact, it may even be considerably smaller. Bringing it closer to the camera and placing the others farther away permits perspective to operate in favor of the selected object and to make it appear larger in the image.

PLATE 10-4

The boy in the picture is four feet tall; the man is six feet.

Size alone does not guarantee dominance. Placement as well as other factors yet to be discussed have a way of nullifying the emphasis achieved by size.

In Plate 10-5, the large figure of the boy, placed in the center, is unquestionably the dominant element. In another cropping from the same negative, Plate 10-6, wherein the boy's figure is shifted to the left border, it becomes part of the frame and surrenders its dominance to the smaller figure, which now occupies the center.

One needs to experiment with the combination of size, placement, negative space, and other factors in order to arrive at the most satisfactory arrangement. This attitude of self-inquiry will lead to intuitive judgments far more meaningful than mathematical rules or psychological precepts.

PLATE 10-5

PLATE 10-6

Shift the large figure, adjust the size of projection, and be aware of the influence of negative space, until you succeed in obtaining the visual statement that expresses your intention most forcefully.

Now, returning to our basic pattern, we'll experiment with the effect achieved by making the principal square smaller.

Figure 10-3

Notice how attention is drawn immediately to the small square. The reasons for the strong attraction are much the same as those for the larger square. Now it is the negative space around the small square that is larger than the others; the regularity of the rows has been interrupted, and an element of dissimilarity of figure has been introduced.

We may conclude, therefore, that in any composition where regularity of size prevails, the single element which breaks the uniformity is the one which will attract the greatest attention. A small child set against a background of adults has as strong a potential for attraction through dissimilarity as an adult set against a background of small children.

PLATE 10-7

Even more generally it may be stated that a small form isolated against several large forms can emerge as a dominant.

PLATE 10-8

CONTRAST OF LIGHT AND DARK

Another way of achieving contrast is to make the principal object darker.

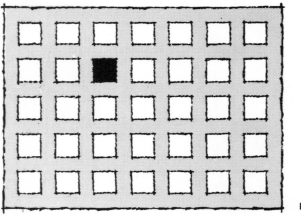

Figure 10-4

The dissimilarity created by contrast of dark against light is a powerfully attractive force. Combining contrast of size and contrast of dark and light intensifies the attraction considerably.

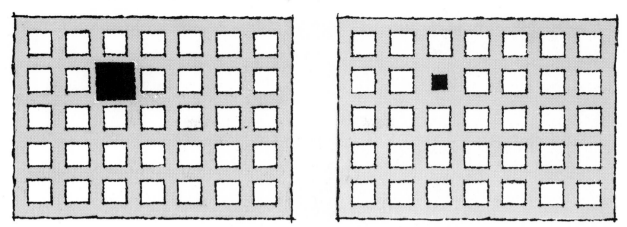

Figure 10-5

Conversely, dissimilarity can be achieved by leaving the principal square light and making the others dark.

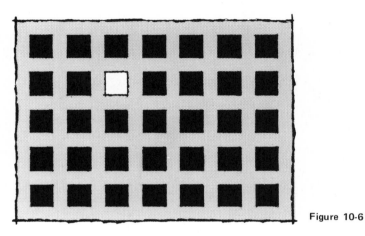

Figure 10-6

In actual photographs, the greatest contrast is effected when the principal object is a strong dark and is surrounded by the lightest light, and vice versa.

PLATE 10-9

PLATE 10-10

PLATE 10-11

There may be times when extreme contrast is too obvious and, therefore, undesirable. When a more subtle effect is desired, the principal object may be placed against an intermediate tone rather than its extreme opposite.

We may use light against middle tone,

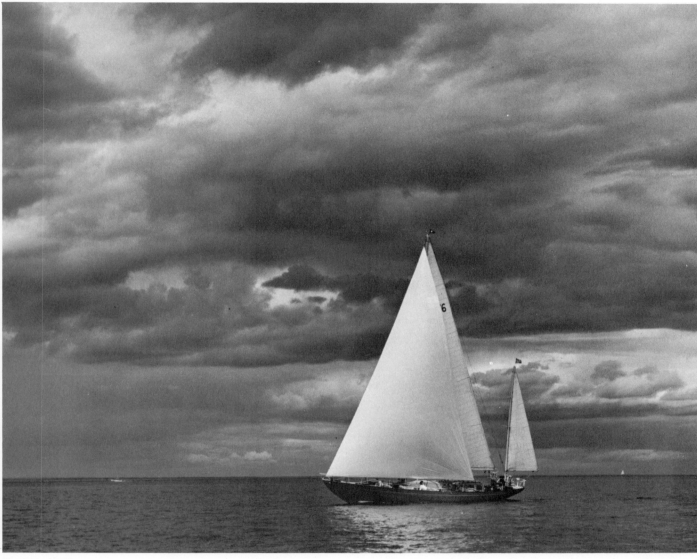

PLATE 10-12

middle tone against light,

PLATE 10-13

dark against middle tone,

PLATE 10-14

middle tone against dark,

PLATE 10-15

or a combination of dark and light against middle tone.

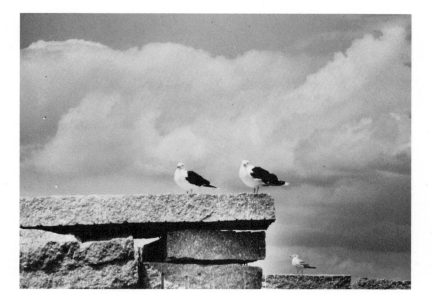

PLATE 10-16

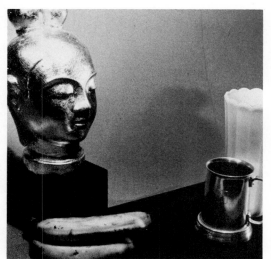

Be sure, however, that sufficient additional factors of contrast operate in favor of the principal object so that the dominance is not stolen from your intended expression. All other elements in the subject must be subordinated in size and tone.

Note, again and again, the interdependence of all the principles. Even with the combination of contrast of size and light and dark, poor placement can cancel out the intended effectiveness.

PLATE 10-17

CONTRAST OF SHAPE

Maintaining similarity of size and light and dark, one may still achieve contrast by changing the shape. In Figure 10-7, the circle projects itself out of the surrounding pattern of squares. In Figure 10-8, the square makes an equally strong appeal for attraction in the environment of circles.

Figure 10-7

Figure 10-8

The circular emblem in Plate 10-18 stands out boldly against its background mainly because of contrast of shape. This is strongly supported by such factors as contrast of size, placement, and the uniqueness of both design and lettering. The tonal value throughout the entire picture is moderately consistent.

PLATE 10-18

In addition to the contrast of shape developed by the irregularly shaped figure against the geometric background, dominance of the figure in Plate 10-19 is unchallenged because of the added attraction of size, light and dark, and directional contrasts, as well as the placement of the figure near the center.

PLATE 10-19

CONTRAST OF DIRECTION

Dissimilarity that results from a change in direction is a powerfully attractive force. .

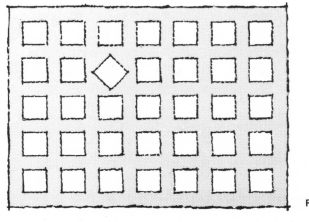

Figure 10-9

We cannot avoid fixing our attention on the intended center of interest; yet the only thing done was to rotate the square slightly around its center. No change of size, shape, or dark and light is needed to support the attraction.

Merely to prove that the attraction is due to dissimilarity rather than to any special force implicit in an angular form, note that the converse of the previous figure still permits the selected center of interest to assert its dominance.

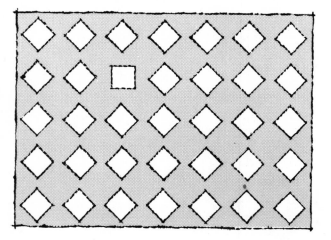

Figure 10-10

As in the previous types of contrast, a number of forces combine with directional change to bring emphasis to the center of interest square: interruption of both figure and row regularity and a significant change in the shape of the negative space around the square.

Even more powerful than directional change of shape is the contrast that results from change in linear direction.

Figure 10-11

The single line in the field in Figure 10-11 is selected to become the center of interest. It is placed near the center of the field and if there were no other directional factors in the composition, its dominance would go unchallenged.

Let us suppose, however, that this is only one of a number of poles that have been set upon a support and consequently they are seen in the viewer as sloping in the same direction.

Figure 10-12

Notice how the additional lines have nullified the dominance of the original line so that there is no longer a center of interest.

If, however, the added lines were sloping in the opposite direction, an entirely different result would be obtained.

Figure 10-13

Although more lines have been added than appear in Figure 10-12, the original line retains its strength as center of interest and dominance. Continuing this procedure, it is almost impossible to overcome the power of its presence, no matter how many lines are added, even to the point of near obliteration.

Figure 10-14

The lines of opposition do not necessarily have to be completely opposite the center of interest. As long as there is sufficient change in direction, the central feature will emerge as the dominant element.

Figure 10-15

We tend to think in terms of things rather than people when the matter of direction is involved. There are, however, strong compositional and emotional responses related to the angle of inclination in which the head, the body, and all its parts are shown in relation to each other and to their surroundings. Haven't we all, at some time, relaxed the rigidity of a portrait subject by suggesting even a slight tilt of the head?

Standing does not necessarily mean verticality; one may bend or lean forward, backward, or to either side. One does not have to be a professional psychologist to relate angular and curvilinear directions of sitting postures with personality and

mood expression. Lying down, walking, running, working, playing, relaxing—all have directional characteristics to which the photographer must be sensitive for both idea expression and compositional stimulation.

PLATE 10-20

PLATE 10-21

PLATE 10-22

CONTRAST OF MOOD

Contrast of direction contributes more than just the establishment of dominance, as the linear diagrams indicate. It is an important ingredient in achieving the mood of strong action, excitement, competition, and resistance, as well as relaxing calm.

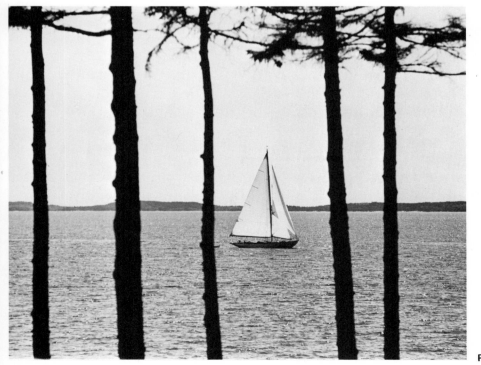

PLATE 10-23

Great pictures impart a sense of mood that develops from the presence of lines, shapes, and tones interacting in a way that expresses the photographer's feelings at the time the pictorial essence in his subject was revealed to him. Expressions of stateliness, dignity, conflict, triumph, fear, calm, reflection, and tranquility require more than the inclusion of topical material that relates to these moods. The selection and arrangement of elements and principles that are appropriate to the mood are as much a factor in the expression as the selection of content.

Except for the center of interest, the boat, the directional contrast of Plate 10-23 is primarily a formalized horizontal-vertical arrangement. Compare the resultant tranquility with the excitement of Plate 10-24. There, the angular contrasts, not only in the center of interest but also in the subordinate boats and water, generate forceful movement.

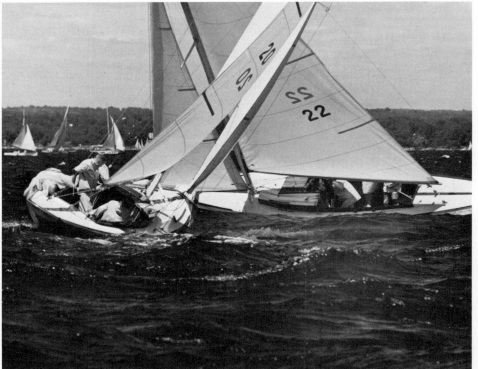

PLATE 10-24

If it were your intention to portray a monumental building as stately, elegant, and dignified, your composition would include elements of landscape, background, foreground, and even sky and lighting that could support these characteristics.

Then the total picture would express the mood you sought. Stately trees, sharp definition of forms, formalities of landscape, and horizontal clouds could contribute the types of shapes, lines, volumes, and textures in harmonies and contrasts that support this mood. If, on the other hand, your purpose was to express displeasure or contempt for the intended monumentality, the elements of landscape and sky you should select would be less majestic. The background might include unfavorable ecological objects and the foreground might show litter, disorder, and misfortune. Instead of clean contrasts of verticals and horizontals, which express strength and stability, irregular contrasts of angular lines and awkward shapes would be emphasized.

While such statements about the interaction of elements and principles may prove to be accurate in most instances, there can be no assurance that they will always function according to plan. There is a very thin line that separates a mood or an action from its very opposite. Facial expressions of great hilarity and deep grief are so close that pictures of one may sometimes be mistaken for the other. Often photographs are intended to show a person opening a door, only to find in the print the appearance of a person closing the door. In the example of the picture of a monumental building, the elements suggested to degrade its importance may function contrarily. They may serve to show the building as an oasis of order and dignity in an environment of neglect and indifference.

CONTRAST OF TEXTURE

An aspect of dissimilarity that is frequently overlooked is contrast of texture. Even within an area that is thoroughly consistent in tone, one may discover a sufficiently diverse texture to concentrate upon and to emphasize for perceptual or esthetic effectiveness.

As the law of simultaneous contrast demonstrates that the greatest brilliance of one color is obtained through juxtaposition with its complement, so does the sensation of one texture attain its greatest effectiveness by being surrounded with its opposite—a craggy face against a silken scarf, stones and pebbles against a quiet lake, a fuzzy caterpillar against a smooth leaf, and shining metal against velvet. Beautiful, superpolished marble is seen frequently to better advantage on a rough base.

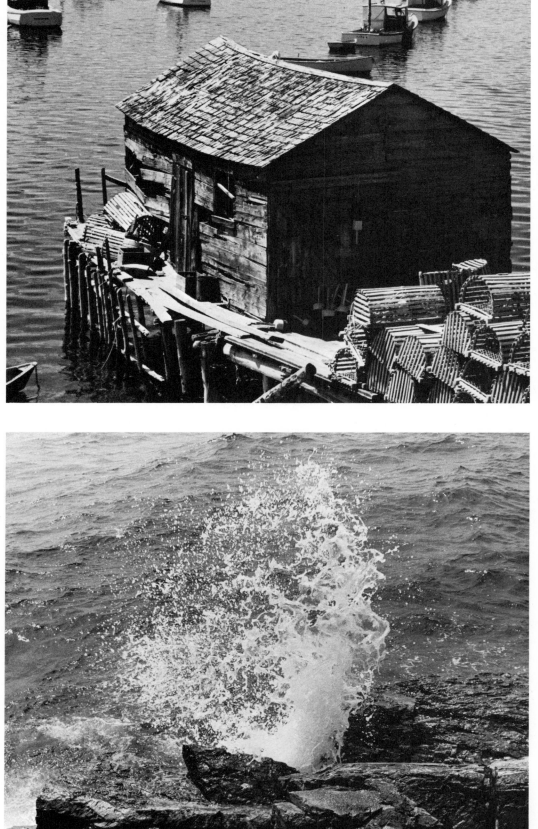

PLATE 10-25

PLATE 10-26

CONTRAST IN THOUGHT AND CONTENT

The examples of contrast we have provided are the ones most frequently used: size, shape, light and dark, direction, and texture. One of the most effective contrasts, color, has not been touched upon because this book is concerned with composition in black and white only. The whole study of color, of which contrast is only a part, is extensive and fascinating within itself.

Contrast, however, is an attitude that needs to be present in a photographer's mind constantly. It is not merely a device for attracting attention but rather a fundamental law of nature that cannot be ignored in art; it is the most compelling means of representing energy, vitality, and tension.

When photographers have an opportunity to use a conscious and deliberate control of the resources of composition, too often they strive for desired harmony by using similarities. Much similarity of anything produces monotony—dullness. Harmony can be produced with equal effect through the balance that arises from opposites—black and white, thrust and counterthrust, active and passive.

Like antithesis in writing, some ideas are made clearer and more dramatic by emphasizing important differences of objects, attitudes, and activities. These differences need to be shown as extreme opposites so that the photographer's conviction is grasped quickly.

It's worth the time and effort to think about and even to list some of the numerous contrasts that may be useful in photographic practice. Here are a few to start:

suffering—pleasure	fluid—rigid
crude—refined	grouped—isolated
natural—artificial	primitive—sophisticated
fragmentary—complete	similarity—difference
superiority—inferiority	whole—part
order—disorder	beginning—end
transient—durable	permanent—changing
cause—effect	strength—impotence
interior—exterior	forward—backward
tough—brittle	good—bad

Plate 10-27 is concerned with just such an idea contrast, the transportation of pleasure boats for summer sailing during a winter snowstorm.

PLATE 10-27

Contrast of content is one of many important organizing devices in idea composition. Unlike contrast of size, shape, tone, direction, and texture, it is not an absolute requirement for every picture. Many other alternatives are available for interpretation of the subject. Which one to use of the several depends on the subject, the photographer's point of view, and the viewers for whom the picture may be intended.

Rhythm
pattern and pace

Even though each of us has a different idea of what constitutes organization, we share a natural craving for its outcome—orderliness. A substantial part of our lifetime is spent in arranging our immediate environment, tools, and activities. We do this not only to function more effectively but also for the satisfaction that comes from a systematized, structured pattern of living.

Outside our immediate environment, we derive pleasure from activities and surroundings that are well organized, either by nature or man. An overgrown thicket or a dense forest has little appeal, except for the challenge it holds for a naturalist. But we are all delighted with the magnificent arrangement of an undulating meadow surrounded by verdant hills that merge into rolling mountains. We are equally pleased by the patterns of a contoured farm, an interesting park, or a well-planned town.

Uncertainty results when we have little or no control over some part of our life experiences. It is a concern that most people find unpleasant and try to avoid. They take pains, therefore, to find the satisfaction of a more certain and orderly outcome in the parts of their lives that they can control. Feeling this psychological need for himself and for others, the artist aims to project into his work the sense of order and harmony that can provide this satisfaction.

In the presence of natural or man-made disorganization, a less sensitive person merely registers inward displeasure and moves onward. He has neither the capacity nor the inclination to explore a jumbled mass, especially when the possibility exists that elsewhere he may find ready-made order to fulfill his psychological need.

The artist, on the other hand, is challenged to stop and seek some measure of harmonic order within the disorder. He sees in such confusion a reflection of a part of life that may be embarrassing, unpleasant, or even shameful. Quite apart from social comment, he may discover neglected beauty. Looking for a point of view that varies from the accepted one, the artist will avoid the typical orderliness that attracts the layman. It has already become cliché.

Confronted with a conglomeration of objects and forms, each different in shape, color, and texture, the artist's mind is constantly inquiring and perpetually striving to sort harmonious elements out of the chaos. This is the beauty that exists in ugliness—a sense of organization where it is least likely to be found, especially when there is no inherent beauty in the subject, or object, itself.

This is also the essense of pictorial composition, an organization of all the parts, so that the object, element, or idea selected to be noticed is successfully expressed. Supplementary elements or objects are present in the picture, but their importance is subordinated.

In the previous chapter, we have demonstrated how order is obtained through an effective use of dissimilarity. Opposing elements, with their definiteness of difference, emphasize elements that might otherwise be lost. Thus it becomes easier to perceive what is intended to be seen. Through controlled opposition, a balanced, stabilized unity of conflicting elements is created. Verticality has its greatest meaning when conceived in relation to horizonality; the concept of dark is understood only in relation to light; large implies a sense of size only with respect to a specific small.

The number of elements in the subject that are set in opposition, as well as the degree of opposition of each, determines the strength of emphasis obtained. It is possible to include so much opposition in every part of the picture that utter chaos may result. If the subject lends itself to chaotic interpretation, and chaos is the mood the photographer intends to express, then dissimilarity and opposition should be exploited to the fullest extreme.

HARMONY THROUGH SIMILARITY

Having just pointed up the need for dissimilarity, it may appear contradictory to state that equally effective harmony may be accomplished through organized similarity. Here objects and elements with similar properties are identified and coordinated.

There is really no conflict between the two because the photographer must discover and exploit, for the greatest esthetic advantage, whatever appears to him as the essential visual quality in his subject. The solution to an esthetic photographic problem depends on what is available in the subject, what the photographer identifies as personally meaningful, and what the personal means are that he selects to achieve his intention.

The chaos that confronts one in a heterogeneous mass may be similar to the effect achieved in the following figure of aggregates that contains many elements, too similar in size and shape to permit the selection of a single dominant.

Figure 11-1

Since the subject offers no perceptible resources to establish an effective contrast, the inquiring eye of the artist strains to find elements of common qualities within the jumble. These may be combined in a way that sets them apart from the others. They may be similar in size, shape, direction, tone, or texture.

Let us suppose that the most significant elements to satisfy this condition are the circular forms. They are approximately the same in size and shape and are sufficiently different from all the others to be worth exploring for the possibility of a more meaningful relationship. This procedure differs from that of the previous chapter in that we shall not isolate a single unit for emphasis but rather bring attention to a unified group.

Either through negative control with filters or through print control, or perhaps a combination of both, it is possible to lighten the circles to a similar tone and at the same time to darken the remainder of the figures in the field.

Figure 11-2

A striking similarity relationship is now revealed with qualities that appear to be worthy of more intensive study. The figures are similar, the intervals between them are apparently equidistant, and a sense of organization is evident. Even though they do not physically connect, there exists an impression of wave movement as we perceive the entire set of figures against what has now become the background.

As the listener in music becomes aware of a beat that can be anticipated, so can a viewer recognize the appearance and anticipate the reappearance of a unit in a set of similar elements. A feeling of planned movement along the rhythm organization leads the viewer along the picture surface, gratifies the visual experience, and holds the attention.

This repetitive succession of circles and intervals pulls a semblance of order out of the disorder that formerly existed and contributes a greater feeling of satisfaction. Because it is a visual representation of the beat of music and poetry, it is called *rhythm*.

RHYTHM

As artists, we cannot avoid being affected by the natural forces of which rhythm is a part. The regular movements of day and night, the sequence of the seasons, waves breaking on the shore, the beating heart—each has its own tempo to which we are so completely attuned that any deviation would constitute crisis. The rhythm of daily life in relation to the changes of time zones is so vital that travelers by jet plane to distant places require several days of physical adjustment before their constitutions can adapt to the change.

Every aspect of our work and play is either based upon or conditioned by rhythm. It even reaches out as a controlling force in the interrelationship of universal bodies. Light, heat, sound, and magnetism all are variants of rhythm in which the slightest change produces significant differences. The periodic sequence of waking and sleeping is basic to well being.

Rhythm is a systematizing process, setting a pattern and pace that is dependable. Having established a specified rhythm, we anticipate its continuation and are pleased when it is maintained.

Because of its persistent pattern of accents and intervals, rhythm is ideal for stimulating and expressing emotions. Except for actual emotional content, it can be the most influential part of art that relates to the sensation and

perception of emotional feeling. Rhythm has the capacity to kindle and nourish the imagination.

A sense of rhythm is inherent in most people. From the back view, watch the walk of a well-coordinated person, and notice how rhythm is maintained. This is evident not only in the sound of heels striking pavement but also in the swing of the arms, contrasting and alternating tilt of shoulders and hips, and the flexing movements of the spinal column. There is a characteristic walking rhythm for each age of life. In early youth, differences begin to show between girls and boys, growing more decidedly different as maturity is attained. Within each age and sex group, the individual develops and expresses a personal walking rhythm.

Every human activity is allied to a rhythmic pattern. Watch a carpenter sawing wood, a rower in a boat, and a competent swimmer, and observe how the regulated beat and pause makes efficiency easy. Tempo provides pleasure in both the doing and observing. We can't help being caught up in the beat with sympathetic vibrations.

Just as a person who lacks rhythm appears ludicrous when dancing, so does a picture that contains all the ingredients for a rhythmic experience and fails to make it work. One receives the impression of a disagreeable jerkiness. The swing that should be apparent in the relationship of line, shape, and tone to the whole of the picture never becomes established.

It is unlikely that we may find rhythms in which either the units or intervals are exactly alike; nor is it desirable to seek exact repetition. Subtle variety and modulation prevent a mechanical appearance and add interest to the formation.

VISUAL PLEASURES OF RHYTHM

Pictures do not necessarily have to have meaning. Their basic purpose beyond function is to provide visual pleasure from being seen. While visual experience is completely individual, depending on what takes place inside one's self, most experience is accompanied by some emotional reaction. There is always a feeling, favorable or unfavorable, that is part of the experience.

More than any other principle that affects composition, rhythm accounts for visual pleasure. Its presence is so vitalizing that even in the dullest subjects the discovery and recording of an aspect of rhythm can result in a picture that stimulates an impressive experience.

RHYTHM THROUGH REPETITION

The simplest form of rhythm is established through the regular recurrence of any unit of elements with the same interval, in accordance with some definite scheme or pattern. In place of the circles used in Figure 11-2, one may use any shape.

Figure 11-3

The formation does not necessarily have to follow a flowing path.

It may be along a horizontal,

Figure 11-4

a vertical,

Figure 11-5

a diagonal,

Figure 11-6

or an arc.

Figure 11-7

The use of two units permits only one interval.

Figure 11-8

Since the unit has been repeated but the interval has not, the rhythm has not been established. It is necessary to have at least three units represented so that the interval may be repeated at least once.

Figure 11-9

Any unit of content or design elements may be used. The repetition of shape, line, tone, or texture with a recurrent interval can constitute a rhythm.

Figure 11-10

Among the obvious representations of rhythm through repetition are picket fences or a row of columns, arcades, or windows in a building. In some instances, the unit and interval are so accurate as to manifest a mechanical coldness. The slight differences of unit and interval in a picket fence may be more interesting to look at than the seemingly absolute measure of architectural column and interval.

PLATE 11-1

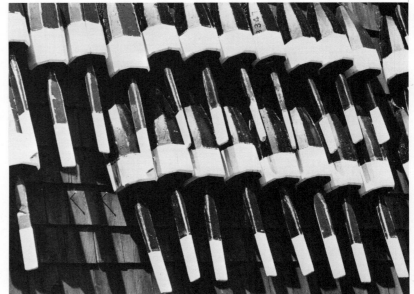

PLATE 11-2

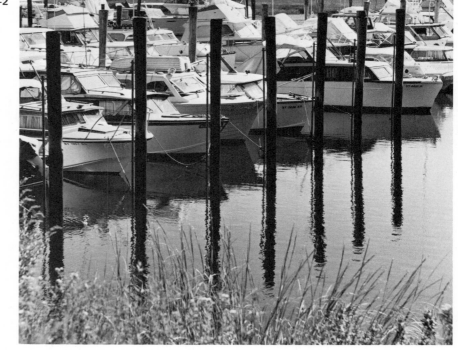

PLATE 11-3

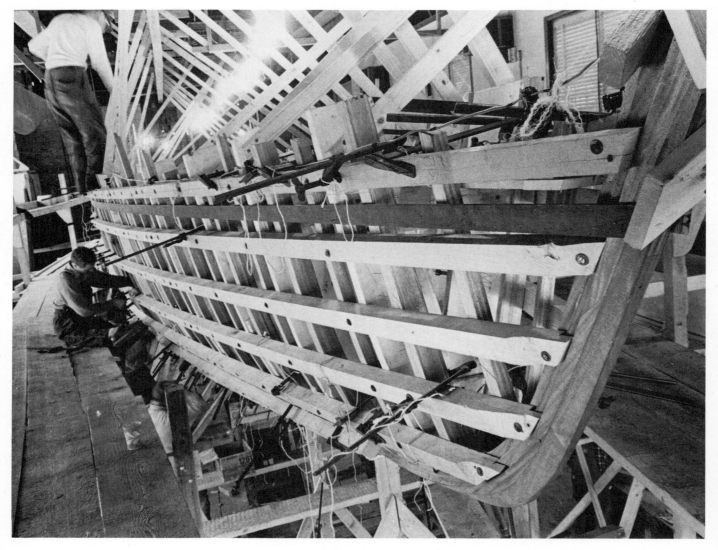

This is true also of the photograph of lobster buoys, neatly hung outside the lobsterman's shack. The units and intervals are sufficiently similar to set up a definite repetitive rhythm. Slight differences, particularly in the intervals, add the warmth of human involvement to the arrangement. The gentle movement upward or downward of each individual buoy, particularly in the upper row, creates a stripe of rippling movement along the white forms that is echoed in moderate variation by the white bases. The open space caused by the missing buoy serves to explain how the buoys are hung for storage and, more importantly, relieves the composition of dulling sameness.

In the photograph of the harbor, repetition of the boats reinforces the rhythm obtained through repetition of the vertical piles.

Just as an overabundance of dissimilarity induces chaos, an overabundance of similarity may lack interest and produce monotony. No matter how many forms of rhythmic sets the eye can discern in a picture composed exclusively of a compact lawn, a dense field of flowers, or a large brick wall, overwhelming similarity cancels out organization. Unity and harmony have been established to such a marked degree that pictorial effectiveness is minimized.

Such a sight may be beautiful in nature because the eye is not fixed on it for any considerable length of time. The viewer's attention roves to other features in the landscape for relief. The image that is impressed in the mind is not the one that may be on the picture but a combination of the lawn, or field, or brick wall, with adjacent features superimposed.

Photographers have to be wary of the psychological tricks the mind exerts on our senses. It takes a long time and much experience to realize that what we accept as fact in seeing is actually a combination of many responses. One is the above mentioned impression of adjacent forms superimposed on the selected area to be photographed. Another is the feeling that, because the eye can focus on a single element or on an organized combination, and mentally eliminate unwanted details, the camera lens will do the same. Still another occurs when similar parts of the subject are judged too hastily as being absolutely repetitious, thus ignoring variations that may yield unique results. The reduced scale of the photograph and the limitations of its frame are potent influences in the difference between subject and picture.

We need to repeat again that there are no absolutes in art! While one may expect that complete similarity will yield monotony in most situations, it is not always so. There can be instances where an image that is put together with all the ingredients of monotony is perceived by an artist to express a unique attractive texture.

PLATE 11-4

INTERVAL REPETITION

Interval plays a more important role in rhythm than may be generally believed. In fact, it is the functioning of the interval as much as the unit that makes the rhythm work. If the unit is repeated regularly and the interval is not, there will be no rhythm.

Figure 11-11

Whenever this happens, the mind seeks to find some ordered relationship within the system of intervals. If it is not found in direct repetition, then perhaps it exists in a more complex set. For example, in Figure 11-12, the units are repeated simply but the intervals alternate.

Figure 11-12

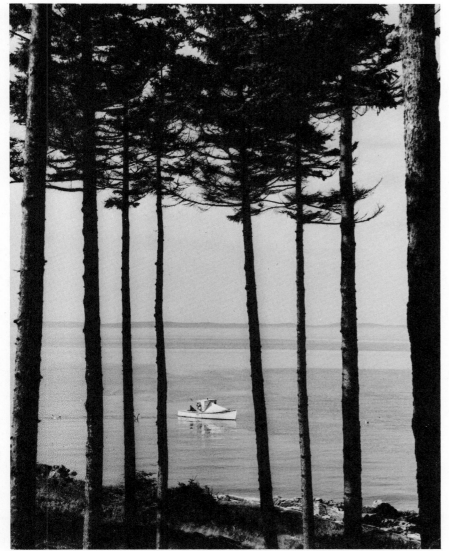

PLATE 11-5

Another variation might be a progressive increase in the width of the intervals.

Figure 11-13

COMPLEX SETS

The unit of repetition need not necessarily consist of only one shape or line. A grouping or set of a number of elements that relate in some way may serve as the unit to be repeated.

Figure 11-14

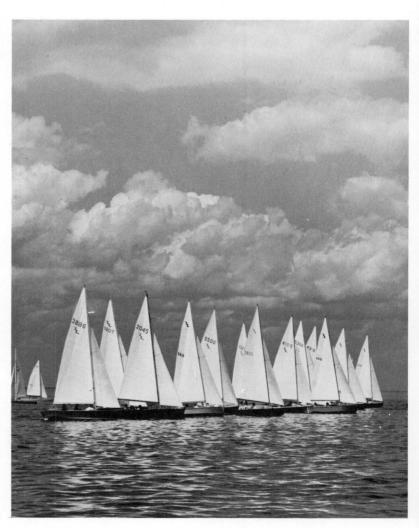

PLATE 11-6

The mainsails, jibs, masts, and hulls of each of the racing yachts in Plate 11-6 constitute a compound set that is repeated with similar intervals. Seen as a complex unit or as a series of individual parts, there are many aspects of rhythm to hold the attention in this photograph.

Look about your environment and take note of the examples of rhythm through repetition that are so much a part of your daily life. Wallpapers; printed and woven fabrics in upholstery, draperies, wearing apparel, and patterned rugs; grillwork designs in radiators, television, and air conditioners; carved moldings; and rows of books—the list could be considerable.

It is interesting to reflect on the fundamental truth that the higher levels of any study bring us closer to nature for insight and information. Everything we discover about order and organization in art has long had its counterpart in natural law.

When we look below the surface into the structure of the plant and animal world, we find that most are constituted of basic modular units that differ for each species in both form and special scheme of repetition. No two are exactly alike; the variety goes on infinitely. Examine such things as seedpods, pinecones, flowers, cross sections of various parts of plants, seashells, starfish, insects, honeycombs.

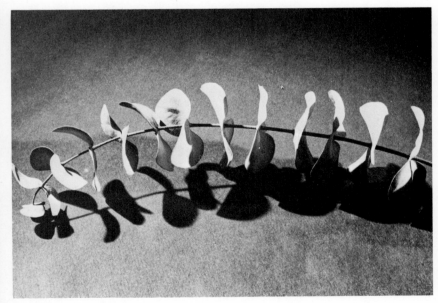

PLATE 11-8

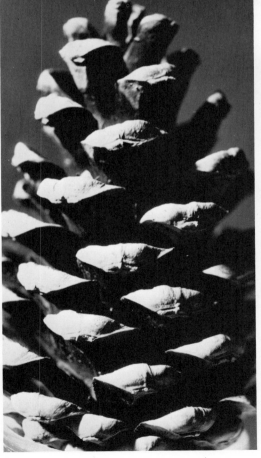

PLATE 11-7

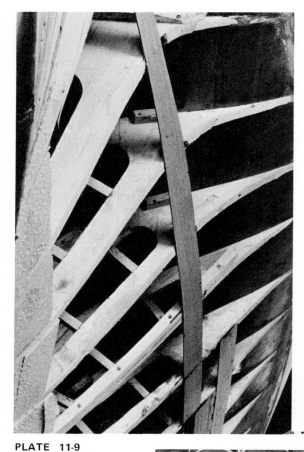

Photographers have to become increasingly sensitive to the mysteries of nature and to the correlated order that lies hidden below the surface. Having established personal contact with some of the rhythms of life, their imaginations can be unleashed to discover an abundance of similar order in the limitless objects and activities that appear as chaos to nonartists.

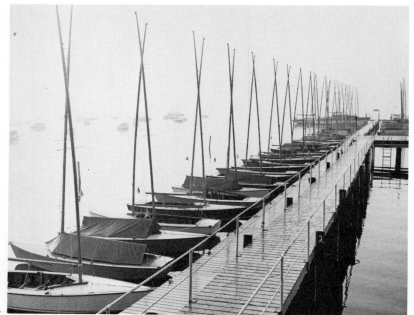

PLATE 11-9

PLATE 11-10

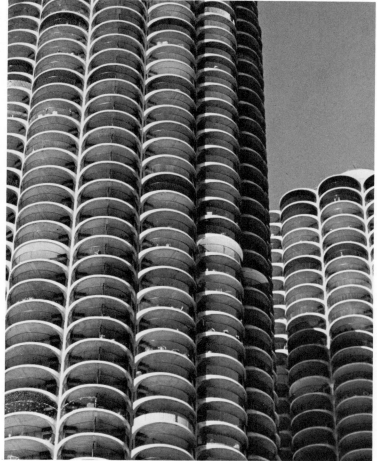

PLATE 11-11

Repetition is the simplest form of rhythm in the visual arts as it is in music. Since the value of an artwork is in no way related to its complexity, the use of a simple or obvious rhythm does not automatically classify the work as elementary. Suitability and effectiveness are the ultimate criteria.

RHYTHM THROUGH ALTERNATION

Alternation introduces variety into the beat. The variety may consist of a change of shape, line, direction, position, tone, or texture. The change helps to relieve monotony because of the slight modification of emphasis.

In one form of alternation, two separate units are involved, each making its appearance alternately.

This may be of different shape but the same size,

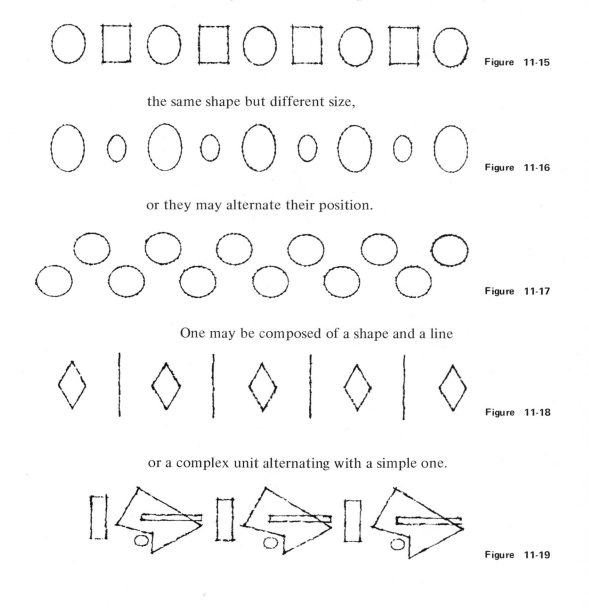

Figure 11-15

the same shape but different size,

Figure 11-16

or they may alternate their position.

Figure 11-17

One may be composed of a shape and a line

Figure 11-18

or a complex unit alternating with a simple one.

Figure 11-19

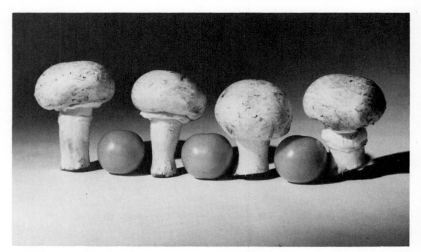

PLATE 11-12

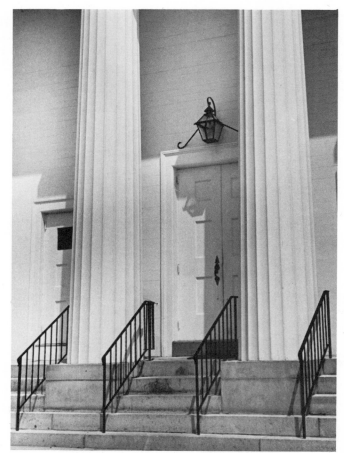

PLATE 11-13

One could go on forever discovering and inventing variations of these rhythms, especially when we have the opportunity to relate sound rhythm to the visual rhythm of the subject. The possibilities for such relationships can occasionally be found in subjects that deal with music, dance, or industrial machinery. Whenever one is lucky enough to come upon a composition that expresses both rhythms, the chances are strongly in favor of producing an exceptional picture.

In a sense, alternation is merely another form of repetition because the two alternating units with their common interval may be considered as the complex unit of the set.

RHYTHM THROUGH PROGRESSION

A more distinctive variation of rhythm develops in a consistent progression, where units increase or diminish in size, shape, tone, direction, or even idea. Progression relates to crescendo and diminuendo in music. It is a dynamic device that builds attention through

size,

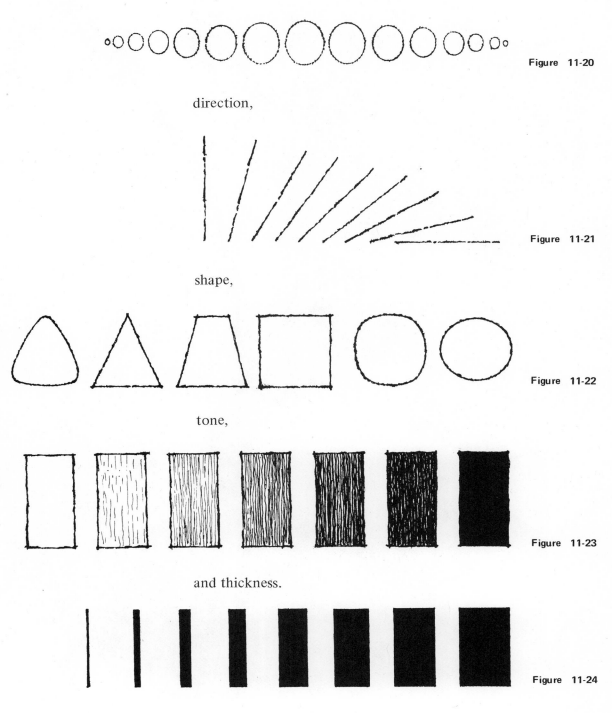

Figure 11-20

direction,

Figure 11-21

shape,

Figure 11-22

tone,

Figure 11-23

and thickness.

Figure 11-24

203

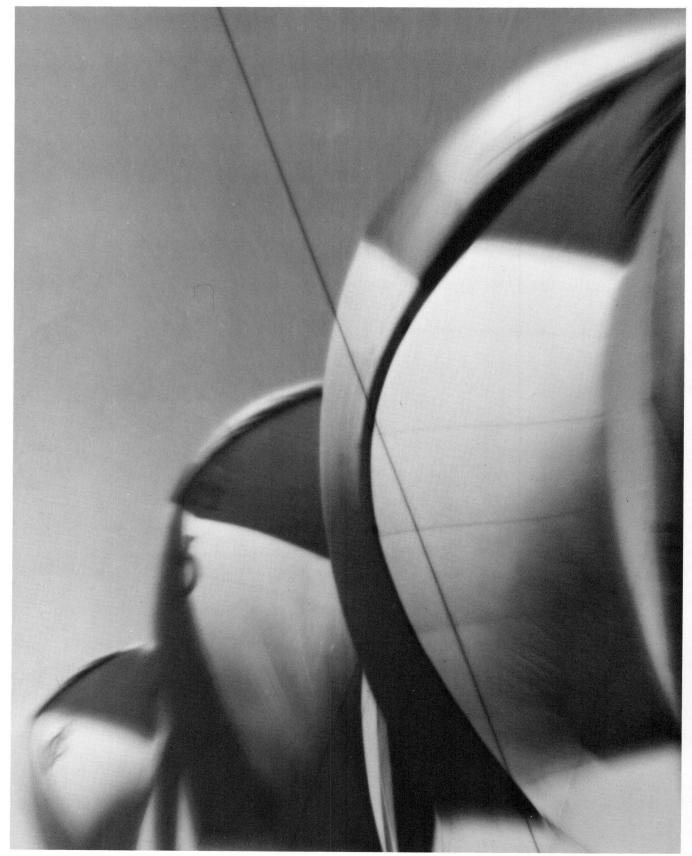

PLATE 11-14

PLATE 11-15

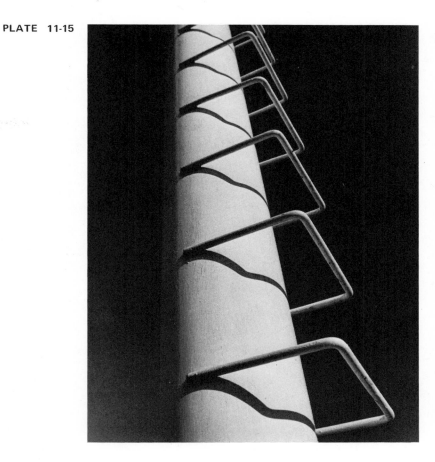

PLATE 11-16

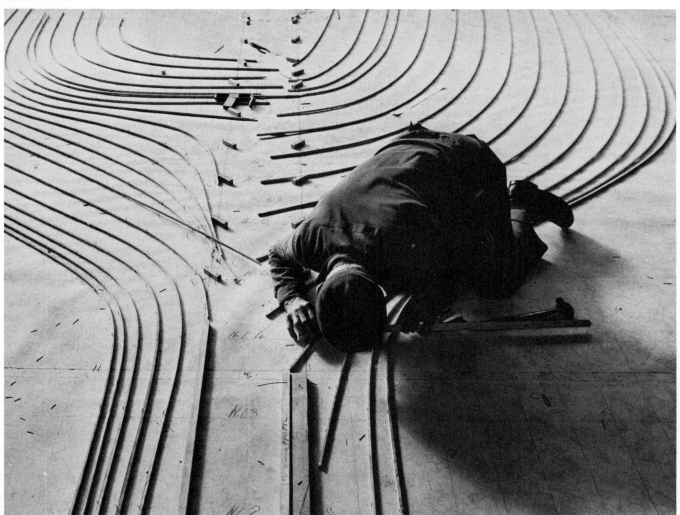

RHYTHM THROUGH RADIATION FROM A POINT

Examine this photograph of a city street.

PLATE 11-17

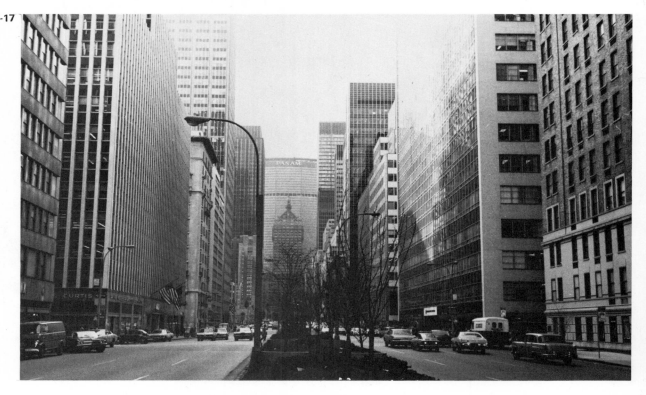

It was taken so that the vanishing point of the perspective system is situated close to the center of the picture.

Notice how practically all the lines except the verticals radiate from the vanishing point, which is located in the Grand Central Terminal in front of the Pan Am Building in the city of New York, making the Terminal the center of interest. No matter what part of the picture your attention is focused on, it is led back to this center point.

This, of itself, doesn't make the picture interesting; it merely demonstrates the power of the point from which the lines radiate and the rhythmic organization of the radiating lines throughout the picture.

An obvious example of this form of rhythm can be found in the rays of the sun when it rises or sets or in the spokes of a wheel,

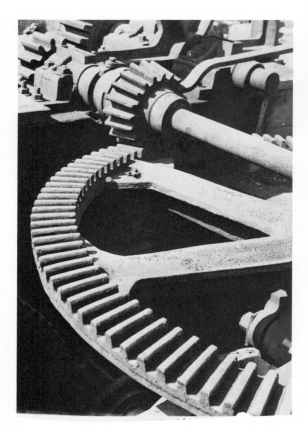

PLATE 11-18

in many types of flowers, a spider's web,

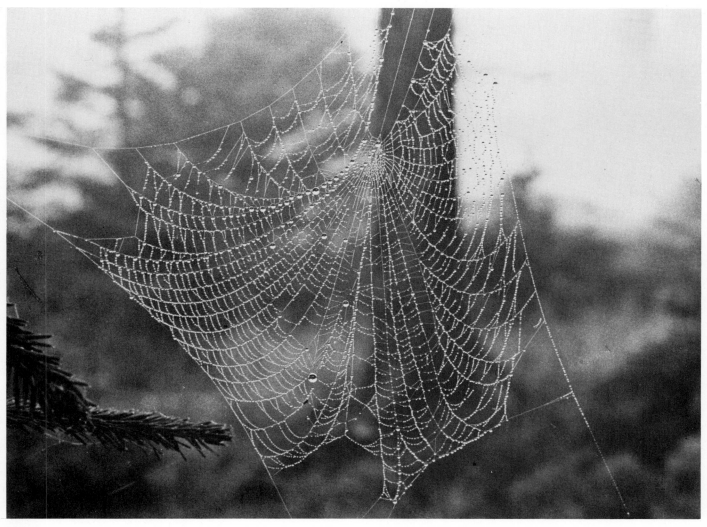

PLATE 11-19

or a seashell.

PLATE 11-20

Plate 11-21 demonstrates the sensation of radiation from a point, achieved through dark and light rather than through linear means. This was produced in the printing process from a conventional negative.

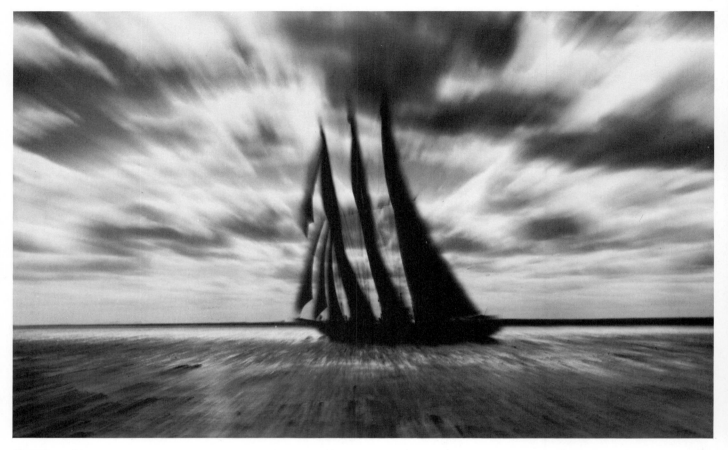

PLATE 11-21

RADIATION FROM A CENTRAL AXIS

Nature produces many varieties of radiation from a central axis.

Figure 11-25

The radiation may be repetitive as in Figure 11-25, which can be found in some types of plants,

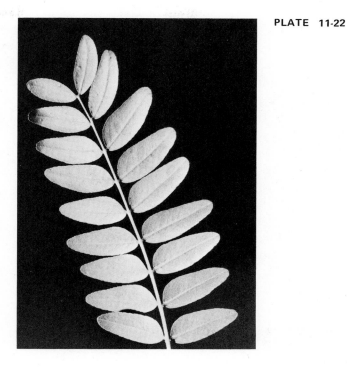

PLATE 11-22

or it may be alternating in position.

PLATE 11-23

Frequently, as in tree structures, radiation from a central axis is accompanied by alternation and progression.

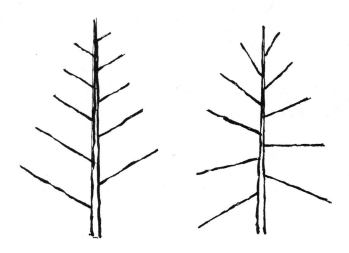

Figure 11-26

Central axis organization has the kind of strength that may be likened to a strong family tie. Elements venture away from the axial base without releasing their hold on the home.

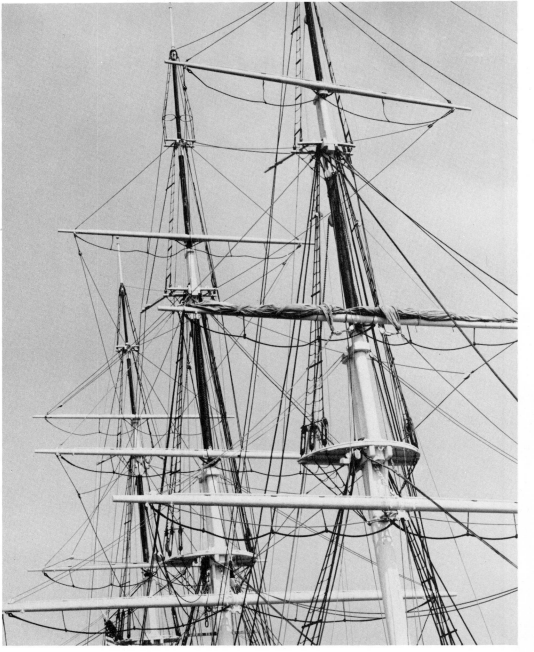

PLATE 11-24

Essentially, Plate 11-24 is an example of radiation from a central axis; the masts are the attachments for crossbeams, various ropes, and ladders. There are, however, many other types of rhythm acting in support of the total organization.

Due to perspective, the masts appear progressively shorter and thinner. The crossbeams become progressively shorter as they are set higher on the mast. Finally, sets of lines radiate from fixed points at different levels of each mast.

PERCEPTION OF VISUAL MOVEMENT

While rhythm functions as an organizing principle, bringing together elements of similarity for the purpose of unity, it also induces a quality of movement and flow. Depending on the rhythm used, it can transport attention from one element in the picture to another. As in music or the dance, its kinetic tempo may be staccato or flowing, rapid or slow, consistent or interrupted.

All the previous manifestations of rhythmic movement are derived from recurrent units and intervals that follow relatively fixed patterns of anticipated lines and shapes. A more subtle but equally effective application can be attained with recurrent color or texture and, in some instances, with tone. With or without a confining shape, the sequential appearance of any feature in some maintained order creates movement. Even though only a few viewers can appreciate the planned or discovered structure responsible for the sensation, most can feel it.

There are, however, aspects of movement which implicate rhythm but which do not confine themselves to recurrence. They follow an unanticipated path, are less formal in their organization, and demonstrate an attitude of freedom.

Little if anything in life is static. Even if a thing is fastened in place, it is part of a larger unit that may move. If it does not move physically, it may move visually. As part of an everchanging landscape across which people move, it takes on an impression of movement. A person in a moving vehicle watching from a window gets the impression that the landscape is moving, not the vehicle.

We respond emotionally to movement; sometimes we respond so strongly that certain types of unfamiliar motion can make us violently ill. Others can be soothing, satisfying, or thrilling.

Visually, certain moire patterns produce dizziness. Several color combinations produce vibrations in the retina of the eye—a distressing reaction that makes us feel that our eyes are malfunctioning.

As an expression of life, art cannot avoid communicating movement. If it is not inherent in the subject, it is implicit in the organization.

IMPLIED MOVEMENT

Motion pictures have a built-in capability for the capture and expression of physical motion. In this medium, the photographer has an infinite range of movement from which to select and organize. While still photography cannot record objective physical movement, it is enormously capable of expressing implied movement. This is done through the use of a directed path along which the eye and the attention move.

The most obvious means for expressing movement in a still photograph is to superimpose in one picture a sequential progression of a physical activity. Each stage represents a static segment of the total action. All of us are familiar with stroboscopic photographs that record the swing of a golfer or a baseball batter and the movements of a person walking up a flight of stairs.

The eye, passing from one phase of the action to the next, receives a sensation relating to that of the original physical movement. In art, since the reaction to an activity is even more significant than the activity itself, the feeling of participation or at least of observing actual movement in the still picture is obtained.

Following the line of reasoning that progressive changes of the same element produce the effects of movement, it may be seen that rhythm, through progression, makes the eye and mind react in a similar manner.

The impact of physical movement may not be as clearly implicit in rhythm through repetition and alternation, but there is about them a feeling of continuity that is only a slightly different sensation of movement. The similarity of unit and interval makes our eyes and our minds follow the continuity from one fixed station to the next.

Movement, then, is a matter of controlling the course of attention from unit to unit. An arrow or a pointing finger will lead the attention to the direction of the point. Similarly, any movement, such as a person or animal walking or running or the action of a vehicle, will impel attention in the direction of the movement. The eye tends to follow the direction of movement of the person or object. It will even follow the direction in which it faces.

Any shape which has strong directional force can create a path of attention which is hard to resist following.

RHYTHM AND MOVEMENT
IN FREE-FLOWING LINE

There is much to be learned about rhythm from examining doodles and scribbles. These are made subconsciously by people who have a need to involve their hands while their minds are almost completely involved in some other activity.

Some are thoroughly disordered and indicate a lack of control.

Figure 11-27

Others are imitative of current drawing forms.

Figure 11-28

Still others are tightly controlled and highly restricted to forms that have been taught in early years.

Figure 11-29

The scribbles of people who have a feeling for or who participate in activities that embody graceful or flowing movement are strikingly fluent. Such people frequently reflect their emotional reactions to choreographed rhythm they feel within themselves. This occurs with dancers, skaters, some actors, and musicians.

Figure 11-30

Sometimes these are expressions of gestures or the paths of motion taken in mental participation; at times they are a visual representation of a rhythmic flow that is experienced inwardly.

When we look at these flowing lines, our eyes are caught in the path of motion, and an emotional reaction is transmitted. We cannot help responding to the variations that are so diverse that a tremendous range of feeling can be stimulated.

Rhythm is felt because a sense of subtle repetition with variation leading to fluctuating progression is formed as the line undulates through space and changes its direction

Figure 11-31

or its tempo

Figure 11-32

or its pattern.

Figure 11-33

Casually drop a piece of string or thread about two yards long on a table and observe the linear flow that develops. Continue to drop the thread many times, studying both the linear curvature and the negative shapes created between them. After a while, you will be caught up in the rhythm you see and be better prepared to discover rhythmic flowing lines and shapes in other subjects. Yarn, rope, wire, and electric cords add a variation of linear character and texture.

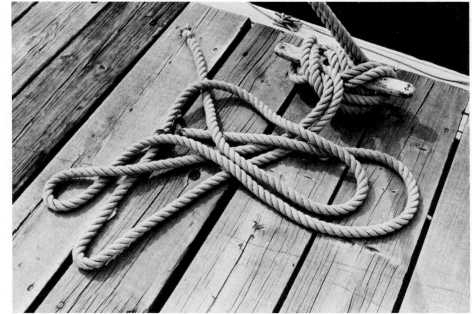

PLATE 11-25

Attractive contrapuntal movements can be obtained from the combination of two or three strands, each of which differs in thickness, tone, and texture.

Then drop a silk cloth on a table and light it from an angular source so that the folds cast shadows. Notice, again, how the convolutions of the folds form attractive rhythms.

The paths of motion do not have to be complicated. This photograph of a basket creates interesting shapes in both figure and negative space. Even more important, it emphasizes a rhythmic flowing line around its contour.

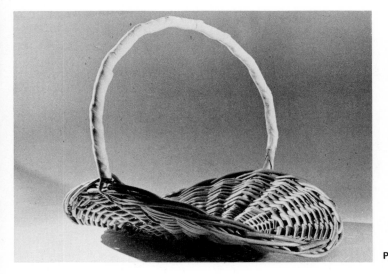

PLATE 11-26

Notice too how the radiating lines of the ribs from the center and the concentric repetition of woven fiber around the ribs create supplementary rhythms.

215

RHYTHM AND MOVEMENT
IN FREE-FLOWING SHAPES

We have seen in Figures 11-20 through 11-24 how progressions in the change of shape create rhythmic movement. Our attention moves along from one shape unit to the next. Unity is maintained through the similarity of each successive form; yet each is sufficiently different to lead from one unit to the next by anticipated expectancy.

In the freer environment of nature, it would be a rarity to discover such formal, progressive changes of shape. Each related unit in the more common groupings is usually markedly different. Nevertheless, the sensation of being led along a path of movement can still be present.

The nature of the unit shape and its general tilt of inclination persuades us to look at another unit in the direction to which it seemingly designates. The next unit conveys us to the following one. Although nothing in the subject actually moves, a dynamic impulse to follow the implied directional movement of each shape can be felt.

This phenomenon is evident in Plate 11-27. No matter where our interest settles first in this picture, it is drawn to an adjacent feature and swung back again. A particularly sensitive viewer might experience a sensation of billowing movement, similar to that experienced in actual sailing. Because the shapes have counterdirectional qualities, we may find our interest swept back and forth until the total picture surface is covered several times.

PLATE 11-27

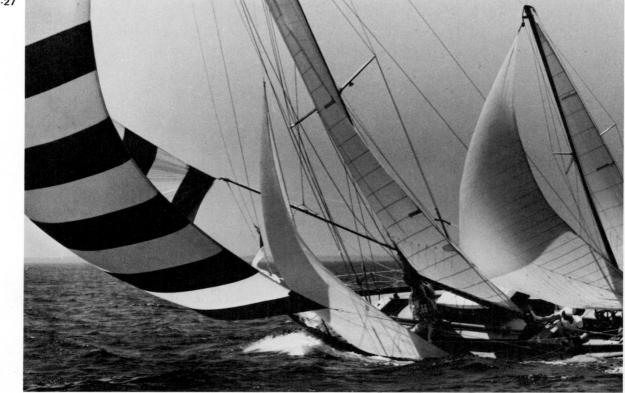

Out in nature, you'll have no difficulty finding subjects which feature both free-flowing lines and shapes which generate implicit movement.

Some suggestions as to where to look are

fluttering banners, flags, streamers, pennants

dancers—individually and in groups

waves, clouds, and vapor trails

curved roadways, particularly interchanges

contoured farms and land formations

rock formations, fissures in stone

musical instruments.

Debunking Balance

Of all the nonsense perpetrated upon serious students of photography, commentaries on the principle of balance are the most meaningless. Because they are eager to advance their esthetic understanding, such students become gullible victims of pretentious "experts" whose actual knowledge extends little further than familiarity with the vocabulary of pictorial composition.

All picture makers share a common desire to have their work seen and appreciated. Hoping to improve pictorial qualities, many take seriously the criticism that is imposed upon them. Too often the alleged critic is neither capable nor interested in providing constructive advice. Rather, he seeks to impress the artist, and all who would listen, with the great depth of knowledge stored within the secret precincts of his own mind. In reality, many times that knowledge is limited to superficial gobbledygook about balance. Perhaps because it appears to be the most tangible and presumably the most easily understood principle of design, balance is the basis most frequently used in the evaluation of pictures.

We have often observed the frustrations of capable students who have been told by self-styled critics how their pictures need to be altered in order to make them balance. Many sensitive, expressive compositions have had their interest, movement, and vibrancy made static in an ill-fated attempt to arrive at ridiculously dull equilibrium.

SYMMETRICAL BALANCE

In their early years of art experience, children are said to have an innate urge to establish a central vertical division, felt rather than expressed, and to paint on one side of the picture a near mirror image of the opposite side. The child apparently derives unconscious satisfaction from symmetrical duplication of houses, flowers, trees, mountains, and people, even though from a grown-up, realistic point of view the results may appear absurd.

Many adults never grow out of this primary stage of artistic development. In arranging the furnishings of their homes, they are most comfortable when they balance a room by placing on one side a symmetrical duplicate of the opposite side. Occasionally, after being urged to try an arrangement based on function or on a freer type of organization, they may deviate from absolute symmetry but even then only slightly.

In the early primitive stages of art history, artists composed their pictures along similar symmetrical patterns for three reasons. First, because their pictures were used as functional and decorative elements in religious structures, they followed the formal, symmetrical, architectural design of which the pictures were so much a part. Second, since only the most privileged could read, these pictures had to convey the religious and ethical message, often through symbols, and consequently had to be simple and obvious. Third, the bold, innovative concepts of composition had not yet been experimented with and established. Both artists and viewers had to be educated slowly to move away from the ultrasimplified obvious to the more complex subtleties.

This is not meant to condemn symmetrical composition as being of no value in painting or photography. There are instances when symmetry is an excellent means of expression for a subject, especially where dignity, formality, the decorative, and the spiritual are to be set forth. Partly because of its rigid orderliness and partly because of its association with established tradition, symmetry is an appropriate format where discipline, severity, and regulation are needed. The chances of coming upon subjects that suggest symmetrical arrangement are most likely to be found in state buildings and houses of worship. Occasionally one may find in nature a compelling formality that suggests the spiritual and the formally ordered.

In modern times, symmetrical, or formal balance as it is sometimes called, is not frequently used except in the most conservative situations. Because it is rarely used, it attracts attention to its simplicity and exerts a direct, dignified, and sometimes quaint appeal.

TRADITIONAL NOTIONS OF BALANCE

The time-honored analogies for explaining how balance works
are the balance scales and the seesaw.

In symmetrical balance, equal weights are placed equidistant from the center (fulcrum) so that the plank (lever) remains
balanced in a horizontal position.

Figure 12-1

PLATE 12-1

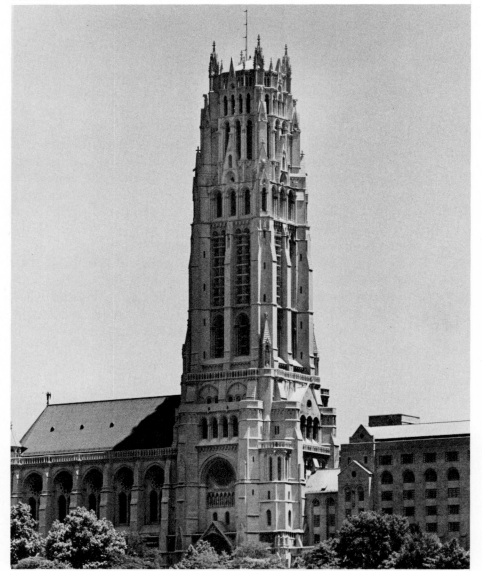

An often rationalized variation of symmetrical balance deals with the seesaw in perspective. The forces are presumed to be approximately equal, but the fulcrum is situated deep inside the picture space.

Figure 12-2

A photographic representation of this phase of the principle would be Plate 12-2. The building in the left foreground is supposed to balance the building in the right background, and the fulcrum is supposed to be approximately in the perspective center between them. Each building is approximately equidistant from its adjacent border.

PLATE 12-2

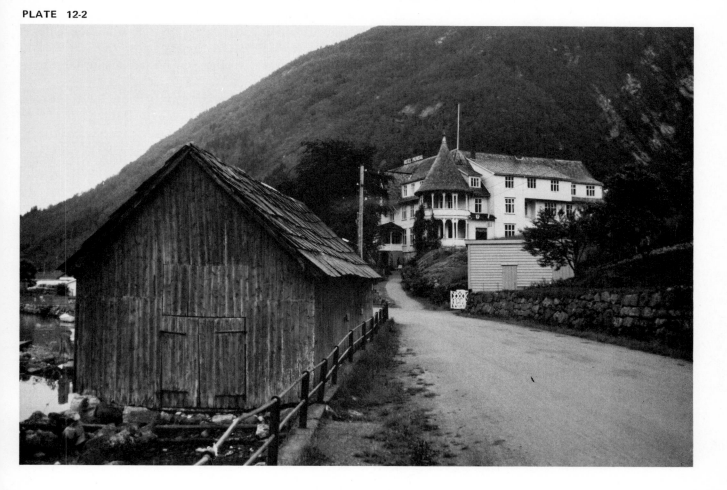

Superficially, one may be led to believe the reasoning to be logical evidence of balance. Squint at the picture, however, and observe how the reasoning is actually unsound.

In tonal value, the foreground building dissolves into the background, losing practically all its contrast. Instead of serving to set it off from its surroundings, the structural lines of the roof and the fence point in the direction of the light building, bringing greater attention to the light building and helping to make it dominant. The roadway is a specific pointer directing further attention away from the foreground.

In addition, two powerful constituents of dominance are present to give even greater emphasis to the distant house—its tonal contrast against the background and the fact that it contains the only important horizontals in the picture to contrast with all the angular lines.

ASYMMETRICAL BALANCE

It is in the area of asymmetrical, sometimes called informal or occult, balance that the most preposterous rationalizations are made. The imaginary central vertical is still presumed to be present, but instead of mirror images on each side the elements are notably different in size, shape, light and dark, and placement. Equilibrium is established by equalizing the forces in spite of their dissimilarity.

Asymmetry is introduced when two or more lighter forces, whose total weight is equivalent to the single one, are substituted on one side.

Figure 12-3

Such a state of equilibrium may appear to be worthwhile, or at worst harmless, until we examine carefully how it may affect the picture and the artist. The most objectionable part of the procedure is that physical, quantitative considerations, particularly factors of weight, are the determining means for arriving at balance.

Then there is the perplexing problem of establishing relative weight values for each unit in the composition in order to arrive at some form of stability. Does negative space exert positive or negative gravitational force? Does it signify heaviness or floating lightness? Is an emotional or active unit heavier than a passive one? How does one equate a long thin

line with a small shape, a light area versus a dark one, rough texture as opposed to smooth? To what extent is a geometric form more weighty than an irregular one?

Finally, there is the ultimate question as to whether absolute equilibrium is desirable at all. Is stability a worthwhile aim? Might not certain pictures be more expressive of the artist's original intention if they are planned to be "out of balance"?

Interpreted visually, one would place a large form on one side of the center and two or more small forms on the other side.

Figure 12-4

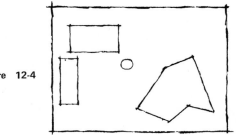

A variation of this involves balancing a heavy force with a single light force by placing the greater one close to the fulcrum and the light one farther away. This is the physical phenomenon of moment, in which the force on each side is computed by multiplying the weight times the distance from the fulcrum. When the products are equal, balance is achieved.

Figure 12-5

In the visual interpretation, one would effect balance by placing the large form close to the center and the small one close to the edge of the frame.

Figure 12-6

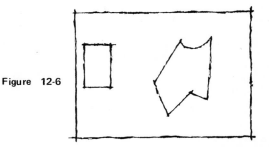

Herein is the absolute illogic. We have seen in our experiments in placement that when a number of figures are set in a field, those placed closest to the center generally attract the

greatest attention. If we combine the greater attraction value of size with the advantage of placement, how can we accept the Figure 12-6 as balanced? What chance does the small form have, so far away from the center, to overcome the tremendous attraction impact held by the large form at the center? If anything, the small form loses attraction value when it is placed so close to the frame, especially when another form, a much more powerful one, is placed close to the center.

Interestingly enough, when we remove the small form completely, the large form remains in excellent balance.

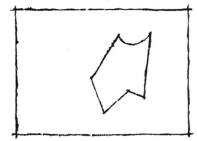

Figure 12-7

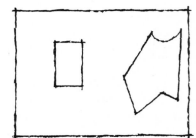

We may go even further and demonstrate that the reverse of the principle is closer to the truth.

Figure 12-8

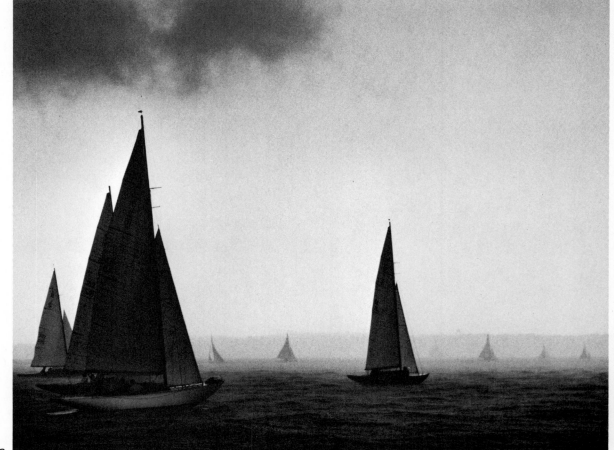

PLATE 12-3

PHYSICAL FORCES VERSUS VISUAL FORCES

The fallacy lies in equating physical forces and visual forces in pictorial composition. Gravity is an essential influence in physics, while in pictures (except for some associations) it has no application at all. A given volume of wood may weigh considerably less than the same volume of iron; yet the visual impact of each may be the same. Either one can be made more important, depending on arrangement and visual surroundings.

It is impossible to arrive at either a quantitative or qualitative interpretation between physical weight and visual force so that an equivalency relationship can be determined. All the matters involving contrast of size, shape, light and dark, texture, and direction have a way of changing attraction values. Every aspect of rhythm, placement, and unity can affect the total relationship, the way we see the picture or any of its components. Analogies of weight, movement, and gravity have absolutely no bearing on matters of visual interest. The representation of a single light-toned feather in the foreground, placed against a simple dark background near the center of the field, can easily overbalance the attraction value of a whole trainload of iron ore anywhere in the picture.

Plate 12-4 is a picture that shows acceptable balance of physical forces. We believe that advocates of the principle of balance would find this a satisfactorily balanced picture and could draw analytical diagrams to demonstrate the forces that contribute to equivalency.

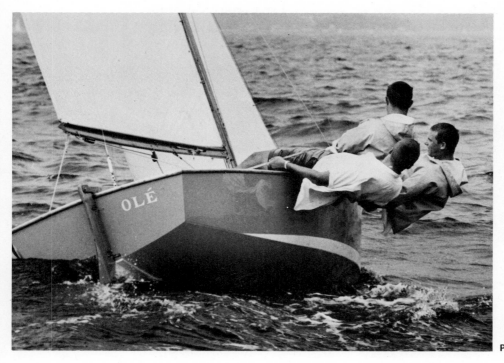

PLATE 12-4

If we were to change the format so that the center of interest is shifted to the right or left, the physical balance of the picture would remain undisturbed. Yet the visual impact will have been strongly affected. How can we now rationalize the existence or nonexistence of balance?

PLATE 12-5

PLATE 12-6

Certainly each of these pictures expresses a slightly different idea, but the differences are representative of the changes that result from placement and negative space. Balance is not involved at all!

Again, the analogy of physical forces to visual forces is unsound and should not be used, even in the most offhand way. If we are to aim for visual balance, then we must deal only with visual forces.

Here again we are confronted with a staggering problem, that of allocating attraction values and equivalents to subject components. Who is to state authoritatively that one object is more meaningful than another? Such values depend on one's interest, past experiences, and reaction quotient. How can anyone equate for someone else the attraction value of one shape against another, a tonal contrast, a linear direction? For each individual there are both conscious and subconscious preferences for one variation or another. Much is dependent on the interrelationship of any one part with the others and with the shape and nature of the enclosing frame. Psychological interest plays a tremendous part in the process because values may vary according to the current mood of both the artist and the viewer and consequently from one time to the next. Curiosity, a potent component of pictorial appeal, is a thoroughly unstable element, varying not only among individuals but also at different times with the same individual.

PERSISTENCE OF THE IMAGINARY VERTICAL AXIS

A significant factor in balance is supposed to be the existence of an imaginary yet ever-present central vertical axis that acts as a fulcrum. Equivalent distribution of weights on either side of this axis results in balance.

Primarily, we cannot help doubting the centrality of the axis. Pictures have a way of aligning themselves according to the nature of the subject with little regard for centrality. As we have seen, the center of interest does not necessarily have to be in the physical center of the field. If an axis can be seen or felt at all, it doesn't have to appear midway between the sides of the frame.

The sketch in Figure 12-9 demonstrates placement of the center of interest in the vertical visual center of the picture. It is, however, by no means near the vertical midline of the field.

Figure 12-9

Some pictures, such as Plate 12-7, appear to arrange themselves along a diagonal or angular axis.

PLATE 12-7

Others may determine their axis around an irregular broken line, and still others around a flowing curve that takes in both sides of the picture and may even suggest a stronger horizontal division than a vertical one.

What is so sacred about the central vertical axis or any axis at all for that matter? Merely because it is present in children's paintings is an insufficient basis for continuing its use in adult photography. There is reason to believe that children may be following an easily adopted procedure that was taught by adults indirectly through example or through exposure to related experiences in the child's environment.

Photographs are not paintings, certainly not in any way like primitive paintings of the early Renaissance. There is no reason to perpetuate the burden of useless rules or principles of balance that have no bearing on the art form of photography.

More so than with any other aspect of art, teachers, writers, and critics are carried away with increasingly ridiculous notions about relative weights or pictorial components. Large massive shapes are supposed to be "heavier." Is this true about a large shape of sky or water seen through the framing of trees? Warm colors are "heavier" than cool; intense colors, "heavier" than subdued colors; coarsely textured surfaces, "heavier" than smooth. Like everything else, these are true sometimes! The writers recall how strongly it was impressed

upon them that large dark areas should always be placed on the bottom of the picture; otherwise they will appear to be falling dangerously from a height.

THE QUESTIONABLE NEED FOR STABILITY

Balance, equilibrium, symmetry—all are words that connote stability. The principle aims to guide artists to achieve an equalization of forces. Very often, the equality goes beyond acceptable stability and results in static dullness.

In some pictures, stability may be desirable and thoroughly in keeping with both the subject and the artist's response to it. Other subjects and other expressions of the same subject may regard stability as an undesirable outcome, a much too studied, carefully preplanned exercise lacking excitement, informality, and spontaneity. That which some label as imbalanced may be capable of promoting strong emotion, action, and movement.

Exaggeration is an artistic device that emphasizes the artist's feelings about his subject. Most good pictures are exaggerations in some form or other. As we see it, it would be virtually impossible to accomplish effective exaggeration while maintaining a strong interest in balance.

INTUITIVE APPROACH TO BALANCE

Then to what extent and when should the photographer concern himself with balance in the construction of composition? Our advice is not to think much about it at all.

If the subject suggests an interplay of equilibrium, and you are sufficiently motivated to emphasize this aspect in your expression, by all means do so! Even if such notions as weight present themselves, don't even be bound by arguments against weight as we have presented them in this chapter or by restrictions you may receive from any other source. Our intention was to counteract the extraordinarily strong emphasis on balance by weight that has been imposed by tradition.

Otherwise, when balance is not strongly implicit either in the subject or in your interpretation of it, the picture has achieved balance when you feel no need to change it. It is balanced when the photographer is satisfied that he has established the degree of stability or instability that in his judgment is consistent with the interpretation he intends to give his subject.

Intuition is the most reliable guide. There is no need to try to evaluate stresses, strains, and pulls on the attention. If the picture needs some form of adjustment, you will respond automatically and add or take away whatever is necessary.

Unity
the singleness of intention

FROM SINGULAR TO PLURAL

Early in the study of photography, one learns to avoid pictures like this.

PLATE 13-1

A single picture is intended but the outcome appears to be two separate and distinct negatives printed on one sheet of paper. The bold, white, horizontal band set in the middle of the picture so that upper and lower segments are equal in size supports the apparent separateness.

This problem is encountered most frequently in photographs of nature, where the horizon line is centered and both sky and earth are equal.

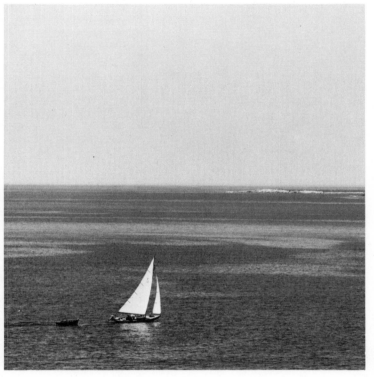

PLATE 13-2

When the two separate elements are unequal, the tendency to regard them as separate pictures is lessened, but the sense of integration, of singleness of organization, is still lacking.

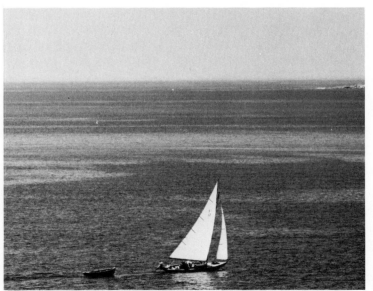

PLATE 13-3

Although it is encountered less frequently, the same problem may be found along a vertical division.

PLATE 13-4

The white edge on the left end of the apartment house acts like a center border to frame two seemingly separate pictures. Cropping, to narrow the exposed space of the apartment building, helps somewhat but the offensive division is still strongly evident.

When perspective represents horizontals as inclined lines, the apparent division of the two parts is lessened even more. There remains, nevertheless, a definite lack of interinvolvement between the light area above and the dark area below.

Figure 13-1

The problem focuses on the principle of avoiding straight lines, especially those parallel to any part of the frame, from continuing uninterruptedly from one border to its opposite. When the continuity is broken and forms from one portion break into the other, integration is more firmly established.

Figure 13-2

Figure 13-3

Figure 13-4

PLATE 13-5

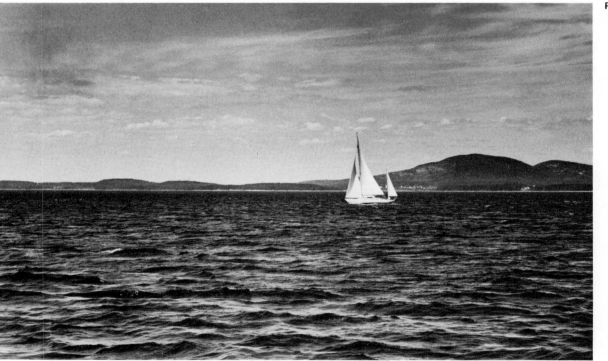

As more dark forms intrude upon the light area and more light forms cut into the dark area, a greater feeling of oneness is established. It is even further enhanced when a few independent light masses are brought well into the body of dark, and vice versa.

PLATE 13-6

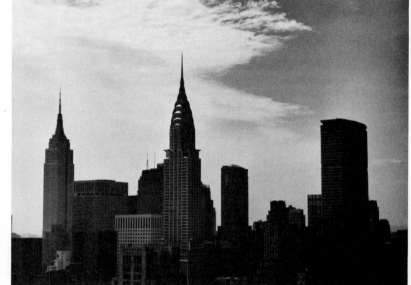

Continuing to advance the process of imposing light forms into dark masses and dark forms into light masses makes the entire picture more active. What had previously been a large, unbroken, flat area is now perforated with many elements that call for attention to themselves. This is the reason Plate 13-6 is so much more restful to look at than Plate 13-7. Plate 13-6 has two solid basic masses, distinctly light and dark, each separate and apart, in spite of the penetration of the edges of one into the other. In Plate 13-7 the separateness no longer exists; light masses and dark masses overlap and intrude upon each other in many places.

PLATE 13-7

Fortunately, the implied ecological message, communicated by squeezing both the Chrysler and Pan Am Buildings between two smokestacks, maintains the unity of subject matter, while the constant repetition of vertical masses supports directional unity. Superimposed darks and lights have contributed to the generation of enormous activity, but they are also responsible for a consequent weakening of the tightly unified dark and light pattern, such as demonstrated in Plate 13-6.

This is the kind of judgment a photographer is always called upon to make. Every statement calls for some sacrifice. One cannot express the kind of activity we see in Plate 13-7 while using a tightly unified dark and light organization.

Theoretically, we could continue in this manner, breaking further into the compactness of the masses until the subject becomes spotty and nearly disordered.

PLATE 13-8

Normally, the rhythmic repetition of window shapes strengthens unity. In Plate 13-8 there are, however, so many window rhythms, in such great variety and in so many directions, that the visual effect is utterly confused. Add to this the total disruption of light and dark unity, and we arrive at almost complete chaos. It is impossible to locate a center of interest, and any message the photographer may have chosen to communicate other than the clamor of a big city is lost.

It becomes evident that the effectiveness of a good idea or practice does not necessarily improve as it is projected continually or indefinitely. We cannot avoid reaching a point where the solution overcomes the original problem and subsequently becomes a problem in itself. Beginning with one form of disunity, we have made adjustments which corrected the fault and then made further adjustments of the same nature which solved the problem satisfactorily. Continuing in the same direction of the solution began to upset the unity until finally the unity broke down completely.

Unity is a singleness of intention and communication throughout every aspect of the photograph. In selecting the objects or people or environment for a picture, the photographer aims to keep his theme consistent so that the picture will not stray from the single main idea or point of view that this single picture expresses. You may realize more clearly now how many of the examples discussed under contrast, rhythm, center of interest, and placement are revealed to cooperate for the purpose of obtaining unity.

A lack of unity in pictures has the same effect as it does in speaking or writing; it induces rambling ideas and scattered attention. The point of the visual idea disintegrates and the segments, which should have contributed to an interrelated entity, remain as meaningless, confusing fragments.

Aside from the aspect of unity discussed in the early part of this chapter, there are a number of ways of developing unity in a picture. Although they all aim to effect the same basic objective, the approach has to be different because the units that constitute the problem are different. The solution to the problem directly under consideration is always unique inasmuch as the components in their various combinations are always different. The following can serve only as a general guide to some of the thought processes that are involved in the solution.

UNITY OF OBJECTS IN THE SUBJECT

An obvious way to arrive at unity is to limit the picture to those figures and objects that relate to the central idea. At the same time, eliminate as much as possible that does not apply directly to the idea or contribute to its intention.

In Plate 13-9, a number of workmen are shown applying cement to shaped layers of wood which with many other such layers will subsequently be laminated. This will form the "plug" from which the mould for a keel is made. The process of cementing the shaped forms is the basic idea. Little is included that may be diverting or distracting from subject matter unity.

PLATE 13-9

The workmen are dressed in similar clothes that vary only slightly; all except one wear caps. All use the same kind of tool and apply the same kind of cement from the same kind of bucket. Each uses about the same amount of energy in the spreading process. Because these two laminations will be adjacent in the joining, they are almost identical in shape. Everything in the picture relates to the one activity, the central idea of showing the application of cement before laminating. With such devotion to a single idea, it is difficult to avoid obtaining subject matter unity.

It may be even more significant to list some of the distractions that might easily have been included at the expense of unity.

There is no concentration on any single individual, no grandstanding in pose or placement. No effort is made to show any form of superiority in rank or importance. Character or personality studies of any individual are omitted. Had any of these been included, they would have established themselves as center of interest, at the expense of unity throughout the overall activity.

Environment is limited to only those furnishings that are necessary for the process. No distracting activities unrelated to the procedure are included. Machines, tools, sails, rope, and other equipment pertaining to ships and shipbuilding have been left out.

237

REPETITION OF SIMILAR FORMS
AND DIRECTION

We have seen in Chapter 11 on rhythm how similar forms can be grouped so that along with a repeated interval they fall into sets. The repetition or progression of these sets creates a beat that in turn expresses movement. Because the units and intervals of the rhythm are similar and because the movement tends to integrate the parts of the composition into a cohesive whole, the composition is unified.

Not all similar forms can be organized into sets with regular intervals to produce specific rhythm. Sometimes repetitions are present, but the beat is irregular, comparable perhaps to the beat of some modern music. Nevertheless, even though specific rhythms cannot be formulated, a sufficient number of similar forms are repeated to establish a distinct unity.

In Plate 13-10, repetition of shape and verticality is a strong integrating factor. Looking at the picture, no one would question what the picture is about; it is the consistency of the theme that prevails and captures the attention. No single form dominates.

PLATE 13-10

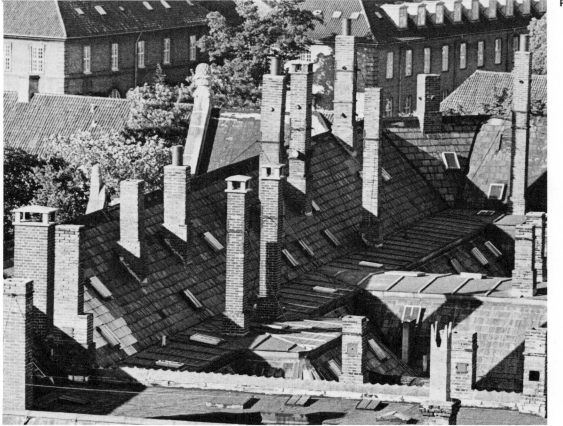

An application of the same principle, coupled with the problem presented in the beginning of the chapter, can be seen in Plate 13-11.

PLATE 13-11

Each half of the picture, upper and lower, is capable of functioning as a separate picture since no part of one projects physically into the other. Ordinarily, such pictures tend to disintegrate. However, repetition of the unique shape of the boats and of the figure spots, countered by the repeated horizontal lines in the background of beach and water, brings about a definite unity. This is strengthened too by the combination of the light upper edge of the lower boat with the light reflection of the upper. The consolidation of light masses serves as a light background against which the dark bottom of the lower boat contrasts.

UNITY THROUGH GROUPING OF OBJECTS

Frequently, we are called upon to photograph a subject that consists of many individual objects. If each of these objects is permitted to appear separately with its individual force of attraction and interest, the resultant photograph would be a scattered conglomeration full of confusion.

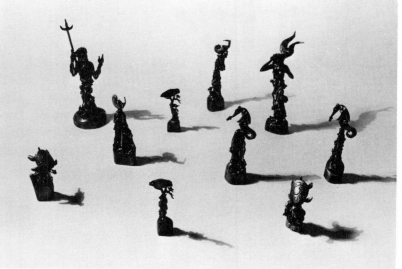

PLATE 13-12

Sacrifice is as much a part of unity as it is of emphasis, not that the two are really separate and distinct beyond the need for separation to permit concentrated study. Individuality of most objects in such a combination needs to be sacrificed by merging into suitable groups so that any one unit may contain several related objects.

Instead of many individual units to confront the eye, the viewer may concentrate his attention, without confusion, on a few groupings. The attraction factor of few is far greater than that of many. After attraction has been established, attention can be directed to examination of individual units within the group.

Objects may be grouped according to size,

PLATE 13-13

shape,

PLATE 13-14

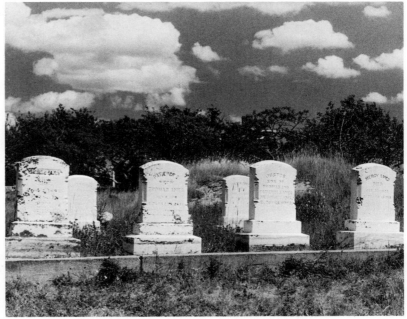

linear character,

PLATE 13-15

function,

PLATE 13-16

and common interest.

PLATE 13-17

Each group needs to be a unity within itself, set off by a background element. This background may be either one of the larger units in the composition or a suitable shape of tone and texture arbitrarily introduced to provide appropriate visibility.

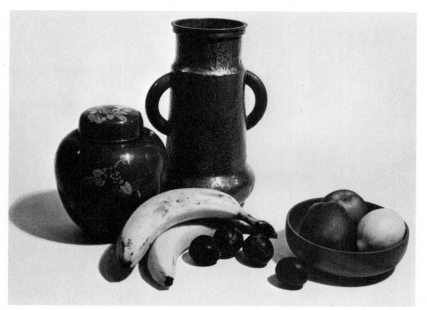

PLATE 13-18

The silhouette shape of each grouping has to be considered as the edge of a single unit; it should be made as interesting as possible within itself, while relating to the other unit shapes that will appear in the picture.

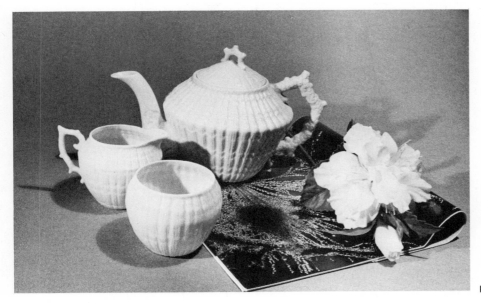

PLATE 13-19

Careful attention needs to be given to the shape design of the group silhouette; otherwise the grouping may appear awkward and counteract effectiveness and interest. If the edges are intermittently light and dark, alternately mingling and coming away from the background, the tonal complexity of edge may interfere with unity. Both conditions contribute to making Plate 13-20 a poor picture.

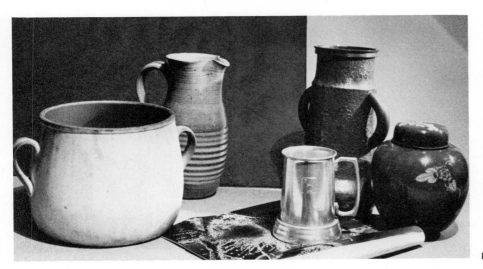

PLATE 13-20

If sufficient similarity can be found, one or more groupings may be organized into a repetitive or progressive rhythm or they may be arranged into a flowing curve.

Unless the rhythm is unmistakably clear, the unity will not be established. In Plate 13-23, there is confusion as to whether the objects in the outer semicircle relate through repetition to each other or through radiation to the inner semicircle.

THE SHIFTING NATURE OF UNITY

Once unity has been established to the photographer's satisfaction, any change can upset the integration. The very forces that tie units together can be diverted to produce reverse effects. Objects which were previously identified in association lose their relationship through the introduction of other objects which form new couplings.

Consider the two figures on a bench in Figure 13-5. Seated at opposite ends of the bench, they are not close together; yet they are united by the fact that they both occupy the same bench, by the horizontal lines of the bench, by the sharing of their individual solitude, and by the similarity of their forms.

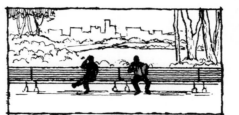

Figure 13-5

As soon as we place another figure close to either one, the unity shifts dramatically.

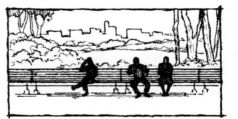

Figure 13-6

Now the primary unity is established between the two figures on the right. The interval between the original figures has become more important and more separating.

The addition of a fourth figure, close to the single figure on the left, completes the break in the original unity.

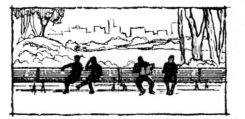

Figure 13-7

245

With the interval between each pair of figures considerably less than the interval between the original forms, each new pair is unified, and the original interval becomes part of the background.

UNITY THROUGH CONTRAST

Unity depends on an interrelationship of the parts of a composition toward one another and toward the whole. Making use of similar sizes and shapes, we have found an obvious means through which such a relationship can be established easily. Our eyes detect quickly the repetition of a unit and readily accept the challenge of discovering the nuances of variation whenever they are present.

There exists, however, an association of opposition that interrelates automatically: In science it is a matter of positive and negative; in philosophy it is the body and spirit; in art it involves dark and light, bright and dull, large and small, and up and down. These are, in effect, contrast relationships that affiliate at least as easily as similarities. It is easier for us to accept white against black than it is to accept white against white, or black against black. Contrasts or dissimilarity, therefore, are effective means for unification.

To follow through on the problem of a subject with many units, one may compose contrasts of groups according to size, shape, tone, and direction and play one group against another in terms of these contrasts.

UNITY THROUGH INTEGRATION

Generally, the fewer the number of units, the greater the attraction power of the picture. Visual impact is more likely to be impressed on the viewer's attention when competition within the picture is lessened. In isolation, the attraction is instantaneous. The addition of a second unit compels the eye to digress from the first unit to the second and back again to the first.

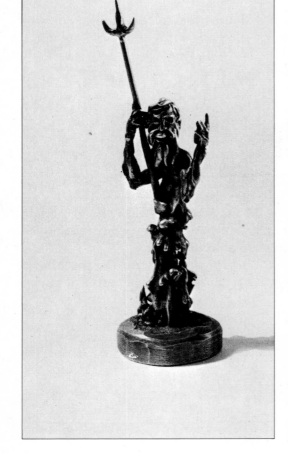

PLATE 13-24

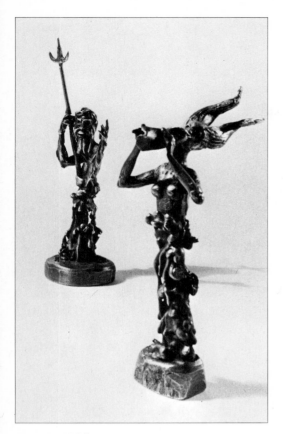

PLATE 13-25

As each additional unit is added, greater time is needed to take in the relationship of idea and form, and the chance for confusion is increased.

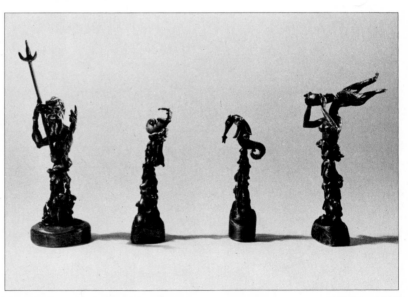

PLATE 13-26

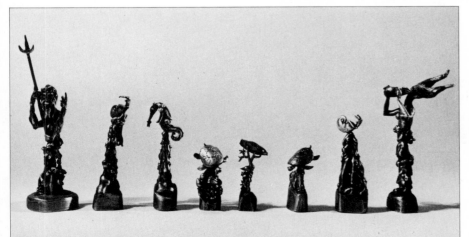

PLATE 13-27

It is helpful, therefore, to limit the number of units to as few as possible through grouping.

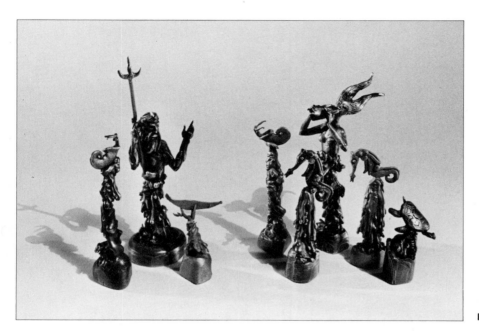

PLATE 13-28

Like every other line of reasoning, the complete integration of units can be overdone. If we were to confine all the objects into one single unit, the excessive solidarity would be most unpleasant. Confusion develops because the objects appear to be more crowded than unified.

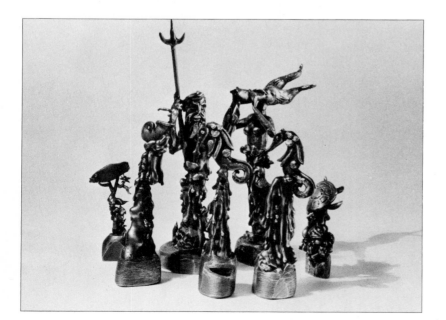

PLATE 13-29

One must constantly experiment and evaluate, in terms of both intention and appearance, to determine the best solution. Principles cannot be depended on for specific application to a problem; they can only direct general thinking.

How many objects need to be combined to make any single unit, how the combination should be chosen, and the number of units in the picture are all factors that should be determined by the photographer as he seeks to achieve his objective. Part of the solution will be suggested by the nature of the subject; most will be decided by the photographer's taste and judgment. Successful outcome of the central theme must be the goal; anything that leads to deviation from the goal or obscures it must be avoided.

INTEGRATION OF LIGHTS AND DARKS

In our study of light and dark, we observed how the design could be changed into many variations, even though the linear design was maintained. Some arrangements distribute darks, lights, and grays in a diverse manner throughout the entire composition. This imparts an active, scattered quality to the design. Although there is unity of shape and a good interrelationship of size in Figure 13-8, the feeling of total unity is not especially strong because of scattered distribution of dark and light.

Figure 13-8

The arrangement in Figure 13-9, using the same linear structure, has combined several shapes with dark, light, and gray, reducing the total number of units considerably. The result is more unified, more compact, and more restful.

Figure 13-9

Consistency of tone is a potent force for unification. If unity is a primary objective and there is no special need for contrast, one may always rely upon a close range of light and dark for integration. This is especially helpful when a number of isolated units need to be brought together and there are no resources of line, shape, or rhythm to accomplish the unity.

Local or actual tone in subdued light is only one factor in the represented tone on the picture. Lighting, either natural or artificial, can alter the tone of any object, making light things dark or dark things light if necessary. The availability of opportunities to make such changes in order to relate elements and principles with subject matter for greater expressiveness is a resource the photographer should exploit. When lines, shapes, and tones are closely related to each other and interwoven with the subject into a consistent pattern that expresses the central idea, the ideal of esthetic unity is accomplished. When every part is related to the whole and the whole is related to every part, a complete harmony is achieved that is felt by the viewer immediately. The composition then becomes all of a piece, unspoiled by jumpiness or jerkiness.

UNITY THROUGH FLOWING LINE

Flowing line is as consistently dependable a means of arriving at unity as it is for rhythm. Moving around the picture surface, it establishes contiguous geographic boundaries that cannot help relating to each other because they share common borders. Through the mutual sharing of the identical line as a consequential part of each unit within the whole, the composition becomes strongly unified.

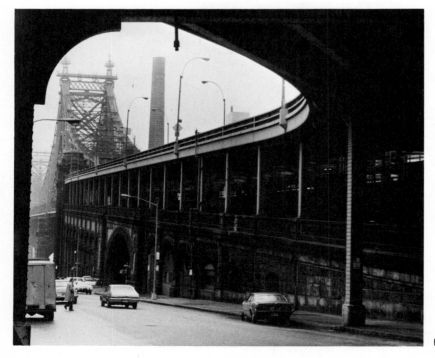

PLATE 13-30

Anyone who has hiked, biked, or taken an auto trip is aware of the unity association of places, visited or passed, in relation to the route followed. It has little to do with the geographic direction of the road, which may follow a meandering course, nor is it concerned with adjacency. The unity of association may involve places that are located at extreme ends.

Unity is related more specifically to physical movement along the road and the touching upon various places. The connection that holds together the association of the several places is established by the movement itself.

So it is with flowing line in a composition. The eye follows the undulating linear track and activates sensations of physical movement in the viewer. Continuous interconnection of parts, in the same sense as physically moving through them, incorporates surface unity.

Figure 13-10 shows a number of single units placed so that no relationship exists among them. No matter how hard we try, and the eye automatically does try, we cannot find any way of bringing them together in some meaningful connection. The picture is spotty.

Figure 13-10

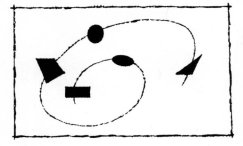

Figure 13-11

When we place a string, a tape, or a ribbon in such a manner that a flowing line is created that touches upon each of the objects, unity is established instantly.

Frequently, flowing lines cross over themselves or come close to another point on the line, thereby effecting a full or partial enclosure.

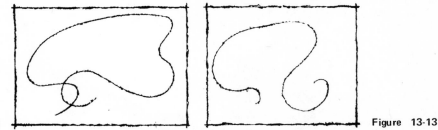

Figure 13-12 **Figure 13-13**

In such a situation, all the elements within the enclosure, regardless of their diversity, tend to be united.

Figure 13-14

Thus far in this sequence on flowing line we have dealt only with the action of easily perceived, tangible lines. Similar reaction can be accomplished with subtler means that can be felt by all but understood mainly by those who have experienced pictorial composition.

These are the flowing lines that develop from the edges of contiguous shapes, shadows, and intervals instead of being derived from a single, long, thin object like a string or ribbon. Such a line is found in one object, moves around the edges of others, and makes itself felt as an organized rhythmic movement that interconnects the objects from which it borrows its continuity.

PLATE 13-31

The interest in the picture of piled cordwood stems from just such a movement that contains not only one but several linear passages. Start along the edge of any single log; follow the line through and immediately the eye is sent on a visual journey along contours of objects, intervals, and shadows. Simplification of tone to two basic values intensifies the abstract character of shape and texture and simplifies the process of perceiving the unity.

BACKGROUND AS A UNIFYING FORCE

Many photographers regard background as space for which there is no subject matter to fill and it is grudgingly accepted as performing neither good nor harm. Some background is tolerated as a device to separate one object from another; beyond that these photographers seek to reduce it to a minimum. Get the objects as big as possible in the print! Bring the edges of the outermost objects out to the edge of the frame! Crop away background so that attention is focused as much as possible on the objects themselves!

What a false premise!

The background is a subtle but powerful force in composition. As we have seen in our study of shape, the areas between objects form negative shapes that affect the appearance of the picture. Negative shapes of a similar nature are formed between the outermost edges of objects and the borders of the print.

Background space has a profound effect on unity, as we shall see from the following experiment: Collect a number of objects, each different in shape and tone and as unrelated in function as possible. Set these on a table with a simple continuous background, being careful to establish as little unity as possible. Avoid grouping and, wherever feasible, overlapping.

Figure 13-15

As you compose the subject in the viewer, arrange to leave a considerable amount of space around the outside of the objects. Expose and make two prints, one cropped close to the objects and the other with sufficient carefully considered space left around the objects as background.

Figure 13-16

Figure 13-17

Notice how scattered and disunited the first picture appears. Perhaps with a great deal of effort one can find elements of similarity of shape, tone, or texture that relate to each other, but the result will be more rationalization than actual interrelationship.

No attempt is made to consider the second as a successful picture. Having started with a disunity, spottiness is still very much evident. But notice how much less spottiness exists! The space around the edges has served to bring the objects together. Because that space is greater than any space between objects, the objects appear to be pulled together more than in the first picture.

This is not to be taken as an admonition to include a great amount of background in every picture. It merely demonstrates the power of background space to alter the unity of positive space. The background may be made smaller when the space between units is small and compactly organized. In that event the small area of background appears to give more "air" around each object and to deemphasize crowding or overabundant solidarity. Crowding can be as much a detraction as extraordinary disconnection.

The background may be enlarged when the space between units is larger so that the unity appears to be threatened and spottiness occurs.

Composition must be thought of as a closely related whole for unity just as it is for any other principle.

Conclusion

There is still another ingredient that is often required to turn good pictures into great ones. Although it has not been identified directly in preceding chapters, it has been hinted many times. For lack of a better name we have to call it *magic*. It constitutes a kind of barrier that is possible to approach but most difficult to cross.

Throughout history, there have been many artists in all mediums who succeeded in doing everything well; yet their pictures failed to be stirring. Many competent writers have learned the principles of good writing, applied them to their books, and yet failed to create anything that may properly be called great literature. Artists who have succeeded in creating great art in one picture may not be successful in another. This happened in spite of the fact that they understood and applied the elements and principles as they did before.

Evidently something special happens from time to time when all the resources within the artist and the subject come together in an enchanted mixture. Unmistakably the result is great art. Often it expresses what previously had been inexpressible or had been neglected to be expressed.

Rarely, if ever, by some freakish accident does it happen to a dabbler, who shoots to obtain illustrations of "pretty things." There is no guarantee that it will occur with any degree of certainty to a photographer with a great deal of experience. Some photographers achieve superb artistry in almost every picture they show. (This does not mean that everything they shoot is successful. They are wise enough to select the worthwhile and discard the remainder.)

All the successful photographers we have known have deep insights into the abstract elements and principles of composition; they respect them, and they use them. These elements and principles are the most dependable means at least to reach the magic barrier. Each artist has an individual bias, a favorite combination that is apparent in most of his work. These combinations are the hallmark of his work and provide the characteristics of individuality that make one's work distinctive and recognizable.

An inherent danger in the study of composition is the interpretation that knowledge of the components and their application is a purely mechanical process. So much of learning has been reduced to step-by-step procedure that in disciplines where an assembly line method has not been provided, some people try to devise one.

Art is a complex study that always resists, and sometimes defies, being contained within any routine procedure. Merely to put together a collection of shapes, lines, and textures, even if they are properly contrasty and rhythmic, does not constitute creativity. If fine pictures could be composed by a prescribed method, there would be many more people capable of producing them than are now available.

Some photographers delude themselves into believing that because they limit their images to purely nonobjective organizations, they are automatically producing art. There is nothing automatic about art. It doesn't really matter if the picture is an abstraction with clearly recognizable reality or a composition of purely geometric forms. It is the translation of abstraction into feeling that really matters. Unless human impulse is the guiding element in the process, the results can be static and dull.

Much of the magic has to do with the degree of involvement connected with the development of the picture from the instant the subject is perceived. The artist's inner resources are stimulated by abstract forms within the content, regardless of whether the content is concretely real or nonobjective.

As a poet finds the words to express innermost feelings, so does the photographic artist find the forms to express them visually. Emphasizing exaggerated appearances instead of faithful representation, he demonstrates a strong human presence to translate the content into a unique expression.

INDEX

257